Ceramic Sculpture: Six Artists

Ceramic Sculpture: Six Artists

Ceramic Sculpture: Six Artists

Peter Voulkos

John Mason

Kenneth Price

Robert Arneson

David Gilhooly

Richard Shaw

Richard Marshall and Suzanne Foley

Whitney Museum of American Art, New York
in association with the
University of Washington Press, Seattle and London

This book was published in conjunction with an exhibition at the Whitney Museum of American Art, December 9, 1981–February 7, 1982, and the San Francisco Museum of Modern Art, April 8–June 27, 1982, organized jointly by the two museums and supported by a grant from the National Endowment for the Arts.

Cover: John Mason, *Geometric Form—Red X*, 1966 (detail)
Glazed stoneware, 58½ x 59½ x 17″ (148.5 x 151.1 x 43.2 cm)
Los Angeles County Museum of Art

NK4008.C47 730′.0973′07401471 81-14703
ISBN 0-87427-035-9 (WMAA soft-cover) AACR2
ISBN 0-295-95889-8 (UWP hard-cover)

Contents

Forewords

The Whitney Museum of American Art is committed to bringing to the public's attention innovative forms and new directions in American art. Ceramic art, long considered craft because of its association with utilitarian objects, has only recently begun to be considered part of the mainstream of our artistic culture. Richard Marshall and Suzanne Foley have placed the six artists included in this exhibition in the context of the tradition of ceramic art which has been established in California. The careers of these artists demonstrate the master-apprentice relationship which has been a marked feature of this tradition on the West Coast, where ceramics has been a major activity in university art departments. It is the purpose of this exhibition to distinguish these outstanding artists, and celebrate their sustained achievement in a medium which provides opportunities for infinite variation.

The remarkable phenomenon of West Coast ceramic sculpture has become one of the great strengths of contemporary American art, and is now internationally recognized, particularly in Europe. A substantial collection has been assembled at the Stedelijk Museum in Amsterdam, for example, and American museums are beginning to welcome these works into their permanent collections. It is to be hoped that the stereotyped views which have excluded these artists and their peers will now disappear, and that ceramic sculpture will be judged by the same aesthetic criteria as other areas of contemporary art.

The Whitney Museum has recognized ceramic sculpture in surveys of American art since the mid-1960s, and five of the six artists in this

exhibition are now represented in the Permanent Collection. In 1976, the three senior artists—Peter Voulkos, John Mason, and Kenneth Price—were included in our major bicentennial survey, "200 Years of American Sculpture."

It is refreshing to see, within this group of six artists, three who take on the world with a sense of humor, and present a satirical viewpoint in their works of art. Humor has come to be looked upon as inappropriate to significant art — a belief overturned by these artists.

It has been a great pleasure to work on this project with the San Francisco Museum of Modern Art, which—more than any other institution—has been identified with and encouraged artists working in ceramic materials. Our association has added substantially to the importance of this endeavor.

We wish to acknowledge a special debt of gratitude to the lenders to this exhibition, who by their willingness to entrust us with extremely fragile objects have demonstrated an enthusiasm for these artists equal to our own.

> Tom Armstrong
> Director
> Whitney Museum of American Art

The staff of the San Francisco Museum of Modern Art has maintained a continuing interest in the evolution and maturation of what is now defined as ceramic sculpture since its acceptance as a viable means of artistic expression. Perhaps our involvement as collectors and exhibitors developed as a matter of pride since, as this exhibition proposes, the primary artists were working in California and fully one-third of our program is devoted to the presentation of artists connected with this state.

The fact that loans to the exhibition are coming from important American and European museums as well as private collections indicates how widely and how quickly the recognition of this movement has spread since we were first exposed to the work of Peter Voulkos, John Mason, and Kenneth Price in Los Angeles in the mid-1950s. We are grateful to these lenders who are willing to lend their fragile objects to bring this exhibition to fruition in the most comprehensive way possible.

It is always a gratifying experience to work with the staff of the Whitney Museum of American Art, especially so when the exhibition has been co-proposed and co-selected, as is "Ceramic Sculpture: Six Artists." The clear implication of this type of East/West collaboration is that we are not as distant in miles or in thought patterns about art or the importance of an idea as some would like to think. Richard Marshall and Suzanne Foley have had extensive conversations about who should be represented in the exhibition, and it is gratifying to know that the six artists chosen were recognized by both of them to be seminal to a movement which by now includes hundreds of able practitioners.

> Henry T. Hopkins
> Director
> San Francisco Museum of Modern Art

Preface

This exhibition presents six major artists whose work in clay has brought that medium into the mainstream of contemporary sculpture. "Ceramic Sculpture: Six Artists" is the first exhibition to explore in depth the primary artists in this field. It is not a comprehensive survey of all ceramic activity in California or on a national level, but focuses on six artists who have developed a distinctive sculptural statement with clay. Each has produced a strong, resourceful, and influential body of work, expressing individual points of view and diverse uses of the medium. The selection was limited to six artists so that their individual approaches to sculpture could be presented comprehensively and, in many cases, with works of an ambitious scale. With the proliferation of work in clay during the 1970s, it has become essential to make a statement about the origins and leaders of the ceramic movement in American sculpture since the 1950s.

Although this exhibition and book acknowledge the evolution of recent ceramic history, the primary focus is the sculpture itself. Too often, the appreciation or recognition of a work of sculpture in clay is overshadowed by the historical circumstances from which it emerged or by unfounded biases against the material. This group of artists represents some of the most outstanding and influential ceramic sculptors who have emerged in California since the mid-1950s, and who are responsible for broadening the sculptural expression in clay from traditional pot and container forms to non-functional, often large-scale, art objects. Peter Voulkos is the acknowledged initiator of the revisionist approach to ceramic work. His pivotal position in California's receptive and fertile artistic atmosphere in the 1950s, especially in its colleges

and universities, generated the phenomenon of a university-sustained ceramic movement. The majority of contemporary ceramic artists, including the six presented here, have been university trained, have first been introduced to each other's work in college ceramic departments, and have had careers as instructors. In his role as teacher, Voulkos proposed and encouraged two major deviations from the then-accepted approach to ceramic use: that the utility of a vessel was no longer a prerequisite for its validity, and that ceramic materials could be used to create a major art form. The development of ceramic sculpture in California then underwent a geographical and stylistic shift. It began in Los Angeles in the mid-1950s at Otis Art Institute, where Voulkos was a colleague and teacher of John Mason and Kenneth Price. Their work explored gestural, abstract, and non-figurative sculptural forms. The shift in activity from Los Angeles to Northern California coincided with Voulkos' move to Berkeley in 1959. Here his influence was felt by Robert Arneson, who was to become the major figure of the subsequent generation of ceramic sculptors, including David Gilhooly and Richard Shaw, who used clay for realistic, figurative, and narrative sculptural expressions.

This exhibition evolves from the exhibition "Clay" that was organized for the Downtown Branch of the Whitney Museum in 1974. It included over eighty works by twenty-eight artists from a number of states, and surveyed a wide range of sculptural styles and directions. That exhibition underscored the need for a more selective, in-depth presentation of the primary artists in the origins and development of contemporary ceramic sculpture. It also

enhanced the need to familiarize an East Coast audience with an area of contemporary American art that had not received adequate exposure or attention. On the West Coast, Suzanne Foley, curator at the San Francisco Museum of Modern Art, had organized "A Decade of Ceramic Art, 1962–1972: From the Collection of Professor and Mrs. R. Joseph Monsen" for that museum, and had become interested in the sources of this new form of artistic expression. Her subsequent exhibitions and writings on artists who were instrumental in the dramatic changes taking place in ceramic art—including Richard Shaw and Robert Hudson (1973), Robert Arneson (1974), and James Melchert (1975)—encouraged her to chronicle the evolution of form and imagery in the ceramic sculpture movement.

In 1979 Suzanne Foley and I combined our parallel interests to jointly organize an exhibition of ceramic sculpture to be shown in New York and San Francisco. Grateful acknowledgment is extended to the artists for their continued assistance and cooperation, to the staffs of the Whitney Museum of American Art and the San Francisco Museum of Modern Art for their commitment to the exhibition, and to the National Endowment for the Arts for a grant supporting its organization.

Richard Marshall
Associate Curator, Exhibitions
Whitney Museum of American Art

Ceramic Sculpture in California: An Overview

Introduction

Sculpture in America came into its own in the 1950s and 1960s because it went beyond the traditionally addressed issues of articulated volume and mass. For example, the planar Constructivist aesthetic led to the selection of materials as diverse as steel I-beams or cast polyester resin; gestural form in Abstract Expressionist painting found sculptural realization in welded metal, carved wood, or fired clay. The Dada attitude toward the object as a literary, psychological embodiment was influential for artists who made assemblages of found objects. This introduction and combination of materials not normally used in making sculpture gave great diversity to three-dimensional objects, and enlarged the definition of sculpture.

In this time of inquiry, the phenomenon of a ceramics movement in sculpture appeared on the West Coast. While its beginnings in the mid-1950s were a direct response to Abstract Expressionist painting, in subsequent years the medium of fired clay has been used for a range of sculptural and painting modes, so that now the major work being done relates to the stylistic concerns which occupy artists in other media.

Several factors made this aesthetic expansion possible. In California in the 1950s and 1960s the art climate was open to experimentation. Physically and psychically removed from the New York art world, a California artist felt little restrained by the East Coast's hierarchical and traditional definitions of fine art. The less formal California life-style also encouraged a personal and artistic freedom, as did the influence of Far Eastern philosophies, with their attitude of wholeness in life and work, body and spirit. The concern for the psychological containment and physical interrelatedness of surface, form, and function in the Oriental craft tradition was a dominant influence on West Coast potters.

As educational programs in art expanded, ceramics was one of many areas that received new emphasis. The artist-educators working in clay were not only participants in the nationwide

network of craft exhibitions and publications, but they were also colleagues of painters, poets, sculptors, and philosophers. As potters, they mastered the technical processes of creating functional objects within the craft tradition; pushing forward, they took the option of relating these processes to ideas outside the craft world.

Clay as an art medium has unique qualities that have special appeal to the artist and viewer alike. Its relation to primordial expression—its source in the earth—gives it metaphoric associations with nature and man. Its plasticity requires an immediacy of handling, provoking the artist's intuitive more than conceptual response. Its formed and painted surface offers the special property of a three-dimensional painting. The opportunity for sculpture to convey the aesthetic of painting with the psychological presence of the object was the incentive for artists to develop ceramic sculpture as a new area of expression.

The six artists in this exhibition began, in most cases, as studio potters, and the sources of their ideas were in the craft tradition. When the problems they set for themselves went beyond the handling of materials to show technical achievement and addressed problems of perception, scale, inherent energy, implied human presence, or psychological challenge, the work transcended craft and became a force in painting and sculpture. It was still possible for these ceramicists to use a plate, cup, or vase form, but the end product invariably defied a functional use. Basically, their work deals directly with the issue of pictorial sculpture. Kenneth Price confronts issues of formalist painting in objects of brightly colored cup or geometric form. In the early work of John Mason and Peter Voulkos, sculptural mass counterpointed by painted surface imagery is imbued with the contained energy of gesture. In pictorial subject matter, Robert Arneson's visual metaphors add sculptural dimension to his expressive painting statements. David Gilhooly contributes mythic, narrative sculpture, while Richard Shaw describes pictorial illusionism in three dimensions. Over the past two and a half

decades ceramic sculpture has established a place for itself in current sculptural expression, and response to it has increased on a national and international level.

The Formative Years in Los Angeles: From Pottery to Sculpture

Into the 1950s sculpture on the West Coast had virtually no indigenous expression (the exception being, of course, in the work of eccentric visionaries like Simon Rodia, whose *Watts Towers* in Los Angeles embody unique personal and public art expression). Sculpture in the modernist tradition came to California from elsewhere: in Southern California in the Cubist-rooted bronzes of Bernard Rosenthal or the romantic, figurative expression of Jack Zajac's cast images; in Northern California in the Surrealist-Constructivist sculpture of Adaline Kent and Robert Howard. Many California artists were trained in Europe or New York and developed their mature work prior to settling in California. It was the post-World War II generation that developed an indigenous sculptural expression.

The craft tradition in California, as well, was full of activity in postwar years, gaining a distinctive identity nationally. The "California look" was a colorful, informal one which integrated handcrafted objects into a modern living environment in a warm, personalizing manner. The many studio potters working in California were generally bound to the smooth forms and technical procedures inherited from European sources. An increasing interest in Oriental pottery, particularly Japanese folk pottery, produced rough, irregular shaped ware—potters admired the unpredictable changes in glazes that occurred during firing.

In the postwar years an art student had the opportunity to become skilled in various disciplines, from drawing, painting, and sculpture to ceramics, metalcraft, and woodworking. It was through the classroom dynamic that a new attitude could develop which questioned the conventions of traditional forms

and validated alternative approaches to using materials.

Such experimentation was not what Millard Sheets anticipated when he invited the Montana potter Peter Voulkos to establish a ceramics department at Otis Art Institute in Los Angeles in 1954. What came out of Voulkos' five-year tenure in Los Angeles was an attitude about the artist's personal commitment to follow his intuitive, creative inquiry, regardless of what was expected of a material or an image. Bringing the Abstract Expressionist spirit of spontaneity and gesture to realization in the neglected sculptural medium of clay, Voulkos had a catalytic effect on the formal evolution of the ceramic artists who worked with him (Fig. 1). The individuality of Paul Soldner, John Mason, Kenneth Price, Billy Al Bengston, Jerry Rothman, Michael Frimkess, and Henry Takemoto—their wide-ranging aesthetics and formats—bear out Voulkos' role. These men, of varied ages and stages of professional development, gained from their association with Voulkos a commitment to risk and experimentation backed up by a competence in technical skills.

Voulkos already had a national reputation as a potter when Sheets invited him to Los Angeles. The pots had a sureness of form, shaped directly on the wheel by a potter who had consummate skill in his craft. The inventive surface decoration of his pots and its compatibility to the vessel's form won him innumerable awards at exhibitions around the country and in Europe. Voulkos was in contact with the major figures in ceramics. When the English potter Bernard Leach toured the United States in 1952 with Shoji Hamada, Japan's leading potter, they visited the Archie Bray Foundation in Helena, Montana, where Voulkos and Rudy Autio conducted an active workshop for studio potters. Yet it was Karen Karnes' and David Winerib's invitation in 1953 to teach a summer session at the ceramics institute at Black Mountain College near Asheville, North Carolina, that expanded Voulkos' creative resources. Immersed in an atmosphere of experimentation, surrounded by artists working

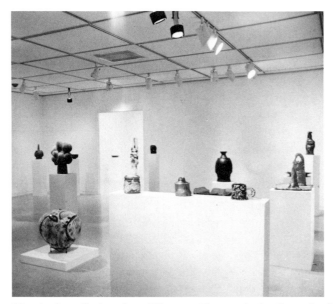

Fig. 1 Installation view, "Abstract Expressionist Ceramics," Art Gallery, University of California, Irvine, 1966.

in all media, Voulkos' aesthetic horizons broadened. His visit was completed by a trip to New York with Black Mountain friends, the poet-painter M. C. Richards and the musician David Tudor. In New York, he frequented the Cedar Bar, meeting Jack Tworkov, Franz Kline, and Philip Guston. Being in the midst of the energy and interaction of this Tenth Street artists' haunt at the moment when Action Painting was emerging gave Voulkos' own interests definition.[1]

Voulkos' move to Los Angeles in 1954 was a turning point for him and for ceramic art. He frequented galleries and museums, at last seeing firsthand work he had known from reproductions in books: Picasso at the Frank Perls Gallery; Miró at a 1959 Los Angeles County Museum exhibition. Abstract Expressionist painting from New York was seen increasingly in museum and commercial gallery exhibitions. Voulkos shared with artists who were his students, as well as with painters such as Richards Rubin, a consuming interest in all that was going on, not just in painting but in jazz, the movies, the "alternative" or "underground" attitudes of the Beat period. The teaching environment at Otis was equally a part of this exchange of energies. Working initially with students his own age— Paul Soldner and John Mason, who wanted to broaden their own skills and vision—Voulkos soon was joined by younger students, such as Billy Al Bengston and Kenneth Price, who were seeking definition in their own artistic commitment.

In this environment of exchange and competition, and of an unspoken need for change in the craft tradition, Voulkos' work expanded radically. The liberating attitudes of Abstract Expressionism affected his ceramics in two areas: in surface decoration and in sheer size and articulation of form. It also spurred him on to make paintings again. The tactile surfaces—the sand and impasto—on his canvases related directly to the surface decoration of pots and plates. His admiration for Picasso's approach to decorating clay—as if it were painting-in-the-round—was an incentive to create a more complex surface articulation on his own vessels, to play the two-dimensionally "drawn" image against the three-dimensional form. Voulkos applied thin clay cutouts to the pot's surface, but then found he could achieve a greater overall surface variety by assembling different pot forms into one unit, manipulating their shapes by paddling or cutting through them. By 1956, these assembled and decorated vessels were exhibited in Los Angeles at Felix Landau Gallery.

The magazine *Craft Horizons* was the major organ of communication in crafts, reporting on the crafts support-system activities: the associations and guilds, the invitational and juried exhibitions, and the commercial gallery exhibitions. The September/October 1956 issue, featuring California craft activity, included an article on Voulkos, one of the first to appear nationally. Within the ceramics tradition, his described attitude toward teaching, his sources, his work method, his philosophy as an artist were radical. Rose Slivka wrote a perceptive review for Voulkos' 1957 exhibition at Bonnier's in New York:

Peter Voulkos, the potter, reveals a restlessness with the confines of his craft. He has pushed it as far as he can in the directions of modern painting and sculpture, retaining only the central form of a basic hollow container on which he then proceeds to build.... The influences of Picasso, Japanese pottery and the American "action" school of art are there along with Peter Voulkos himself, who emerges as a truly magnetic experimentalist. This fine and accomplished potter, searching his craft for new solutions more related to the explorations taking place in modern art today, utilizes these elements: the new consciousness of spontaneity as a force, and the deliberate effort to achieve it; the charm of "accident"; the violation of precedent (this does not mean a disrespect for it) in order to disturb old ideas and stimulate new ones; the new freedom of the artist to express his particular personality and psyche

with directness and depth. Voulkos has ventured courageously into a risky area for potters. That there is an ambivalence in his results is perhaps inevitable. But Peter Voulkos the potter and Peter Voulkos the painter and Peter Voulkos the sculptor all make a fascinating pot and a controversial one.[2]

As his pieces evolved from vessel to sculpture, the assembled forms grew as large as Voulkos could structurally make them. Viewing a Fritz Wotruba sculpture exhibition gave him ideas for stacking and cantilevering volumes from a central core. Voulkos moved to a new studio in 1957, which he shared with John Mason; here there was more room to make and fire large sculpture (Fig. 2). By 1958, through much trial and error, he combined thrown and manipulated elements to create sculpture over five and a half feet high. Several series of these monumental pieces were made over the next two and a half years.

An exhibition of Voulkos' sculpture and painting at the Pasadena Art Museum in 1958 gave museum recognition to the mature body of work he had achieved. This exhibition was one in an ongoing series at the museum of solo shows of emerging talents. Director Thomas W. Leavitt emphatically supported Voulkos: "Voulkos is the outstanding pioneer in large-scale ceramic sculpture and his technical and creative innovations should have a profound influence upon the art of our time.... The impact of this exhibition will be enormous."[3] In reporting on Los Angeles art for *Art News* in 1959, Jules Langsner commented that this was the liveliest Los Angeles art season yet; Peter Voulkos "heads for the front ranks of West Coast abstract artists." This extraordinary body of work brought Voulkos to national attention when he was named as one of *Art in America*'s 1959 New Talent artists in sculpture. This was followed in early 1960 by a solo New York exhibition in the Museum of Modern Art's New Talent series in the Penthouse Gallery (Fig. 3). Six of the 1958–59 sculptures and six paintings from 1958 were

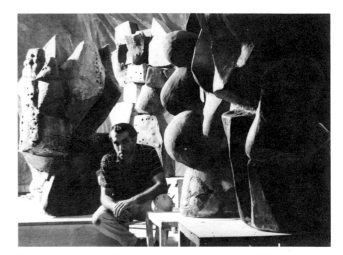

Fig. 2 Peter Voulkos in Los Angeles studio, 1959.

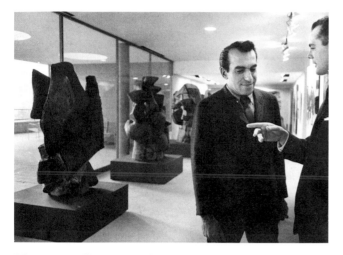

Fig. 3 Installation view, Peter Voulkos (left) at "Sculpture and Paintings by Peter Voulkos: New Talent in the Penthouse," The Museum of Modern Art, New York, 1960.

shown. The critical response, notably in two reviews by Dore Ashton, emphasized the organic quality and vitality of nature generated by the pieces.

In these monumental pieces Voulkos achieved several definitions of sculptural form through his method of assembling clay forms thrown on the potter's wheel. Monoliths of large, bulbous parts assembled around a central cylinder implied mass and volume with a static profile. Monochromatic, they were covered with black iron slip, and their flowing surfaces reflected the modulation of light and shadow.

Other pieces incorporated more angular forms constructed with greater diagonal thrusts. Facets and joined planes were emphasized or negated by the application of surface color—black, blue, and white. Voulkos expressed his interest in carrying further what he learned from Picasso about color on a three-dimensional vessel in a 1959 statement:

I brush color on to violate the form and it comes out a complete new thing which involves a painting concept on a three-dimensional surface, a new idea. These things are exploding, jumping off. I wanted to pick up that energy. That's different from decorating. Decorating enhances form, heightens the surface. I wanted to change the form, get more excitement going.[4]

More columnar pieces of 1959–60, still monochromatic black, are comprised of smaller units, most of which are rent and gouged, giving a lively surface play of light and shadow. Again the profile is monolithic, but the sense of mass is contradicted by the active, plastic surface articulation.

The inherent physical nature of clay immediately signals its material properties. Everyone who looks at a clay object knows what it feels like to the touch, because we daily handle objects made from clay; everyone knows how it responds to human touch, that it was once soft and malleable and hardened as it dried. These qualities give it the closest association of any sculptural material to the intuitive spontaneity of

the Abstract Expressionist attitude toward making art—an attitude responsible for Voulkos' short span of production in monumental clay sculpture. As he commented, "The minute you begin to feel you understand what you're doing, it loses that searching quality."[5] In 1960 his search for solutions to cantilevering forms and more open structure in his sculpture led Voulkos to cast in bronze the elements for assembly—still an intuitive procedure, but slower.

Voulkos' approach to making ceramic sculpture—no matter how large, no matter how many elements went into a piece—was still based in the potter's wheel, where every element had its beginning. For this reason, his sculptures clearly differentiated form and surface. Two of the artists working with him at Otis Art Institute—John Mason and Kenneth Price—created sculpture in clay where form and surface were one. Their three-dimensional works, each in diametrically opposed ways, related to different issues in painting.

John Mason had been making pottery for about four years before he joined Voulkos at Otis Art Institute in 1954. The association enabled Mason to break through the conventions of the craft tradition that had restricted his intuitive response to the plasticity of the medium. Quickly he exploited this plasticity in a pot form by denting, flattening, or creasing the vessels, or in clay plaques by subjecting them to surface incident of dent, fold, or tear. By 1957, Mason concentrated on building forms of clay reflecting the physical properties of the medium. In a series of wall reliefs, he assembled strips and hunks of clay in gestural configurations, like brushstrokes in clay. A large wall-relief piece in 1960, comprised of eighteen two-foot-square rectangles, had a troweled, modeled, landscape-associated surface, which reflected an active play of light and shadow (Fig. 4). Generally monochromatic, through the application of colored slip, the pieces were often heightened with the bright local color of low-fire glazes. Showing little debt to recent sculptural predecessors, these reliefs emulated the gestural

content of Abstract Expressionist painting.

By 1960, Mason concentrated on a series of freestanding vertical sculptures, made by assembling rectilinear strips or hunks of clay into a columnar shape. This approach related the space-form tensions of the surface articulation to the contained energy of the mass, evoking a vigorous sculptural presence. The vertical, columnar form of Mason's sculpture implied an organic, growing energy. To probe to the source of this energy and take his formal investigations to an essential, primordial expression, Mason began building cross-shaped pieces, simplifying the gesture around a centralized source of energy and thereby achieving a more abstract symbolism. Subsequently, the attenuated cross arms were contained in massive circle or cross forms—stele-like monochromatic pieces.

In the 1950s Mason consistently showed ceramic plates, pots, and sculptural forms in pottery exhibitions. However, in this same period, his ideas and inquiries about art were allied with a group of Los Angeles painters for whom Abstract Expressionist painting prompted experimentation. Greater visibility was offered these artists in March 1957, when Walter Hopps and Edward Kienholz, who had each been showing the work of young artists in their respective galleries, joined forces to open the Ferus Gallery on La Cienega Boulevard in Los Angeles. Painting dominated the gallery's schedule, but in the summer of that year the gallery showed its first exhibition of objects—ceramics by Paul Soldner, John Mason, and Jerry Rothman, all artists who were working with Peter Voulkos at Otis Art Institute. In the fall of 1957 Mason had a solo exhibition at Ferus, followed by three more, in 1959, 1961, and 1963. (The gallery closed in 1966.) In May 1960, Mason's sculpture was presented in a solo exhibition at the Pasadena Art Museum (Fig. 5), and he was selected for inclusion in *Art in America*'s New Talent issue in 1961—but in the Crafts section. By 1959 and 1960 both Mason's ceramic pottery and his fired-clay sculpture were shown regionally as well as in major national compe-

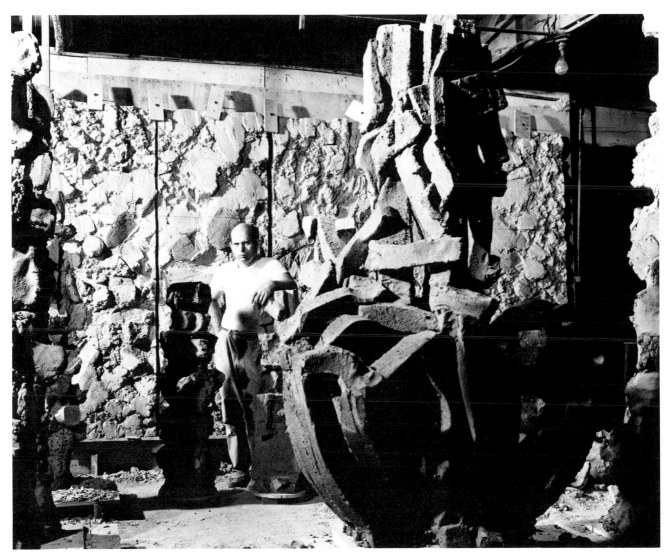

Fig. 4 John Mason in Los Angeles studio, 1960.

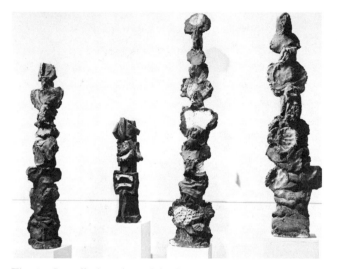

Fig. 5 Installation view, "John Mason," Pasadena Art Museum, 1960.

titive and invitational exhibitions. Critics such as Los Angeles' Jules Langsner often prefaced comments on the sculpture with observations like: "Abstract fired-clay sculpture has appeared here in the last few years with remarkable vigor."[6]

In the early 1960s, the emerging vanguard in Los Angeles painting and sculpture quickly grew beyond the expressionist ethos and assumed clearer definition. Attention shifted from the experience of the artist recorded by the painting or sculpture to the viewer's experience through the color, surface quality, and the object's inherent material presence. For artists, the most liberating aspect of this focus was the use of "non-art" industrial materials: automobile-body lacquers, epoxies, and plastics. The implementation of these materials was a central aspect of the content of the work, so that a thoroughly crafted conception defined the piece. From 1960 to 1965, the Ferus Gallery exhibitions of Larry Bell, Billy Al Bengston, Robert Irwin, Craig Kauffman, and Kenneth Price gave public expression to this change.

Kenneth Price and Billy Al Bengston both grew up in Los Angeles and had been friends for three years, throughout their art studies, when they sought out Peter Voulkos' ceramics class at Otis Art Institute in 1956. The freewheeling inquiry that the Voulkos milieu offered during their two-year stay contributed in different degrees to each artist's identification of himself. At Otis, Price's cup, plate, and jar forms were more reductive in shape than those of his colleagues, with the surface design or incident always integral to the form, always conscious of the edge, however spontaneous they may appear. Price ranks high among contemporary artists whose conceptually based art finds expression in the material and format that best convey the idea. So a cup or a drawing or a clay "egg" or a Mexican curio shop are each equally viable expressions, with no hierarchical deference. Once accepted, this premise reveals the resourcefulness of an outstanding, creative mind. It also seems to reflect the area in which today's

artist has learned the most from the genius of artists like Picasso and Duchamp.

Price's temperament took him in late 1958 to a discipline at the opposite pole from the Voulkos workshop, a year at the New York State College of Ceramics at Alfred, the famed school of ceramic technology, best known for its work in ceramic glazes. On his return to Los Angeles in 1959, Price showed in a summer group exhibition at the Ferus Gallery and began to plan for his first solo exhibition there the following year. From that time on, Price's unique sculptural expression has developed consistently, resulting in a total body of work that today makes a decided contribution to American sculpture (Fig. 6). Lucy R. Lippard characterizes his position well in a 1966 catalogue essay:

He is involved in a peculiarly contemporary dialectic, but he has deliberately read himself out of the vanguard race for innovation. His pace, like his morphology, is his own. He has chosen an idiom central to modern art in which the working decisions are flexible instead of fixed. There is in his work that simultaneous commitment and detachment identified with the increasingly Oriental cast of Western thought, an unsentimental respect for the shiny armoured surfaces of a luxury civilization as well as a precise and delicate awareness of the most elusive bonds between man and nature. These are not contradictory but complementary aspects of modern life.[7]

Price's small sculpture has a monumentality of scale. He made egg-shaped works no larger than fifteen inches and some small "specimen" pieces three inches long in elaborately designed containers. Always conscious of its total impact, Price presented his sculpture on bases, and often pedestals, which he conceived as integral to the work. The orb or mound shape basic to this sculpture evokes the symbolism of an archetypal form. This is further enforced by the small aperture in the surface, revealing tendril-like forms, creating a tension between the contained,

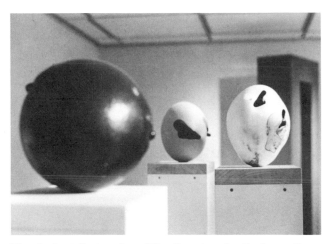

Fig. 6 Installation view, "Five Los Angeles Sculptors," Art Gallery, University of California, Irvine, 1966; from left, Kenneth Price's *S. Violet* (1963), *B. G. Red* (1963), and *C. G. White* (1963).

inert shell and the implied growth of the tendrils. Yet this mystery of implied meaning is almost negated by the form's brilliant color. Applied to these rounded forms, the intense color becomes a physical form. The seamless aspect of the orb supported by an encircling band of another hue enforces the three-dimensional presence of the color. In contrast to the record of facture evident in Voulkos' and Mason's clay sculpture, the clay support for Price's color is anonymous. Only subtle attention to surface texture, which variegates the glossy surface of the glaze or lacquer, gives hint of a support body. While one can make association with the hard-edged abstract painting in Los Angeles, color is Price's intuitive sensibility. A product of this unique vision, his sculpture becomes a three-dimensional canvas.

Ceramics as Sculpture: Critical Reception

In craft exhibitions during the early 1960s the non-utilitarian, expressionist use of clay represented a revolutionary attitude. Rose Slivka, the perceptive editor of *Craft Horizons*, was in touch with both the generative years of Abstract Expressionist painting and sculpture in New York and with activity in the craft world. Her discussions with Peter Voulkos in 1960 supported her contention that the new energies and concerns of Action Painting were finding similar expression in clay. Her 1961 article "The New Ceramic Presence" remains the lexicon for sculptural expression in ceramics.[8] The article discusses attitudes, procedures, and sources for this expression in contemporary culture, but cites no individual artists as examples. It is illustrated, however, with photographs of vessels and plates by fifteen artists.[9] Since the magazine's largest constituency expected it to confirm the traditional craft ideal rather than justify the relevance of the experimental, the article stirred discontent among craftsmen.

Ceramic sculpture fit in easily with painting and sculpture since the trend to diversity meant that a wide variety of materials was being used as sculptural media. This was reflected nationally in established group exhibitions, such as the Art Institute of Chicago's Annual American Art Exhibitions or the Whitney Museum of American Art's Annual Exhibitions in New York. Especially controversial was the Whitney's 1964 Annual, "Contemporary American Sculpture," in which John Mason was included, for the range of styles and materials being employed under the guise of sculptural expression. As well, special exhibitions on both coasts were organized to recognize this resurgence of activity in sculpture. Ceramic sculpture was included in most of the large exhibitions.

While the fired and painted ceramic sculpture of Peter Voulkos, John Mason, and Kenneth Price was shown in these national exhibitions, California exhibitions had a greater variety of artists using clay sculpturally. In Northern California in 1963 at least four different group exhibitions occurred within a short enough time to be reviewed critically in an overall assessment of the current innovations in sculpture in which clay played a prominent role.[10]

The most influential of these exhibitions—because it was published most visibly—was a summer one of almost fifty works, "California Sculpture," held at the Kaiser Center under the auspices of the Oakland Art Museum (Figs. 7, 8). The works were selected by Paul Mills, director of the Oakland Art Museum, Walter Hopps, then curator of the Pasadena Art Museum, and John Coplans, Editor-at-Large of *Artforum* magazine. This San Francisco-based magazine, a year old in 1963, featured the Kaiser Center exhibition in its August issue. The lead article by Coplans, who came to California in 1961, discussed current developments in sculpture in the state. He focused on the Southern California ceramics movement's germinal influence, through the work of Peter Voulkos, John Mason, and Kenneth Price. He mentioned as well the contribution of assemblagists Wallace Berman, Edward Kienholz, and Bruce Conner to an indigenous expression in California art.

Coplans' discussion of Northern California focused on two institutions: the San Francisco

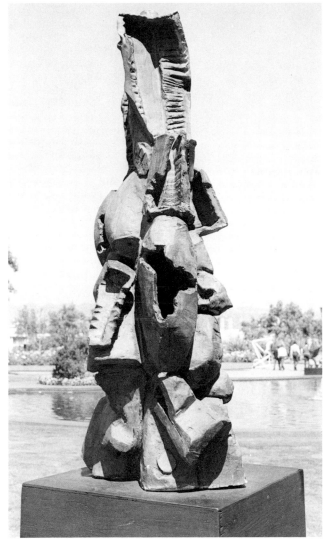

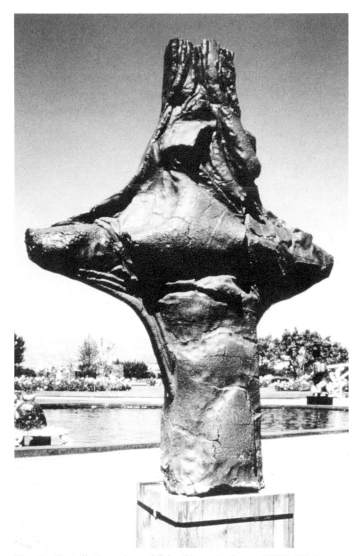

Fig. 7 Installation view of Peter Voulkos' *Sevillanas* (1959), "California Sculpture," Kaiser Center, Oakland, California, 1963.

Fig. 8 Installation view of John Mason's *Cross* (1963), "California Sculpture," Kaiser Center, Oakland, California, 1963.

Art Institute and the University of California, Berkeley. At the former, expressionist-oriented sculpture of welded metal, wood, and plaster by Robert Hudson, Alvin Light, and Manuel Neri dominated, while bronze casting characterized the work from the University of California campus—sculpture by Peter Voulkos, Harold Paris, and Don Haskin. Voulkos' presence in Berkeley since late 1959 had attracted a group of artists who used clay as a major material in their sculpture, often in combination with other materials. Represented by ceramic pieces in the Kaiser Center sculpture exhibition were Stephen De Staebler, Michael Frimkess, James Melchert, and Win Ng. The August 1963 *Artforum* concluded with a picture portfolio of sculpture by more than seventy-five artists in California, illustrating ceramic sculpture by eleven of them. The front cover dramatically reproduced a Kenneth Price sculpture—a red sculpture against a red background—and the back cover showed a view of the Kaiser Center exhibition featuring the Peter Voulkos ceramic sculpture *Little Big Horn*.

When the Los Angeles County Museum of Art moved into new buildings in 1964, it reflected the growing importance of Los Angeles as a national art center. *Artforum* moved its offices from San Francisco to Los Angeles in the fall of 1965. With the presentation of the major exhibition "American Sculpture of the Sixties" in 1967 at the Los Angeles County Museum of Art, it was clear that the Minimalist aesthetic was predominant in Southern California and that nationally, color in sculpture raised new issues about the relation-ship of painting to sculpture.[11] Included in the exhibition were John Mason's reductive clay sculptures. Impressive five-foot-high rectangles with monochromatic glazes gestural enough to suggest a painterly surface, they were Color Field paintings in a tangible, physical presence.

In the 1960s, John Coplans made a distinctive contribution as critic and curator in identifying and interpreting the new aesthetics emerging in California art. Coplans espoused the clay sculpture "movement" and identified it in many

articles from 1963 to 1966.[12] His convictions about the germinal influence of the Voulkos years in the late 1950s at Otis Art Institute were made visible in the 1966 exhibition "Abstract Expressionist Ceramics" at the University of California, Irvine. In the catalogue essay, Coplans discussed expressionist ceramics produced over a ten-year period in California, yet the exhibition was not a historical survey.[13] In the same year, he wrote a catalogue essay for the John Mason solo exhibition at the Los Angeles County Museum of Art and organized two exhibitions of Los Angeles artists in which Kenneth Price was included: "Five Los Angeles Sculptors," for the Art Gallery at the University of California, Irvine, and "Ten from Los Angeles," for the Seattle Art Museum.

Northern California: From Abstraction to Representation

Peter Voulkos' residency in the San Francisco Bay Area was a catalyst for work in ceramic sculpture, even though Voulkos himself soon began to work only in bronze. In the fall of 1959, he had been appointed by the art and design departments at the University of California, Berkeley, to develop a ceramics department. His arrival attracted graduate students James Melchert and Stephen De Staebler, who both earned master's degrees in sculpture from the university in 1961. Since his student years, De Staebler has produced a consistent and impressive body of ceramic sculpture in an expressionist, direct approach to the materials, creating fragmented torsos in totemic columns. Other artists, such as Ron Nagle, came especially to study with Voulkos in ceramics, even though most of Voulkos' energies were going into building a foundry with sculptors Don Haskin (who had recently come from Minnesota) and Harold Paris (newly arrived from New York). In the sculpture and design departments clay was but one of the materials available. Students and teachers alike made clay sculpture or used it in multimedia constructions, as well as learned casting and welding techniques. Harold Paris

made several large clay wall reliefs and found his expressive imagery well suited to abstract clay sculpture, although he continued to work in cast bronze.

Traditionally, the San Francisco Bay Area was an active area for crafts, particularly ceramics, and a number of nationally known potters worked or taught there—in particular Marguerite Wildenhain and Antonio Prieto. In the 1950s ceramics classes were taught at the California College of Arts and Crafts and Mills College in Oakland, and across the bay at the San Francisco Art Institute (then the California School of Fine Arts). By the 1960s non-utilitarian work, both Constructivist and expressionist in approach, was appearing. Win Ng, who graduated in 1959 from the California School of Fine Arts, exhibited Constructivist-related abstract clay sculpture that same year in a San Francisco Art Association Painting and Sculpture Annual, and in 1961 in a solo exhibition at Mi Chou Gallery in New York.

The announcement in the September 1960 Oakland Art Museum *Bulletin* for recent Mills College graduate Robert Arneson's current exhibition reflects a similar transition from craft to sculpture:

Originally planned as a pottery exhibition, this turns out to be almost more of a sculpture show. Robert Arneson, like other adventurous young ceramicists, has pushed beyond the craft of useful objects into a world of large, vigorous sculpture which exists for the sake of expression only. Arneson shows with the Mills College Ceramic Guild and in distinguished ceramic exhibitions throughout the country.

"Work in Clay by Six Artists," held at the San Francisco Art Institute in late 1962, exhibited work of former Voulkos students James Melchert, Stephen De Staebler, Ron Nagle, and Ann Stockton, along with Art Institute artists Ricardo Gomez and Manuel Neri. Nagle by that time had begun to work with low-fire earthenware, experimenting with glazes, lustres and silkscreened photo-decals—factors in the change that was taking place in ceramic art. Melchert was using lustres on stoneware for surface texture contrasts, to make it look wet.

The focus on surface decoration that occupied Nagle and Melchert presaged a new and influential direction in ceramic sculpture. By 1962 they were both teaching at the San Francisco Art Institute, where they were colleagues of Manuel Neri, a sculptor who put swaths of bright-colored paint on life-size plaster figures as if they were canvases, and Joan Brown, whose colorful impasto paintings of figures and interiors could also appear as abstract paint gestures. When they saw Kenneth Price's high-color mono-chromatic sculptures in Los Angeles, Melchert and Nagle were acutely aware of how the perception of an object's form can be manipulated by color. They began using earthenware, low-fire glazes, and china paints, so the emphasis at the Art Institute shifted from stoneware to earthenware clay bodies on which color described a three-dimensional image.

That color could define or distort form was of growing interest in sculpture generally, in work as diverse as that of Claes Oldenburg, George Sugarman, and, in the San Francisco Bay Area, Robert Hudson, William Geis, and Ron Nagle. What Nagle did with color in ceramics related more closely to the new aesthetic in Los Angeles, where the artist employed the processes or materials of commercial production. Nagle used the cup form as his basic image. His thin-walled earthenware cups and jars are reductive forms that focus attention on the sensuous aura of color he created on the surface. They became so highly stylized that the surface articulation and color were intrinsic to this three-dimensional "shaped canvas." Nagle's influence has been great through his attention to craftsmanship and his approach to subject matter—the cup as formal vehicle rather than as utilitarian function.

A shift of content took place in the art of the early 1960s, which necessarily encompassed ceramic sculpture. In the San Francisco Bay Area the transition from self-referential formal

considerations to thematic subject matter with personalized reference gave a unique quality to Northern California art. Three influences shaped the approach. Painting had espoused figurative and landscape subject matter in the late 1950s, albeit with an Abstract Expressionist brush. The assemblagists, an active aspect of San Francisco's Beat-period art scene in the early 1960s, literally incorporated objects from everyday experience into their art with distinctly Surrealist overtones. Pop Art, in its East Coast exponents, provided a vocabulary and direct sources for ideas and images. Out of these grew the distinctive concept of "personal myth." For an artist, the primary sources for expression relate to a perception of meaning within the individual's private world. This identification with personal experience focuses on one's immediate environment and communicates a similar immediacy. William T. Wiley or Robert Hudson, in their painting and sculpture, developed a vocabulary of personal images, pyramids, Benday dots, and stripes, which they used formally to describe the "situation" that was taking place. In ceramics, James Melchert developed a series of clay "ghostware" pieces in 1964 which incorporated a blindfolded mask on boxes or plates with cryptic symbols, parts of words, or patches of stripes or dots. The pieces implied an event or situation. Subsequent objects that he made of clay from 1965 to 1970 conveyed fragmented experience through visual language—a cast hand setting down (or picking up?) a coffee cup, a game board with a coat hanger or block letters as playing elements. Other artists pitted the enigma of incidents from their daily experiences against the conventions of art expression with results akin to Surrealism or Dada. A typewriter Robert Arneson made of glazed earthenware in 1966 had fingertips with bright red fingernails in place of keys. An entire exhibition, "The Slant Step Show" in 1966, centered on a slanted step William Wiley bought for Bruce Nauman in a salvage store. Subject matter from the banal to the fantastic broadened art expression beyond the conventional expectations of painting and sculpture. And ceramic sculpture was a primary beneficiary of this change.[14]

Robert Arneson's development of subject matter opened up a whole area of thematic sculpture. Clay was an especially adaptable medium—clay bodies could be hand-formed, molded, or slip-cast and painted or glazed to achieve a variety of forms, surface textures, and colors. In Arneson's work the potential of the three-dimensional painting in the exposition of the personal myth was fully realized, and he was the most influential artist working in clay in Northern California in the late 1960s and well into the 1970s.

Arneson's move from expressionist pots to objects began with items of daily use and the associations they provoked. These inevitably engaged fantasies of experience or word-play, especially puns and their multiple levels of meaning. For example, the 1961 bottle *No Return*, shaped on the potter's wheel but topped with a clay bottle cap and embellished with the words "No Deposit," was at once an actual object, a representation of a bottle, and in pun, a "pop" bottle. The relation of fantasy to everyday object produced both surreal images—a toaster with fingers reaching out of the slot—and humorous images, such as the carton of six bottles of Diet Pepsi portrayed as thin, attenuated bottles. Fantasy did not restrict him from using sexual or scatological images. A series of toilets, urinals, and trophies ("loving cups") with hearts and genitals (Fig. 9) received considerable critical attention in their San Francisco and New York showings: "art and artifacts for a crazed civilization, uniform in innocence, obscenity, and something like grandeur."[15] Reactions to the sculpture made Arneson realize the psychological power an object held.

From the stoneware, self-contained objects-as-ideas, Arneson moved to making series of objects, almost as expositions of ideas. A change from stoneware to earthenware in the mid-1960s seemed equivalent to a move from oil painting to watercolor. In fact, almost all his thematic series

Fig. 9 Robert Arneson with trophy sculptures, 1964.

included watercolors and drawings as well as sculpture. For Arneson the clay body was a blank canvas to be painted with bright, freely brushed glazes. In a series of dirty dishes, the objects were formed as well as painted illusionistically. Arneson's subject matter addressed not only nostalgia for the artifacts of our own time—in a brilliant series on his suburban tract house on Alice Street in Davis—but seemingly endless sources in the history of ceramics and ceramic processes, from Sung-inspired celadon porcelains to terra-cotta bricks. With the 1966 opening in San Francisco of the Avery Brundage Collection of Asian Art in the Brundage Wing (now the Asian Art Museum) at the M. H. de Young Memorial Museum, centuries of Oriental ceramics were available for study. Arneson's use of a specific clay body and glaze to convey a particular idea is so imaginative and pertinent that you cannot conceive of the idea being made in any other way. His life-size presentation of themes was especially important in the early 1970s, when he began making a self-portrait head to embody an "idea." Encompassing emotions or actions, the heads convey relatively abstract themes through an explicit, familiar reality—the Arneson visage.

Robert Arneson's portrait heads have grown in scale and diversity in the past decade. He has made busts of friends or famous people, dwelling on salient characteristics of personality and physiognomy. His own portrait heads continue to reflect metaphorically on the human condition, not without the regenerative Arneson humor (Fig. 10). The translucency of color that Arneson has achieved in lithographs is captured similarly on the clay surfaces, visually dissolving the surface plane in painterly definition. His sculpture, both in theme and execution, is among the most poignant figure sculpture being created.

Puns and surreal juxtapositions find basic parallels in human experience. This attitude was most influential in the 1960s in the art department at the University of California, Davis, eighty miles east of San Francisco. Working with William T. Wiley, Roy De Forest,

Fig. 10 Robert Arneson working on *Up Against It*
in Benicia, California, studio, 1977.

or Robert Arneson, students as diverse as Bruce Nauman and David Gilhooly developed their own mature statements in art. As Arneson's ceramic sculpture evolved in thematic subjects, other artists studying with him developed their own vocabularies of images, sharing and borrowing ideas in a working community. They each claimed areas of subject matter for themselves to which they custom-fit technical processes. The ceramics output approximated a collection of visual poems and short stories. David Gilhooly, at Davis from 1963 through 1967, made life-size animals (or parts, like a camel's head), some rare or extinct, some household pets. All were named after friends or relatives and even suggested a reverse anthropomorphism, since they were so lovable and wanting to please. Margaret Dodd from Australia replicated in toy size the vans and cars of friends in colorful ceramic sculpture. Peter VandenBerge, a graduate student in the early 1960s, created heads of an expressionist nature and glazed-together tea sets. Graduate student Chris Unterseher made miniature narrative tableaux, featuring Boy Scout episodes, surfing escapades, or family vacation travels inspired by *National Geographic* magazine; they were chronicles of Americana. As his work evolved, he focused more on the essence of the subject in increasingly abstract compositions. In his graduate studies at Davis, Richard Shaw made small, realistic environments, like restaurant interiors or a theater box-office booth, which were inhabited by anonymous clay people. He also made cows of clay on which he painted their landscape habitat, a transition to the surreal juxtapositions he would invent in the 1971 ship sinking in an ocean painted on the cushions of a clay sofa (Fig. 11).

This attention to object making in Northern California ceramics dominated a 1965 exhibition, "New Ceramic Forms," at the Museum of Contemporary Crafts, New York. The change in approach to form, image, and technique manifested by a Richard Shaw miniature armchair, Joseph Pugliese shoe, or Robert Arneson six-pack was assessed as a positive,

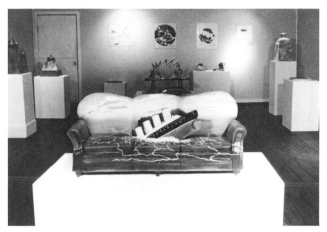

Fig. 11 Installation view, "Richard Shaw," Quay Gallery, San Francisco, 1971.

27

broadening vision for ceramic art.[16]

While the 1967 exhibition "American Sculpture of the Sixties" at the Los Angeles County Museum of Art established the Southern California Minimalist aesthetic in a national context, an exhibition at the University Art Museum, University of California, Berkeley, attempted to designate a distinctive Northern California "style." With the exhibition "Funk," Peter Selz described an art expression that was non-formalist, "bizarre... sensuous; and frequently it is quite ugly and ungainly.... Funk art... is largely a matter of attitude. But many of the works also reveal certain similar characteristics of form—or anti-form."[17] The works of art that he selected could be judged on their own merits. Some were powerful, eccentric statements; others were self-conscious, student gestures. The characteristics of form they had in common had little, if anything, to do with the origin of the term "funk" in San Francisco Bay Area art, thus confusing the earlier attitude and the present images.[18] While the term usually describes images that are made purposely in bad taste or to test the limits of outrageousness, "funk" has been used in art criticism to identify any art of expressionist subject matter from Northern California. Robert Arneson's ceramic objects, with their punning and wry humor, especially fall prey to dismissal as "funk" art, rather than be appraised as expressions of visual metaphors.

The 1970s: Diversity of Styles
The 1970s was a decade in American art which saw the greatest decentralization of art activity since the 1930s. This occurred because there was no singular, dominant style on the New York scene, so that an artist had more freedom to choose subject matter, "style," and media. Consequently, the most diverse expressions were validated as art. Not only did the vestiges of process and materials art from the 1960s continue and become finite and more elegant—in what Lucy R. Lippard has called "eccentric abstraction"[19]—but the opposite pole, Super

Realism, was espoused by many painters. As well, issues of Minimalism, of Surrealism as it was realized through collage and assemblage, of Conceptual art, and of narrative art were addressed in direct, approachable works of art. The artist, finding the idealism of an earlier decade irrelevant to making sense out of his or her own time, focused on day-to-day subject matter. Rather than build an abstract sculpture that referred to a heroic scene, an artist might choose to replicate old work shoes, implying their discard after years of wear, as Marilyn Levine did in stoneware. An increasing number of artists found clay the most relevant medium for them. Some strong, individual statements have been made in clay that thematically relate to painting or sculpture approaches. Prominent among them are narrative art and art that reflects a Surrealist assemblage interest.

The interest in subject matter related to personal experience provoked a resurgence of narrative art. While drawing and painting lend themselves more naturally to visual exposition, the unique quality of clay to create three-dimensional paintings has provoked some imaginative narrative sculpture. David Gilhooly is perhaps the major exponent of this idiom. The story he tells, the myth of the Frog World, and the characters in his story, described in a freely formed, brightly colored manner, would traditionally have been realized in paintings or drawings. In sculpture this fantasy really exists—in a tangible reality.

Gilhooly has revealed his narrative with the tongue-in-cheek authority of a historian or anthropologist. He made a few frog pieces after he left the University of California, Davis, in 1967, but not until he moved in 1969 to Regina, Saskatchewan, did he discover the whole frog civilization. The frog world is virtually a parallel to that of man and has had some surprisingly parallel religions, leaders, and artifacts. Gilhooly's amazing intuition in developing the frog-world images provokes levels of association—the mythic, the symbolic—beyond the appealing, humorous image. With their

obvious human parallels frog activities give humans an oblique look at themselves, to laugh or shudder. The series as a whole becomes political and social satire in the tradition of *Gulliver's Travels*. The pervasive spirit in all Gilhooly's work, beginning with the objects and animals of the late 1960s, is one of a humanistic concern for social responsibility and values.

Gilhooly's attitude toward his work represents a non-elitist approach to art objects, an attitude prevalent among artists in the 1970s. He makes art for all pocketbooks. He markets the work assiduously, selling donuts and vegetables off a vegetable-cart sculpture or making "mass-produced" frog-tacos or frog-chip cookies. This style of art-and-life, myth-and-reality, is Gilhooly's special mastery, and its realization in his narrative sculpture has contributed a resourceful body of work to American sculpture. Gilhooly's work has been shown extensively in solo gallery and museum exhibitions in the United States and Canada, and appears in several permanent installations—one, an ark of animals at the entrance to the Seattle Zoo (Fig. 12).

During the mid-1960s, when ceramic artists shifted from high-fire stoneware, where their interests focused on the forms they achieved, to low-fire earthenware and its brightly colored surface decoration, more than technical changes took place. The sources for ceramic art broadened to encompass contemporary and historical art, the decorative art of the 1920s and 1930s—Woolworth's knickknacks, cornball souvenir postcards, surburban lawn and garden sculpture[20]—along with techniques from commercial ceramics and industry. The meticulous attention to craftsmanship in work by Kenneth Price in Los Angeles and Ron Nagle in San Francisco gave a pristine aesthetic to the ceramic art of the 1960s. This was heightened in the 1970s by Nagle's student Richard Shaw, when he began working in porcelain in 1971.

Shaw worked with porcelain for a two-year period in his Bay Area studio with sculptor Robert Hudson, each producing a unique group

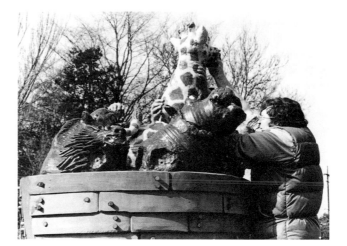

Fig. 12　David Gilhooly with *Seattle's Own Ark*, 1979, Woodland Park Zoo, Seattle, Washington; City of Seattle 1% for Art, Department of Parks and Recreation Collection.

of pieces (Fig. 13). Slip-casting molds made from everyday objects—fish, duck decoys, rocks, squash, or twigs—they combined these elements with thrown or hand-built cups, bottles, or pot forms. Decorating the matte surface with underglaze or china paints, they achieved the appearance of the real object. These cast parts were combined in a composition as formal elements, obscuring both the original function of the object and the intended function—teapot, cup, lidded jar—of the porcelain piece. A fish suspended on a curved tube over a fluted base forms a teapot. In Shaw's earthenware pieces of the 1960s, the painted imagery supported surrealistic associations—an ocean liner sinking into the sofa on which the ocean was painted. Here the painted forms replicate the imagery and their combinations provoke surrealistic overtones.

Shaw continued to work in porcelain after completing the 1971–73 series of cups, jars, and teapots. He perfected a technique of replicating surfaces through photo-silkscreen decals. His images also became more realistic. Shaw made stacks of books with old letters and pencils on them and tenuously balanced stacks of playing cards. The affinity with American nineteenth-century trompe-l'oeil painting was greatest in wall reliefs of simulated clippings and letters. Most recently Shaw has made lanky figures, assemblages of bottles, boxes, cans, twigs, pencils—his entire repertoire of images (Fig. 14). These pieces go one step beyond the multimedia assemblages of the 1950s and 1960s, where real objects were combined in a formal context, yet still retained the material immediacy of their former use. A discarded coffee can balanced on a curved stick with a hatchet lashed to it was a sculpture of found objects for an assemblagist. Here Shaw makes these parts of porcelain and replicates the surface appearance by painting or, for the coffee-can label, with a photo-silkscreen decal. In effect, on the homogeneous surface of porcelain is a picture of these real objects. The total image is relayed by the aesthetic of the medium, similar to a photograph or trompe-l'oeil

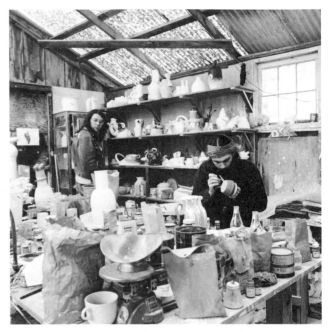

Fig. 13 Robert Hudson (left) and Richard Shaw (right) in Stinson Beach, California, studio, 1972.

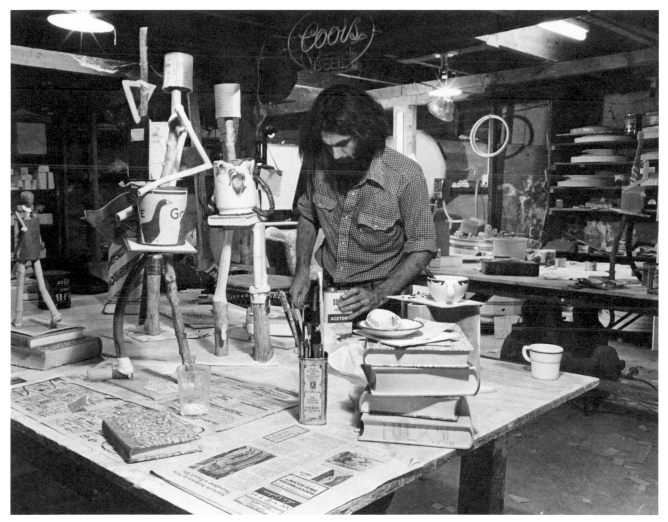

Fig. 14 Richard Shaw in Fairfax, California, studio, 1978.

painting, where the photographic process or the paint describes the information about the objects. A psychological distance from the original object is thereby created. The enigma of context is a consistent characteristic of Shaw's pieces. The porcelain elements continue to be used for formal reasons to develop an interesting composition; the context or story they convey is in the viewer's imagination and sense of discovery. While Shaw's influence has been great in his exploration and refinement of technical processes, his own work avoids being only an exercise of skill. His technical virtuosity is transcended by his delight with imagery and his love of humor.

As more and more artists have worked in clay in the 1970s, their distance from the breakthrough years has given them freedom to relate their work directly to ideas in painting and sculpture. The control and mastery of technical processes has brought about imagery as diverse as the replicated leather objects of Marilyn Levine, miniature porcelain narratives of Chris Unterseher, symbolic sea tableaux of John Roloff, geometrically based forms of David Middlebrook, and grid-patterned wall plaques of Tony Costanzo. As well, ceramic sculpture has found ready expression for psychological expositions of human concerns in the imagery of Viola Frey, David Best, and Karen Breschi.

For ceramic sculpture, like other special art expressions, there are particular individuals and institutions whose perceptive vision has identified work that is breaking new ground. John Coplans, as critic and later as curator, championed ceramic sculpture in the 1960s in California. Allan Stone was the first New York dealer to purchase and exhibit in 1965 the clay objects coming out of the kilns at the University of California, Davis. Beginning in 1974, the Allan Frumkin Gallery in New York showed ceramic sculpture from the San Francisco Bay Area in the context of painting and sculpture, including work by painter-sculptors from Northern California—William T. Wiley and Robert Hudson—and the painter Joan Brown. Along with Robert Arneson, these artists share an art

expression that reflects the "personal myth."

When there is a period of diversity in art expression, attention is directed more closely to the individual artist's unique contribution. To preserve this individuality, artists generally resist categorization or labeling; hence a solo exhibition is the most sought-after exposure. In the 1970s, sculptors working in clay have become nationally recognized artists through a continuing presentation of work in solo gallery or museum exhibitions and inclusion in painting and sculpture exhibitions.

Kenneth Price, who moved to Taos, New Mexico, in 1971, annually has shown new groups of work in galleries from Hamburg, Cologne, and London to Los Angeles and New York. Through these exhibitions the evolution of his cup format can be consistently followed. Recent Constructivist cup sculptures, in their size, complex shapes, and brilliant coloring, maintain a scale larger than cup size. These new works are prominent even in a group exhibition as diverse as the Biennial Exhibitions at the Whitney Museum of American Art. During 1972–77 in Taos, Price worked on an environmental sculpture, inspired by Mexican curio shops, entitled *Happy's Curios* (Fig. 15). Five years in the making, it was presented at the Los Angeles County Museum of Art in 1978. *Happy's Curios*, another example of Price's consummate genius, has been interpreted in almost as many ways as there are critics who have written about it. It is an environmental installation of cabinets and shrines filled with pottery jars and plates decorated in Mexican folk-pottery patterns. The criticism runs from social comment—homage to the bad taste of souvenir ware—to aesthetics—an environmental decorative painting.

In the early 1970s, John Mason abandoned fired and glazed Minimalist clay sculpture for modular sculpture made of firebricks. Both aspects of his work were shown in a retrospective at the Pasadena Museum of Modern Art in 1974. In 1978 he had the incomparable opportunity to design six different installations of firebrick pieces for six museum interior spaces in a

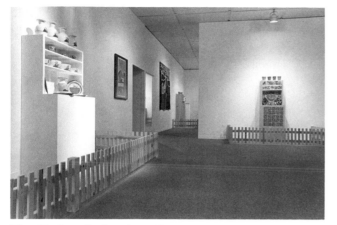

Fig. 15 Installation view, "Ken Price: *Happy's Curios*," Los Angeles County Museum of Art, 1978.

sequence of exhibitions. The series began at the Hudson River Museum in Yonkers, New York, hence its name, the *Hudson River Series*, and continued in floor-related, horizontal configurations especially designed for the Des Moines Art Center, the Corcoran Gallery of Art, Washington, D.C., the Minneapolis Institute of Arts, the San Francisco Museum of Modern Art, and the University Art Museum at the University of Texas, Austin. Mason has since made several permanent site-related outdoor installations of metal elements.

In 1978, thirty years of work by Peter Voulkos was shown in a retrospective exhibition organized by the Museum of Contemporary Crafts, New York. The huge exhibition of 130 vases, plates, and sculptures opened at the San Francisco Museum of Modern Art and traveled to the Contemporary Arts Museum in Houston, the Museum of Contemporary Crafts in New York, and the Milwaukee Art Center. Voulkos' resurgent interest in making large clay vases now focuses on surface color and on the embellishment gained in the firing process.

Ceramic Sculpture: State of the Art
From the mid-1960s, group exhibitions were assembled to show the surge of activity in clay sculpture, its expansion of traditional forms. One of the largest exhibitions, which toured the United States beginning in 1969, was "Objects: USA." This huge collection of crafts was assembled for S. C. Johnson & Son, Inc., by Lee Nordness. The ceramics in the collection reflected the proliferation of ceramic objects as well as non-utilitarian ware that was emerging from pottery. The 1971 exhibition "Clayworks: 20 Americans," organized by the Museum of Contemporary Crafts, New York, declared conclusively that the "object" was the current expression in ceramics.[21] That the twenty artists in the exhibition came from university campuses in California, Washington, Wisconsin, and Ohio geographically defined the "grass roots" origin of this work. An active community in Seattle, led by Fred Bauer, Patti Warashina, and Howard

Kottler, took Pop Art imagery into a camp expression in which stylized forms of Art Deco and its dime-store interpretations were produced in the most blatant clay bodies and glazes. The Midwest exponents were not without their Pop Art references, but stated them in folksy, narrative themes.

Concurrent with the 1971 exhibition, Rose Slivka's skillful prose in her article "Laugh-In in Clay"[22] again gave characterization to a new swell of expression in ceramics. In effect, she states that the artist, rejecting the idealism of his heritage, speaks from a humanism of now, responding to the immediacy of day-to-day life: "artifacts of our time," she calls them, "as if [our time] were nostalgia anticipated...."[23] William Lombardo with *D. C. Lunch Break*, a small sculpture of a cow nibbling away at the Washington Monument, mounted a campaign to replace the American eagle with the cow as the number one American symbol. Roger Lang put a slice of pie on a plate through a series of visual metaphors; similar approaches were taken by Kurt Fishback with houses, Jack Earl with penguins, and James Melchert with the lower-case "a."

Peter Schjeldahl characterized this type of work in a review of another exhibition, "Clay," at the Whitney Museum of American Art, Downtown Branch, three years later:

In general, the mood of this exhibition is slangy and informal. It suggests a milieu in which artists work largely, if not mainly, for the approval of an immediate circle of friends, a milieu that encourages extravagant peculiarities and semi-private languages. Meanwhile, the overall level of sheer craft, of skill and resourcefulness with ceramic mediums, is extraordinarily high, underlining the fact that most of these artists are university-trained and -based.

This is an odd phenomenon—a virtual academy of resolutely anti-conventional artists, linked to one another by their common devotion to an ancient, difficult, and until recently, seemingly alien or debased art form. It couldn't have happened in New York, where the achievement of a high style, in whatever medium, is the ruling artistic imperative. But it did happen in America, and it deserves more recognition than it has gotten so far.[24]

The consciously "lowbrow" approach and seeming disregard for the established hierarchy of subject matter and medium in the fine arts that this ceramic art displayed denied it critical assessment by standards employed in painting and sculpture criticism. Undoubtedly, this is because the work was often generally presented in a crafts context and written about by writers who measured its innovation by standards of the craft tradition. In that context, work that was fresh and timely, innovative in content and form, was welcome as a vitalizing element in a previously confined tradition. Exhibitions organized around the clay medium and the variety of ways it is used paid little attention to defining the difference between the work as art or as craft. If the use of clay in art expression is to be fairly assessed, such a distinction must be focused on. In a 1980 article Calvin Tomkins states an art critic's observations on the crafts scene:

It remains to be noted that the crafts movement has generated an appalling amount of bad art. Clay, for some reason, seems to lend itself particularly to "humorous" treatment— anthropomorphic animals and anecdotal japes that may be wonderfully expert in the technical sense but whose effect is often as numbing as a row of ceramic novelties in an airport gift shop. Arneson, Price, and one or two others skirt this abyss with great style, but their followers and imitators often do not. A straining after effect is apparent in much of the work in other media, as though the maker, uneasily astride the tightrope between craft and art, had confused cleverness with imagination. There is neither the serenity of traditional craftwork nor the authority of an artistic statement.[25]

In the past several years a few group exhibitions have dealt with this issue, seriously examining the nature of art expression in clay. Two differing points of view can be cited in two exhibitions. In "Viewpoints: Ceramics 1977," at Grossmont College, El Cajón, California, the catalogue essay by ceramic artist Erik Gronborg speaks from the craft tradition:

Though trends in ceramics largely follow general stylistic developments in art, the ceramic works never quite lose the craft element: the manipulation of a plastic mass, the emphasis on "object," the ready use of color as part of the glaze tradition, the small scale and preciousness of appearance, and the reference in various degrees to the useful object, the pot and the plate. These are the qualities which make the difference between "ceramics" and "sculpture made of clay."[26]

"Nine West Coast Clay Sculptors, 1978" was presented at the Everson Museum of Art in Syracuse, New York. Margie Hughto's catalogue foreword discusses the contribution of West Coast artists to ceramic sculpture. She points out that on the West Coast, ceramic sculpture exists in the milieu of painting and sculpture. Addressing Peter Schjeldahl's observations, she notes:

The blurring of the distinction between art and craft is a very important concept to come out of the West Coast ceramic movement. What this work did was to ignore the traditional principles of ceramics in terms of form, content and craftsmanship and give new thought to clay, and in doing so, redefined the medium itself. By transforming ceramics into a sculptor's medium, and extending the role of painting on clay, "Abstract Expressionist" and "Funk" ceramics destroyed the standard distinction between art and craft.[27]

Until the "craft vs. art" discussion stops being an issue—which it legitimately should do—the relevance to American art of expression in clay will not be fully appraised. The craft point of view is clearly understood; craft relates to materials rather than to intent. Craft implies that the perfection of skill in realizing an object is the goal of making it, that all aspects—materials, image, and design—are utilized to that end. In art, the skill utilized to make an object creates the realization of an idea, the end to which all the other elements are employed. The art is judged on its achievement and the import of its idea for visual expression. There are works of art in the craft tradition as much as there are works of craft in fine arts.

The sculptural statements of the many artists working in clay have firmly established their significance in the mainstream of painting and sculpture. With continued exposure in this context, this distinctive work will become more widely known and recognized.

Suzanne Foley

Notes

1. By teaching summers at Teachers College, Columbia University, and at Greenwich House, Voulkos was able to return to New York annually from 1960 to 1964.

2. Rose Slivka, "Peter Voulkos at Bonnier's," *Craft Horizons*, 17 (March/April 1957), p. 47.

3. Quoted in "Exhibitions: Peter Voulkos," *Craft Horizons*, 19 (January/February 1959), p. 42.

4. Quoted in Rose Slivka, *Peter Voulkos* (Boston: New York Graphic Society,.1978), p. 117.

5. Quoted in Conrad Brown, "Peter Voulkos," *Craft Horizons*, 16 (September/October 1956), p. 12.

6. Jules Langsner, "Art News from Los Angeles," *Art News*, 60 (September 1961), p. 20, a review of the annual exhibition "Artists of Los Angeles and Vicinity." Mason's work usually prompted these remarks as it was consistently included in these exhibitions, often with Michael Frimkess and Jerry Rothman.

7. Lucy R. Lippard, "Kenneth Price," in *Robert Irwin/ Kenneth Price*, exhibition catalogue (Los Angeles: Los Angeles County Museum of Art, 1966), unpaginated.

8. Rose Slivka, "The New Ceramic Presence," *Craft Horizons*, 21 (July/August 1961), pp. 30–37.

9. The fifteen artists are Robert Arneson, James Crumrine, Hui Ka Kwong, John Mason, Malcolm McClain, James Melchert, Harold Myers, Win Ng, Stanley Rosen, Jerry Rothman, Jeff Schlanger, Ann Stockton, Henry Takemoto, Marcus Villagran, and Peter Voulkos.

10. See Anita Ventura, "San Francisco: Field Day for Sculptors," *Arts Magazine*, 38 (October 1963), pp. 62–65.

11. Color in sculpture is discussed in an excellent essay by Lucy R. Lippard, "As Painting is to Sculpture: A Changing Ratio," in *American Sculpture of the Sixties*, exhibition catalogue (Los Angeles: Los Angeles County Museum of Art, 1967), pp. 31–34.

12. See the following articles by John Coplans: "Works in Clay by Six Artists," *Artforum*, 1 (February 1963), p. 46; "Sculpture in California," *Artforum*, 2 (August 1963), pp. 4–6; "Notes from San Francisco," *Art International*, 7 (October 1963), p. 91; "Out of Clay," *Art in America*, 6 (December 1963), pp. 40–44; "The Sculpture of Kenneth Price," *Art International*, 8 (March 1964), pp. 33–34; "Circle of Styles on the West Coast," *Art in America*, 52 (June 1964), pp. 31, 39–41; "Peter Voulkos: Redemption

through Ceramics," *Art News*, 64 (Summer 1965), pp. 38 ff.; "Abstract Expressionist Ceramics," *Artforum*, 5 (November 1966), pp. 34–41. Many of these articles are reworded versions of his August 1963 *Artforum* review.

13. While the selection of works was based on the exhibition's title, "Abstract Expressionist Ceramics," the thin-walled cups and jars of Ron Nagle are the least "gestural" in form. Los Angeles artists were represented by works from important stages in their development, but the examples from San Francisco artists were their most recent pieces. The catalogue essay recounts the history of the activity in the ceramics department at Otis but omits mention of Paul Soldner or Jerry Rothman (who are not in the exhibition). The exhibition includes two San Francisco Bay Area artists who worked with Voulkos in Berkeley— James Melchert and Ron Nagle—yet omits Stephen De Staebler. It also includes a series of three small abstract sculptures by Manuel Neri, shown at the San Francisco Art Institute in 1962, totally incidental to his sculpture oeuvre, but which have been reproduced widely and included in two historical survey exhibitions: "Funk," University Art Museum, University of California, Berkeley, 1967, and "A Century of Ceramics in the United States," Everson Museum of Art, Syracuse, New York, 1979.

14. An excellent assessment of the sources in Northern California "post-Minimalist" clay sculpture is given in an essay by Maija Bismanis, "Historical Sources," in *The Continental Clay Connection*, exhibition catalogue (Regina, Saskatchewan: Norman Mackenzie Art Gallery, 1980), pp. 13–17.

15. Peter Schjeldahl, "Robert Arneson," *Art News*, 65 (Summer 1966), p. 10, a review of an exhibition at Allan Stone Gallery, New York.

16. Other artists in the exhibition—all from California— were Kurt Fishback, Michael Frimkess, Steven Kaltenbach, David Mackenzie, James Melchert, Ron Nagle, and Gerald Walburg. See Bruce Breckenridge, "The Object: Still Life," *Craft Horizons*, 25 (September/October 1965), pp. 33–34.

17. Peter Selz, *Funk*, exhibition catalogue (Berkeley: University Art Museum, University of California, Berkeley, 1967), p. 3.

18. See James Monte, " 'Making It' with Funk," *Artforum*, 5 (Summer 1967), pp. 56–59.

19. Lucy R. Lippard, "Eccentric Abstraction," *Art International*, 10 (November 1966), pp. 28, 34–40.

20. See Richard Shaw, "Overglazing on Contemporary Ceramics, 1960–1977," in *Overglaze Imagery, Cone 019-016*, exhibition catalogue (Fullerton, Calif.: The Art Gallery, California State University, Fullerton, 1977), p. 157.

21. Artists included in "Clayworks: 20 Americans" were Raymond Allen, Robert Arneson, Clayton Bailey, Patti Warashina, Jack Earl, Kurt Fishback, Verne Funk, David Gilhooly, Dick Hay, Rodger Lang, Marilyn Levine, William Lombardo, James Melchert, Richard Shaw, Victor Spinski, Bill Stewart, Chris Unterseher, Peter VandenBerge, Kenneth Vavrek, and William Warehall.

22. Rose Slivka, "Laugh-In in Clay," *Craft Horizons*, 31 (October 1971), pp. 39–47; 63.

23. Ibid, p. 39.

24. Peter Schjeldahl, "The Playful Improvisation of West Coast Ceramic Art," *New York Times*, June 9, 1974, p. 24, a review of the exhibition "Clay" at the Whitney Museum of American Art, New York, Downtown Branch, 1974.

25. Calvin Tomkins, "The Art World: Erasing the Line," *The New Yorker*, July 28, 1980, p. 87.

26. "Viewpoints: Ceramics 1977" was organized by Jerry D. Szymanski, Director, Grossmont College Art Gallery, and included artists Clayton Bailey, Viola Frey, David Furman, Erik Gronborg, Wayne Higby, Howard Kottler, Marilyn Levine, Louis Marak, Richard Shaw, and Chris Unterseher. Erik Gronborg's essay is reprinted in Garth Clark, ed., *Ceramic Art: Comment and Review, 1882–1977* (New York: E. P. Dutton, 1978), pp. 185–92.

27. Margie Hughto, *Nine West Coast Clay Sculptors, 1978*, exhibition catalogue (Syracuse, N. Y.: Everson Museum of Art, 1978), p. 8. Artists included in the exhibition were Robert Arneson, Karen Breschi, Stephen De Staebler, David Gilhooly, Marilyn Levine, David Middlebrook, Kenneth Price, Richard Shaw, and Peter Voulkos.

Selected Bibliography, 1961–1981

This bibliography includes reviews of group exhibitions and general books on ceramic sculpture. Reviews of solo shows, articles on individual artists, and exhibition catalogues are listed in the individual artist sections.

Rose Slivka, "The New Ceramic Presence," *Craft Horizons*, 21 (July/August 1961), pp. 30–37.

Gervais Reed, "Exhibitions: World's Fair," *Craft Horizons*, 22 (November/December 1962), pp. 40–41.

John Coplans, "Work in Clay by Six Artists: San Francisco Art Institute," *Artforum*, 1 (February 1963), p. 46.

Herschel B. Chipp, "The 1963 Paris Biennale," *Artforum*, 2 (August 1963), pp. 7–10.

John Coplans, "Sculpture in California," *Artforum*, 2 (August 1963), pp. 3–6.

"A Portfolio of California Sculptors," *Artforum*, 2 (August 1963), pp. 15–59.

Joseph A. Pugliese, "Casting in the Bay Area," *Artforum*, 2 (August 1963), pp. 11–14.

John Coplans, "Notes from San Francisco," *Art International*, 7 (October 1963), pp. 91–94.

Anita Ventura, "San Francisco: Field Day for Sculptors," *Arts Magazine*, 38 (October 1963), pp. 62–65.

John Coplans, "Out of Clay," *Art in America*, 51 (December 1963), pp. 40–44.

Joanna Magloff, "Art News from San Francisco," *Art News*, 62 (January 1964), p. 51.

Bernard Pyron, "The Tao & Dada of Recent American Ceramic Art," *Artforum*, 2 (March 1964), pp. 41–42.

John Coplans, "Circle of Styles on the West Coast," *Art in America*, 52 (June 1964), pp. 24–41.

Douglas McClellan, "Sculpture," *Artforum*, 2 (Summer 1964), p. 69.

John Coplans, "Los Angeles: The Scene," *Art News*, 64 (March 1965), pp. 28–29, 56–58.

Bruce Breckenridge, "The Object: Still Life," *Craft Horizons*, 25 (September/October 1965), pp. 33–35.

John Coplans, "Abstract Expressionist Ceramics," *Artforum*, 5 (November 1966), pp. 34–41.

Helen Giambruni, "Abstract Expressionist Ceramics at the University of California, Irvine," *Craft Horizons*, 26 (November/December 1966), pp. 16–25.

Joseph A. Pugliese, "At Museum West: Ceramics from Davis," *Craft Horizons*, 26 (November/December 1966), pp. 27–28.

Harold Paris, "Sweet Land of Funk," *Art in America*, 55 (March/April 1967), pp. 95–98.

David Zack, "Funk Art," *Art and Artists*, 2 (April 1967), pp. 37–39.

James Monte, "'Making It' with Funk," *Artforum*, 5 (Summer 1967), pp. 56–59.

Alan R. Meisel, "Letter from San Francisco," *Craft Horizons*, 27 (September/October 1967), pp. 41–42.

Dore Ashton, *Modern American Sculpture* (New York: Harry N. Abrams, Inc., 1968).

Alan R. Meisel, "Funky Figurines," *Time*, April 26, 1968, p. 76.

Billy Al Bengston, "Late Fifties at the Ferus, *Artforum*, 7 (January 1969), pp. 33–35.

Erik Gronborg, "The New Generation of Ceramic Artists," *Craft Horizons*, 29 (January/February 1969), pp. 26–29, 50–51.

Brenda Richardson, "California Ceramics," *Art in America*, 57 (May/June 1969), pp. 104–5.

David Zack, "Californian Myth-Making," *Art and Artists*, 4 (July 1969), pp. 26–31.

Lee Nordness, *Objects: USA* (New York: The Viking Press, 1970).

David Zack, "Nut Art in Quake Time," *Art News*, 69 (March 1970), pp. 38–41, 77.

John Ashbery, "The Johnson Collection at Cranbrook," *Craft Horizons*, 30 (March/April 1970), pp. 34–39, 57–58.

Janet Malcolm, "On and Off the Avenue: About the House," *The New Yorker*, September 4, 1971, pp. 59–62.

Rose Slivka, "Laugh-In in Clay," *Craft Horizons*, 31 (October 1971), pp. 39–47, 63.

Victor Cicansky, "Contemporary Ceramics II: Tokyo," *Artscanada*, 29 (Spring 1972), pp. 76–77.

Joseph A. Pugliese, "The Decade: Ceramics," *Craft Horizons*, 33 (February 1973), pp. 46–49, 76–77.

Jerome Tarshis, "Letter from San Francisco," *Studio International*, 183 (November 1973), pp. 192–93.

Peter Plagens, *Sunshine Muse* (New York: Praeger Publishers, 1974).

Wayne Andersen, *American Sculpture in Process, 1930/1970* (Boston: New York Graphic Society, 1975).

Thomas Albright, "Mythmakers," *The Art Gallery Magazine*, 18 (February 1975), pp. 12–17, 44–45.

Fred Martin, "San Francisco," *Art International*, 20 (March/April 1976), pp. 76–84.

Sandy Ballatore, "The California Clay Rush," *Art in America*, 64 (July/August 1976), pp. 84–88.

Julie Hall, *Tradition and Change: The New American Craftsman* (New York: E. P. Dutton, 1977).

Richard Shaw, "Overglazing on Contemporary Ceramics, 1960–1977," in *Overglaze Imagery, Cone 019–016*, exhibition catalogue (Fullerton, Calif: The Art Gallery, California State University, Fullerton, 1977).

Thomas B. Hess, "For Each Man Kilns the Thing He Loves," *New York*, August 1, 1977, pp. 56–59.

"Civilizations in Clay," *Craft Horizons*, 37 (December 1977), pp. 28–35.

Garth Clark, ed., *Ceramic Art: Comment and Review, 1882–1977* (New York: E. P. Dutton, 1978).

Paul S. Donhauser, *History of American Ceramics: The Studio Potter* (Iowa City, Iowa: Kendall/Hunt, 1978).

Bill Marvel, "A Modern Way with Clay," *Horizon*, 21 (September 1978), pp. 41–47.

La Mar Harrington, *Ceramics in the Pacific Northwest* (Seattle and London: University of Washington Press, 1979).

Calvin Tomkins, "The Art World: Erasing the Line," *The New Yorker*, July 28, 1980, pp. 85–87.

Rose Slivka, "A Panorama of American Ceramics," *Museum News*, 58 (July/August 1980), pp. 58–64.

Garth Clark, *American Potters: The Work of Twenty Modern Masters* (New York: Watson-Guptill Publications, 1981).

Mady Jones, "The Clay People: California's Ceramic Artists," *San Francisco*, 23 (June 1981), pp. 62–71.

Peter Voulkos

Peter Voulkos introduced, established, and extended alternatives to the uses of clay for sculptural expression, liberating a new generation of artists from restrictions and traditions imposed by ceramic history and technique. His presence at Otis Art Institute in Los Angeles signaled the beginning of an upheaval in contemporary ceramics. Despite his long-standing renown and expertise as an accomplished potter, he began to feel encumbered by the traditional definition of pottery. A number of factors, including Voulkos' admiration for historical and contemporary European and Oriental ceramic work, his involvement with jazz, his exposure to Abstract Expressionist painting, and interaction with like-minded colleagues and students, reinforced his interest in using clay as an expressive, sculptural medium.

A number of works from the mid-1950s consisted of cylindrical forms combined with attached slabs of clay. Although these pieces approached sculpture, they still remained variations of a basic pot concept. By 1958, in such works as *Flying Black* (1958), Voulkos exhibited an increased scale and innovative configuration that moved out of the realm of pottery. *Flying Black* is composed of numerous wheel-thrown forms that have been paddled and compressed to obliterate their cylindrical, symmetrical shape, and then stacked, attached, and cantilevered from a central thrown core. The work is coated with black slip to unify the overall form and to enhance the weightiness and massiveness of the assembled volumes. *Sitting Bull* (1959) is a similar construction of multiple assembled forms that display abrupt joints and angles with no smooth, transitional passages, and an awkward, asymmetrical profile. Although these works are composed of a number of traditional, thrown-pot forms, the assembled work makes no reference to function and exists totally as a sculptural object. *Little Big Horn* (1959) continues the exploration of sculptural assemblages of bulging, jutting, and angled volumes, but with increased surface markings, scratchings, and pinching that accentuate the edges of joined planes and forms. A subsequent group shifts away from the monolithic presence of closed bulbous forms, but retains the structural principle of stacked, joined and balanced units. *Camelback Mountain* (1959), *Sevillanas* (1959), and *Gallas Rock* (1959–61) continue to use paddled, wheel-thrown cylinders and slabs, but they have been gouged, ripped, and sliced open, revealing internal space, wall thickness, and open areas that cut through the sculptural mass. These works exhibit an increased angularity and complexity of form that result in a highly active surface of light and shadow, space and mass.

In 1959, Voulkos moved to Berkeley, following his appointment as assistant professor of ceramics at the University of California. It was here that he began a series of works, including *Cross* (1959), *Red River* (1960), and *USA 41* (1960), that are characterized by their display of brightly painted and glazed areas. Voulkos' use of glazes that maintain their brilliant color at a low-temperature firing was a somewhat radical occurrence in a ceramic tradition that relegated low-fire glazes in bright colors to the realm of hobby. In addition, the use of epoxy paints on fired ceramic pieces, such as the brilliant orange areas on *USA 41*, was a new but logical and legitimate alternative to glazing. Voulkos employed color to establish tensions between the assembled forms and the applied coloration, wanting the color intensity and expressiveness to correspond to the structure of the object. As seen in *Red River*, the color is not used as decoration or to delineate the angles and planes of the work. By using a low-fire glaze—rather than more unpredictable final coloration from high-fire glazes—Voulkos was ensured of maintaining the vivid red needed to accentuate and reinforce the jagged, cutting, and scratched surface detail of the entire form.

Voulkos' move to Berkeley also coincided with the beginning of his work in bronze, which he approached with the same energy, technical expertise, and productivity that characterized his work in clay. Although he continued to produce

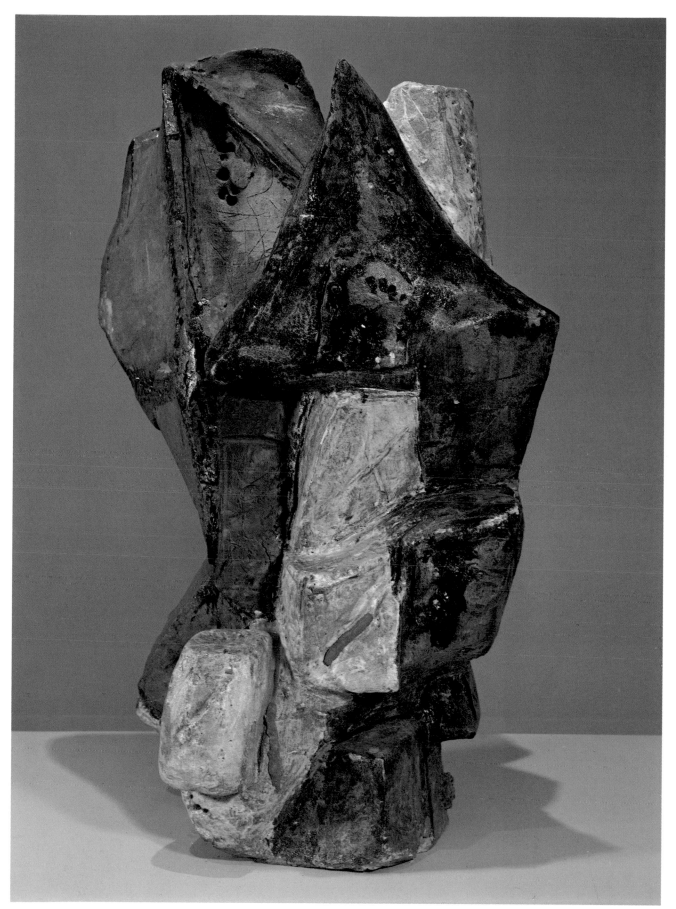

Little Big Horn, 1959
Glazed stoneware, 62 x 40 x 40″ (157.5 x 101.6 x 101.6 cm)
The Oakland Museum, California; Gift of The Art Guild of
the Oakland Museum Association

ceramic pieces—completing hundreds of
sculptural vessels and large-scale plates—bronze
offered new technical and sculptural challenges,
and occupied his energies for a number of years.
A group of recent ceramic works return to a
more traditional bottle or vessel format. The
scale and structure of these works, such as
Anada (1968), retain associations with sculptural
rather than functional concerns. Voulkos uses the
form for explorations of surface incident,
coloration, and manipulation in a way that does
not alter the vessel-like composition of the piece.
Untitled (1980) and *Untitled* (1981) display
Voulkos' experimentation with the effects of a
wood-burning kiln, rather than the previously
used gas kiln. The wood kiln reintroduces aspects
of the unpredictability of surface texture and
coloration, extending the concept of the work
beyond the programmed technical aspects of
ceramics. An unglazed piece fired in a kiln of this
type achieves a variegated richness in coloration,
shading, highlights, and is subject to accidents
that result from the chemical activity of ash and
fire on the clay body in the kiln. *Untitled* (1981)
typifies a number of recent works that make
direct reference to vessel forms. It is composed of
stacked cylinders that form the irregular foot,
body, and neck of a bottle shape. Its utilitarian
associations do not go beyond this configuration,
however, and attention is directed to cuts, rips,
ridges, and incised drawing that actively and
forcefully violate the surface and walls, and
negate any implied functionality. It is this
constant, inquisitive exploration and experi-
mentation in technique, materials, and
forms that continues to direct Voulkos' ongoing
development of the sculptural potential of ceramic
materials.

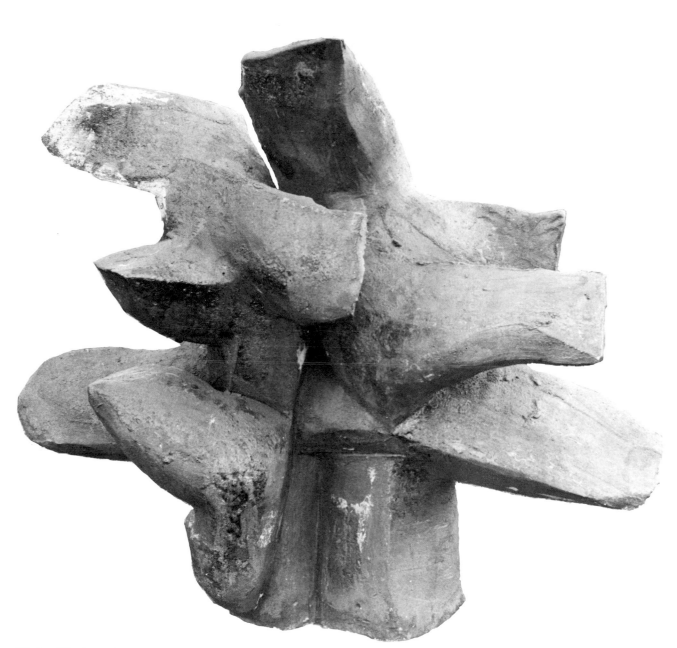

Flying Black, 1958
Glazed stoneware, 39¼ x 45 x 24″ (99.7 x 114.3 x 61 cm)
The Weisman Family Collection

Peter Voulkos

Born in Bozeman, Montana, 1924
Studied at Montana State University, Bozeman (B.S., 1951);
California College of Arts and Crafts, Oakland (M.F.A., 1952)
Taught at the Archie Bray Foundation, Helena, Montana
(1952–55); Black Mountain College, Asheville, North
Carolina (1953); Otis Art Institute, Los Angeles (1954–59);
University of Montana, Missoula (1958–59); University of
California, Berkeley (1959–present); Teachers College,
Columbia University, New York (1960–64)
Lives in Oakland

Selected Solo Exhibitions

1954 Gallery at American House, New York
Felix Landau Gallery, Los Angeles

1956 Felix Landau Gallery, Los Angeles

1957 Bonnier's, Inc., New York

1958 Pasadena Art Museum, California

1959 Felix Landau Gallery, Los Angeles, "Peter Voulkos:
Sculpture, Painting, Ceramics." Exhibition catalogue,
text by Thomas W. Leavitt

1960 Penthouse Gallery, The Museum of Modern Art,
New York, "Sculpture and Paintings by Peter Voulkos: New
Talent in the Penthouse." Exhibition brochure, text by
Peter Selz

1961 Primus-Stuart Galleries, Los Angeles

1965 Los Angeles County Museum of Art, "Peter
Voulkos: Sculpture." Exhibition catalogue, text by Maurice
Tuchman

1967 David Stuart Gallery, Los Angeles

1968 Quay Gallery, San Francisco

1972 San Francisco Museum of Art, "Peter Voulkos:
Bronze Sculpture." Exhibition catalogue, text by Gerald
Nordland

1974 Quay Gallery, San Francisco

1975 Kemper Gallery, Kansas City Art Institute, Missouri

1977 Contemporary Craft Association, Portland, Oregon

1978 Braunstein/Quay Gallery, San Francisco
Museum of Contemporary Crafts of the American
Crafts Council, New York, "Peter Voulkos Retrospective,
1947–1977" (traveled to Contemporary Arts Museum,
Houston; Milwaukee Art Center; San Francisco Museum of
Modern Art). Exhibition brochure

1979 Exhibit A, Chicago
Foster/White Gallery, Seattle
Hills Gallery, Santa Fe, New Mexico

1980 Morgan Gallery, Kansas City, Missouri
Okun-Thomas Gallery, St. Louis

1981 Charles Cowles Gallery, New York
Thomas Segal Gallery, Boston

Selected Group Exhibitions

1952 M. H. de Young Memorial Museum, San Francisco,
"Fifth Annual Exhibition of the Association of San
Francisco Potters." Exhibition brochure

1955 Palais des Festivals, Cannes, France, "Premièr
Festival International de la Céramique"

1957 Museum of Contemporary Crafts of the American
Crafts Council, New York, "Variations in Media"

1958 United States Pavilion, Brussels World's Fair

1959 Musée d'Art Moderne de la Ville de Paris, "Première
Biennale de Paris." Exhibition catalogue
Musée des Beaux-Arts, Ostend, Belgium, "La
Céramique Contemporaine"
The Santa Barbara Museum of Art, California,
"Third Pacific Coast Biennial: An Exhibition of Sculpture
and Drawings by Artists of California, Oregon and
Washington" (traveled to Fine Arts Gallery, San Diego,
California; Municipal Art Gallery, Los Angeles; Portland
Art Museum, Oregon; Henry Art Gallery, University of
Washington, Seattle; M. H. de Young Memorial Museum,
San Francisco). Exhibition catalogue, text by Hilton
Kramer.

1962 Museum of Contemporary Crafts of the American
Crafts Council, New York, "Forms from the Earth: 1,000
Years of Pottery in America." Exhibition catalogue
San Francisco Art Institute, "Work in Clay by Six
Artists"
San Francisco Museum of Art, "Molten Image: 7
Sculptors." Exhibition catalogue
Seattle World's Fair, "Adventures in Art." Exhibition
catalogue, text by Gervais Reed
Whitney Museum of American Art, New York,
"Fifty California Artists" (traveled to Walker Art Center,
Minneapolis; Albright-Knox Art Gallery, Buffalo, New
York; Des Moines Art Center, Iowa). Exhibition catalogue,
texts by Lloyd Goodrich and George D. Culler

1963 London City Council, Battersea Park, "Sculpture in
the Open Air." Exhibition catalogue, text by Herbert Read
Museum of Contemporary Crafts of the American
Crafts Council, New York, "Creative Casting." Exhibition
catalogue, text by Paul J. Smith
The Oakland Museum, California (at Kaiser Center),
"California Sculpture"

1964 Whitney Museum of American Art, New York, "1964
Annual Exhibition: Contemporary American Sculpture."
Exhibition catalogue

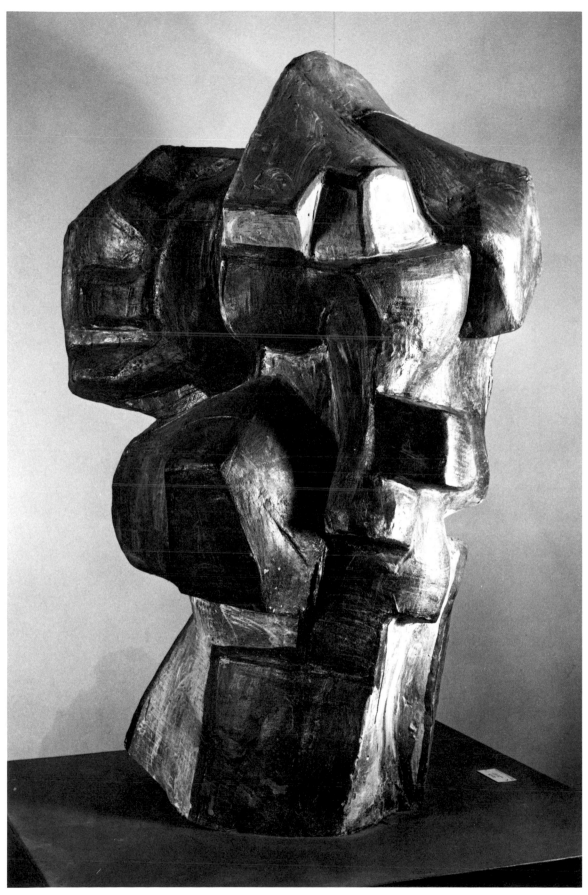

Sitting Bull, 1959
Glazed stoneware, 69 x 37 x 37″ (175.3 x 94 x 94 cm)
The Santa Barbara Museum of Art, California; Bequest of
Hans G. M. De Schulthess

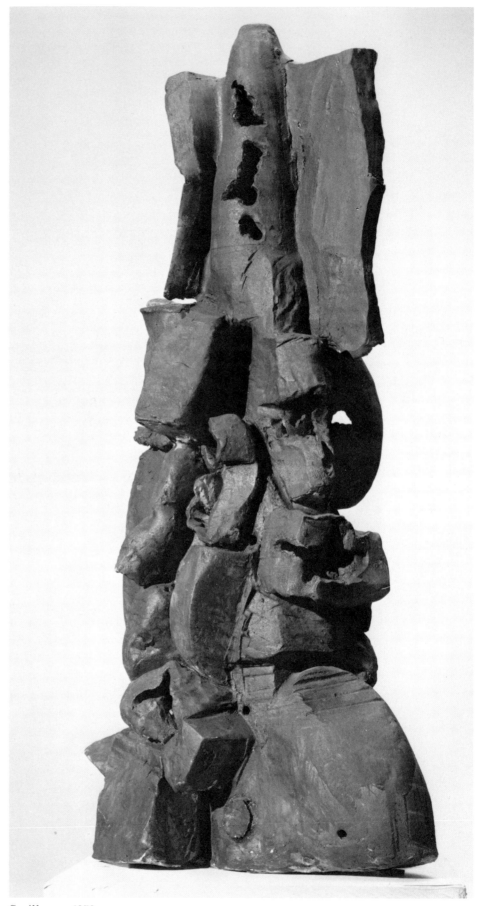

Sevillanas, 1959
Glazed stoneware, 56¾ x 28 x 16⅞″ (144.1 x 71.1 x 42.9 cm)
San Francisco Museum of Modern Art: Albert M. Bender
Collection, Albert M. Bender Bequest Fund Purchase

1966 Art Gallery, University of California, Irvine, "Abstract Expressionist Ceramics" (traveled to San Francisco Museum of Art). Exhibition catalogue, text by John Coplans
 Whitney Museum of American Art, New York, "Contemporary American Sculpture: Selection I." Exhibition catalogue, text by John I. H. Baur

1967 Los Angeles County Museum of Art, "American Sculpture of the Sixties" (traveled to Philadelphia Museum of Art). Exhibition catalogue, text by Maurice Tuchman
 University Art Museum, University of California, Berkeley, "Funk." Exhibition catalogue, text by Peter Selz

1969 National Collection of Fine Arts, Smithsonian Institution, Washington, D.C., "Objects: USA—The Johnson Collection of Contemporary Crafts" (traveled nationally). Exhibition catalogue, text by Lee Nordness
 Pasadena Art Museum, California, "West Coast, 1945–1969" (traveled to City Art Museum of St. Louis; Art Gallery of Ontario, Toronto; Fort Worth Art Center). Exhibition catalogue, text by John Coplans
 Van Abbemuseum, Eindhoven, Holland, "Kompas 4: West Coast USA." Exhibition catalogue, text by Jan Leering

1970 Whitney Museum of American Art, New York, "1970 Annual Exhibition: Contemporary American Sculpture." Exhibition catalogue

1971 The National Museum of Modern Art, Kyoto, Japan, "Contemporary Ceramic Art: Canada, USA, Mexico and Japan" (traveled to National Museum of Modern Art, Tokyo). Exhibition catalogue, text by Kenji Suzuki

1972 San Francisco Museum of Art, "A Decade of Ceramic Art, 1962–1972: From the Collection of Professor and Mrs. R. Joseph Monsen." Exhibition catalogue, text by Suzanne Foley

1974 Lang Art Gallery, Scripps College, Claremont, California, "The Fred and Mary Marer Collection: 30th Annual Ceramics Exhibition." Exhibition catalogue, texts by Jim Melchert and Paul Soldner
 The Oakland Museum, California, "Public Sculpture/ Urban Environment." Exhibition catalogue, text by George Neubert
 San Francisco Art Institute, "Ceramic Sculpture." Exhibition brochure, text by Phil Linhares
 Whitney Museum of American Art, New York, Downtown Branch, "Clay." Exhibition catalogue, text by Richard Marshall

1975 Fendrick Gallery, Washington, D.C., "Clay USA." Exhibition catalogue, text by Daniel Fendrick
 National Collection of Fine Arts, Smithsonian Institution, Washington, D.C., "Sculpture: American Directions, 1945–1975." Exhibition catalogue

1976 San Francisco Museum of Modern Art, "Painting and Sculpture in California: The Modern Era" (traveled to National Collection of Fine Arts, Smithsonian Institution, Washington, D.C.). Exhibition catalogue, text by Henry T. Hopkins
 Whitney Museum of American Art, New York, "200 Years of American Sculpture." Exhibition catalogue, texts by Tom Armstrong et al.

1977 William Hayes Ackland Art Center, University of North Carolina, Chapel Hill, "Contemporary Ceramic Sculpture." Exhibition catalogue, text by Louise Hobbs
 Los Angeles Institute of Contemporary Art, "Foundations in Clay." Exhibition catalogue, texts by Robert Smith and John Coplans

1978 Everson Museum of Art, Syracuse, New York, "Nine West Coast Clay Sculptors, 1978" (traveled to The Arts and Crafts Center of Pittsburgh). Exhibition catalogue, texts by Margie Hughto and Judy S. Schwartz

1979 Everson Museum of Art, Syracuse, New York, "A Century of Ceramics in the United States, 1878–1978" (traveled to Renwick Gallery of the National Collection of Fine Arts, Smithsonian Institution, Washington, D.C.). Exhibition catalogue, texts by Garth Clark and Margie Hughto
 Stedelijk Museum, Amsterdam, "West Coast Ceramics." Exhibition catalogue, text by Rose Slivka

1980 Norman Mackenzie Art Gallery, University of Saskatchewan, Regina, "The Continental Clay Connection." Exhibition catalogue
 San Diego Museum of Art, California, "Sculpture in California, 1975–1980." Exhibition catalogue, text by Richard Armstrong

1981 Exhibit A, Chicago, "Works in 2D: Painting, Drawing, Collage"
 Los Angeles County Museum of Art, "Art in Los Angeles: Seventeen Artists in the Sixties." Exhibition catalogue, text by Maurice Tuchman
 University of Iowa Museum of Art, Iowa City, "Centering on Contemporary Clay: American Ceramics from the Joan Mannheimer Collection." Exhibition catalogue, text by Jim Melchert

Selected Articles and Reviews

Conrad Brown, "Peter Voulkos," *Craft Horizons*, 16 (September/October 1956), pp. 12–18.

Rose Slivka, "Peter Voulkos at Bonnier's," *Craft Horizons*, 17 (March/April 1957), p. 47.

"Exhibitions: Peter Voulkos," *Craft Horizons*, 19 (January/ February 1959), p. 42.

Jules Langsner, "Art News from Los Angeles," *Art News*, 57 (February 1959), p. 49.

"New Talent, 1959: Sculpture," *Art in America*, 47 (Spring 1959), pp. 36–37.

Hubert Crehan, "Peter Voulkos," *Art News*, 59 (March 1960), p. 19.

Dore Ashton, "Exhibitions: Peter Voulkos," *Craft Horizons*, 20 (March/April 1960), p. 42.

Dore Ashton, "Art," *Arts and Architecture*, April 1960, pp. 7–8.

Jules Langsner, "Art News from Los Angeles," *Art News*, 60 (January 1962), p. 52.

Jules Langsner, "Exhibitions: Peter Voulkos," *Craft Horizons*, 22 (January/February 1962), pp. 39–40.

Joanna Magloff, "Peter Voulkos," in "A Portfolio of California Sculptors," *Artforum*, 2 (August 1963), p. 29.

"The Clay Movement," *Time*, August 23, 1963, p. 50.

Nancy Marmer, "Peter Voulkos," *Artforum*, 3 (June 1965), pp. 9–11.

John Coplans, "Voulkos: Redemption through Ceramics," *Art News*, 64 (Summer 1965), pp. 38–39, 64–65.

Arthur Secunda, "Peter Voulkos," *Craft Horizons*, 25 (July/August 1965), pp. 35–36.

Paul Soldner, "Ceramics West Coast," *Craft Horizons*, 26 (June 1966), pp. 25–28, 97.

Jim Melchert, "Peter Voulkos: A Return to Pottery," *Craft Horizons*, 28 (September/October 1968), pp. 20–21.

Rose Slivka, "The New Clay Drawings of Peter Voulkos," *Craft Horizons*, 34 (October 1974), pp. 30–31.

Charles North, "New York: Voulkos and Tchakalian at Braunstein/Quay," *Art in America*, 64 (January/February 1976), p. 99.

Ann-Sargent Wooster, "New York: Peter Voulkos," *Artforum*, 14 (February 1976), p. 60.

Joanne A. Dickson, "Peter Voulkos in Conversation with Joanne A. Dickson," *Visual Dialog*, 2 (June/July/August 1977), pp. 12–16.

Rose Slivka, *Peter Voulkos: A Dialogue with Clay* (Boston: New York Graphic Society, 1978).

Alfred Frankenstein, "Voulkos Gave Creative Precedence to Clay," *San Francisco Sunday Examiner & Chronicle, This World Magazine*, February 26, 1978, p. 58.

Rose Slivka, "Erasing the Line Separating the Arts from Crafts," *Smithsonian*, 8 (March 1978), pp. 86–92.

Elaine Levin, "Peter Voulkos: A Retrospective, 1948–1978," *Artweek*, March 18, 1978, p. 1.

Thomas Albright, "San Francisco: Convulsions of Clay," *Art News*, 77 (April 1978), pp. 114–18.

Elaine Levin, "Peter Voulkos," *Ceramics Monthly*, 26 (June 1978), pp. 59–68.

Thomas Albright, "Peter Voulkos, What Do You Call Yourself?" *Art News*, 77 (October 1978), pp. 118–24.

Hal Fischer, "The Art of Peter Voulkos," *Artforum*, 17 (November 1978), pp. 41–47.

J. Kaneko, "Reflections on the Voulkos Retrospective," *Craft Horizons*, 39 (February 1979), pp. 30–32.

Sylvia Brown, "Peter Voulkos: The Clay's the Thing," *Art in America*, 67 (March/April 1979), pp. 106–9.

Robert Taylor, "Voulkos Clay Explodes from Craft into Art," *Boston Sunday Globe*, May 17, 1981, p. A3.

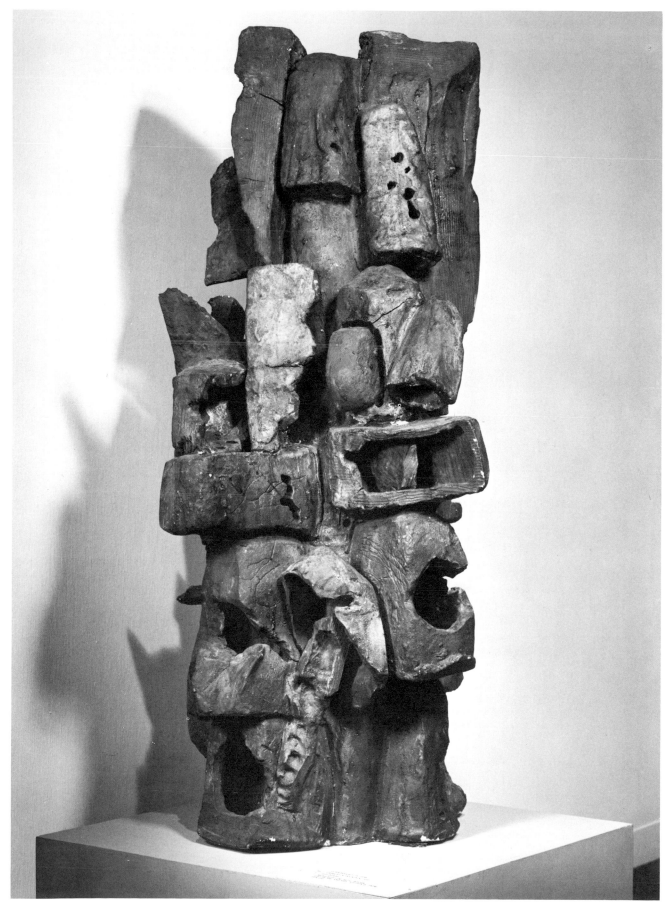

Camelback Mountain, 1959
Glazed stoneware, 45¼ x 19½ x 20¼″ (114.9 x 49.5 x 51.4 cm)
Museum of Fine Arts, Boston; Gift of Mr. and Mrs.
Stephen D. Paine

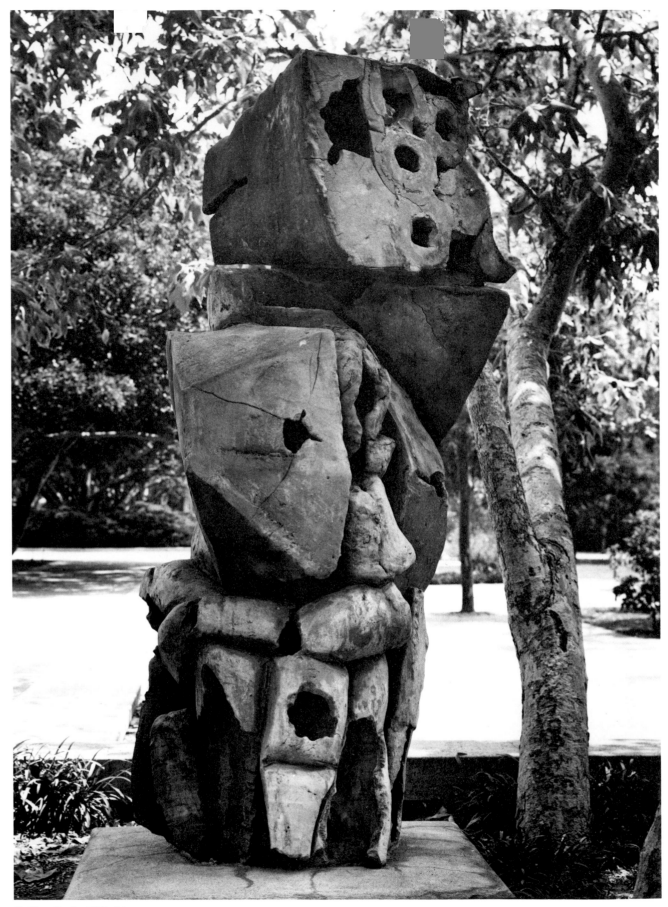

Gallas Rock, 1959–61
Glazed stoneware, 84 x 37 x 40″ (213.4 x 94 x 101.6 cm)
Franklin D. Murphy Sculpture Garden, University of
California, Los Angeles; Gift of Julianne Kemper

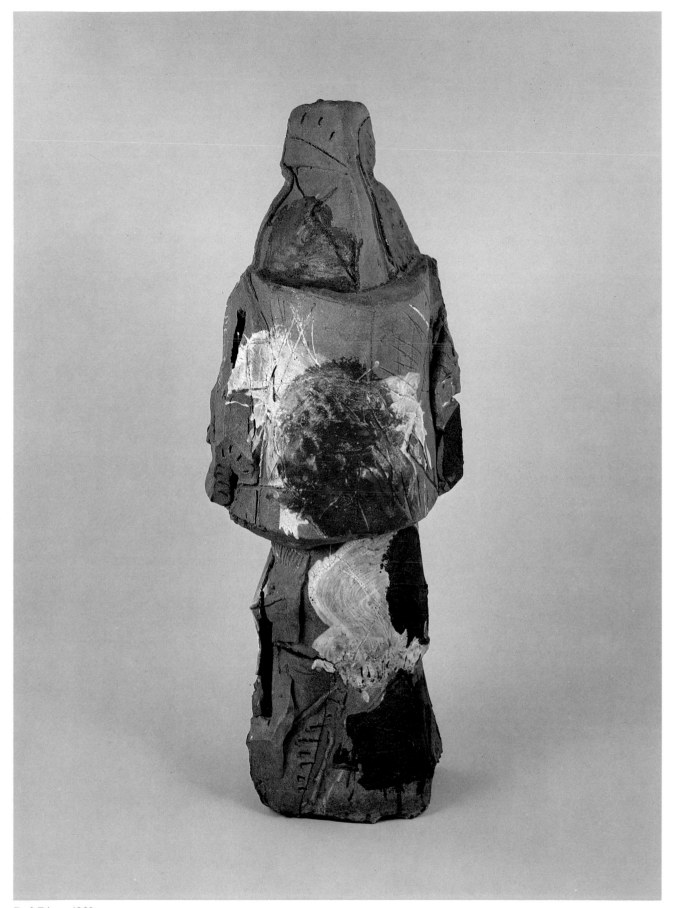

Red River, 1960
Glazed stoneware, 37 x 12½ x 14½" (94 x 31.8 x 36.8 cm)
Whitney Museum of American Art, New York; Gift of the
Howard and Jean Lipman Foundation, Inc. 66.42

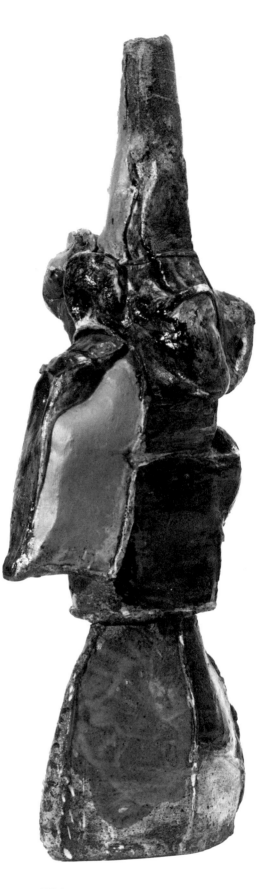

USA 41, 1960
Glazed stoneware with epoxy paint, 34 x 11¾ x 10½"
(86.5 x 29.8 x 26.7 cm)
The Corcoran Gallery of Art, Washington, D.C.; Gift of
Wayne Parrish

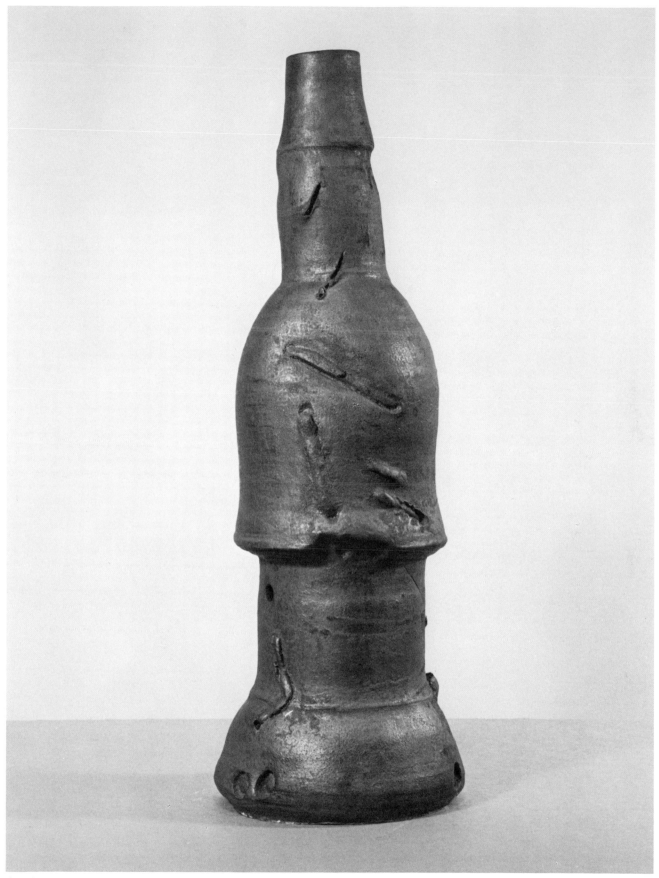

Anada, 1968
Glazed stoneware, 34⅜ x 11¾ x 11½″ (87.3 x 29.8 x 29.2 cm)
San Francisco Museum of Modern Art; Gift of Mrs. Edgar
Sinton

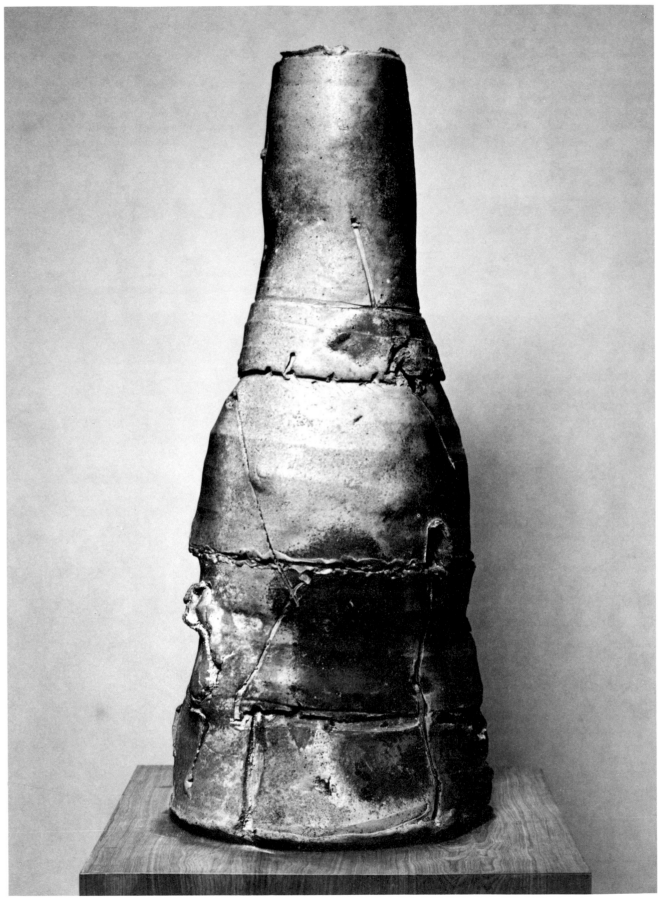

Untitled, 1980
Stoneware, 48 x 18½ x 19″ (121.9 x 47 x 48.3 cm)
Collection of Mr. and Mrs. John Pappajohn

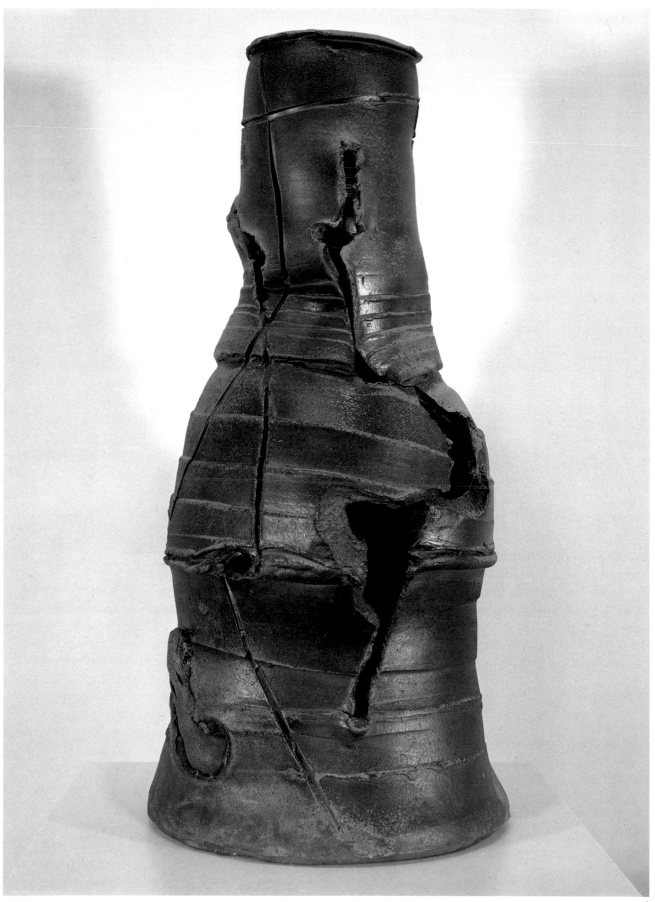

Untitled, 1981
Stoneware, 34½ x 16 x 16″ (90.2 x 40.6 x 40.6 cm)
Thomas Segal Gallery, Boston

John Mason

In 1957 John Mason and Peter Voulkos began to share a studio in Los Angeles, and built a large kiln, enabling them to increase the scale of their work. Until this time, Mason's ceramic vessels were thrown on the potter's wheel, and although they became increasingly sculptural, they retained strong associations with pottery. Mason then began a series of *Vertical Sculptures* that sought to explore the technical and sculptural possibilities of clay. There existed few precedents for this exploration—Mason and Voulkos were groping to develop a vocabulary of ceramic sculpture, knowing only that it was imperative that what resulted not be a pot. *Vertical Sculpture—Spear Form* (1957) was Mason's first large-scale piece—a two-sided totemic upright with eccentrically angled edges and hard-edged glazed areas that loosely echoed the outside form.

The *Vertical Sculptures* of 1961–62 reflect Mason's involvement with the material characteristics of clay—plasticity, malleability, coloration—and with testing its possibilities in form and structure. These pieces exhibit the rawness, spontaneity, and expressiveness of clay, and give the impression of having been formed by natural forces. The formal and technical aspects of balance, proportion, composition, and stability—although purposefully planned and controlled—are subsumed by the very presence of the material itself. The pieces exhibit strong affinities with the Abstract Expressionist mode dominant at that time, but also recall iconic primitive art as well as the topography and coloration of the western United States landscape where Mason has lived.

Desert Cross (1963) and *Cross Form—White* (1964) begin to move away from a completely organic form toward a tightened geometric configuration. The naturalness, fluidity, and layered assembly of the clay remain highly visible, while the increased scale, mass, and volume—possible because of Mason's advanced technical facility—become more pronounced. *Untitled* (1964) and *Dark Monolith with Opening* (1965) evoke an imposing primitivistic

presence and elicit ritualistic associations. Both works contain a centered aperture that makes reference to the openings in traditional vessel forms, but which is now integrated into the overall form in a non-functional capacity. These works foretell the uniformity and consistency of surface, and the singularity of form, that characterize the subsequent group of *Geometric Forms* (1966). This group exhibits Mason's conscious desire to minimize the impact of and response to the ceramic material by emphasizing the dominance of the geometric form—rectangle, cross, or X. The seductive tactility of the ceramic material and the awareness of its manipulation are lessened, so that the sculptural qualities of form and surface predominate. The austerity and severity of these minimal shapes, however, are counterbalanced by the depth and richness of the glazed surface color and texture. *Geometric Form—Red X* (1966), for instance, shows the results of two glaze firings—a deep red glaze that reveals runs and rivulets of the darker underglaze.

The *Firebrick Sculptures*, begun in the early 1970s, reveal a shift in Mason's work away from an involvement with materials and technique toward a concern with the conceptualization and systemization of a piece that is removed from its actual realization. While maintaining an association with the ceramic tradition—firebricks are made of ceramic material and are used for the construction of kilns—their neutral color and standardized form make it possible to conceive of and execute large-scale geometric configurations of stacked bricks, such as *Hudson River Series VIII* (1978), in a variety of mathematically plotted arrangements. These works cannot be perceived as single objects, and move into areas of spatial experience, visual perception and illusion, and architectural site-oriented installations. It is such systematized progression and variation, spatial manipulation and exploration—in both ceramic and non-ceramic materials—that continue to direct Mason's work.

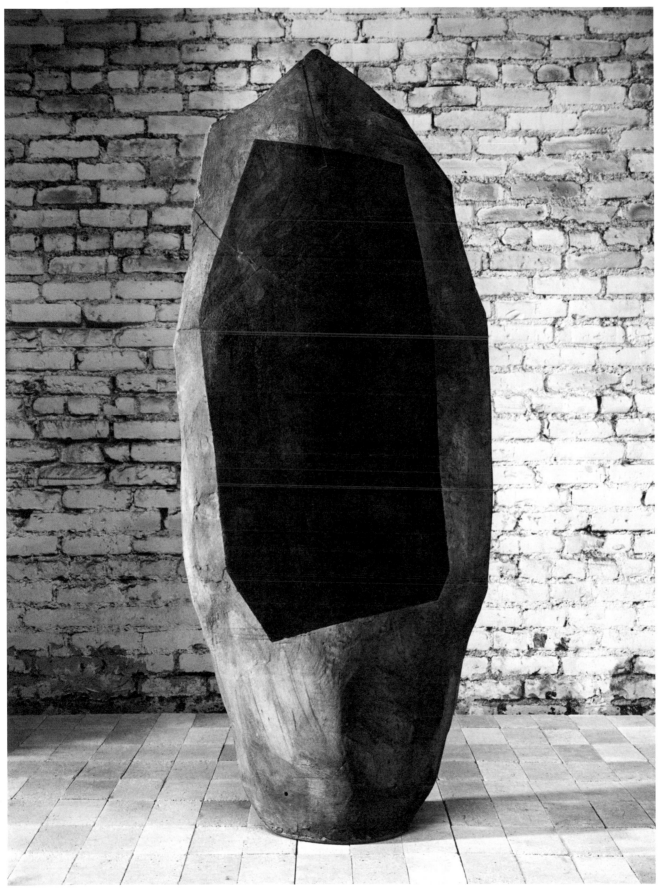

Vertical Sculpture—Spear Form, 1957
Glazed stoneware, 67 x 28 x 12″ (170.9 x 71.1 x 30.5 cm)
Collection of the artist, courtesy Hansen Fuller Goldeen
Gallery, San Francisco

John Mason

Born in Madrid, Nebraska, 1927
Studied at Otis Art Institute, Los Angeles (1949–51, 1954); Chouinard Art Institute, Los Angeles (1951–54)
Taught at Pomona College, Claremont, California (1960–67); University of California, Berkeley (1960, 1964–65); Otis Art Institute, Los Angeles (1961); University of California, Irvine (1967–72); Hunter College, New York (1974–present)
Lives in New York

Selected Solo Exhibitions

1957 Ferus Gallery, Los Angeles

1959 Ferus Gallery, Los Angeles

1960 Pasadena Art Museum, California

1961 Ferus Gallery, Los Angeles

1963 Ferus Gallery, Los Angeles

1966 Los Angeles County Museum of Art, "John Mason: Sculpture." Exhibition catalogue, text by John Coplans

1974 Pasadena Museum of Modern Art, California, "John Mason: Ceramic Sculpture." Exhibition catalogue, text by Barbara Haskell

1976 Hansen Fuller Gallery, San Francisco

1978 The Hudson River Museum, Yonkers, New York, "John Mason: Installations from the Hudson River Series" (traveled to Des Moines Art Center, Iowa; The Corcoran Gallery of Art, Washington, D.C.; The Minneapolis Institute of Arts; San Francisco Museum of Modern Art; University Art Museum, University of Texas, Austin). Exhibition catalogue, text by Rosalind Krauss

1979 University of Nevada, Reno, "John Mason: The Peavine Installation, 1979." Exhibition catalogue, text by Michael Auping

Selected Group Exhibitions

1957 Ferus Gallery, Los Angeles, "John Altoon, John Mason, Jerry Rothman, Paul Soldner"

1958 Museum of Contemporary Crafts of the American Crafts Council, New York, "Young Americans"

1959 The Santa Barbara Museum of Art, California, "Third Pacific Coast Biennial: An Exhibition of Sculpture and Drawings by Artists of California, Oregon and Washington" (traveled to Fine Arts Gallery, San Diego, California; Municipal Art Gallery, Los Angeles; Portland Art Museum, Oregon; Henry Art Gallery, University of Washington, Seattle; M. H. de Young Memorial Museum, San Francisco). Exhibition catalogue, text by Hilton Kramer

1960 Second International Congress of Contemporary Ceramics, Ostend, Belgium, "Moderne Amerikansk Keramic" (traveled to Royal Copenhagen Porcelain Manufactory, Denmark). Exhibition catalogue

1961 University Galleries, University of Southern California, Los Angeles, "Los Angeles Area Sculptors"

1962 The Santa Barbara Museum of Art, California, "Pacific Coast Invitational" (traveled to Fine Arts Gallery, San Diego, California; Municipal Art Gallery, Los Angeles; San Francisco Museum of Art; Seattle Art Museum; Portland Art Museum, Oregon). Exhibition catalogue

1962 Seattle World's Fair, "Adventures in Art." Exhibition catalogue by Gervais Reed
 Whitney Museum of American Art, New York, "Fifty California Artists" (traveled to Walker Art Center, Minneapolis; Albright-Knox Art Gallery, Buffalo, New York; Des Moines Art Center, Iowa). Exhibition catalogue, texts by Lloyd Goodrich and George D. Culler

1963 The Oakland Museum, California (at Kaiser Center), "California Sculpture"

1964 The Art Institute of Chicago, "67th Annual American Exhibition." Exhibition catalogue
 Whitney Museum of American Art, New York, "1964 Annual Exhibition: Contemporary American Sculpture." Exhibition catalogue

1966 Art Gallery, University of California, Irvine, "Abstract Expressionist Ceramics" (traveled to San Francisco Museum of Art). Exhibition catalogue, text by John Coplans

1968 Los Angeles County Museum of Art, "Late Fifties at the Ferus." Exhibition catalogue, text by James Monte

1969 National Collection of Fine Arts, Smithsonian Institution, Washington, D.C., "Objects: USA—The Johnson Collection of Contemporary Crafts" (traveled nationally). Exhibition catalogue, text by Lee Nordness
 Van Abbemuseum, Eindhoven, Holland, "Kompas 4: West Coast USA." Exhibition catalogue, text by Jan Leering
 Pasadena Art Museum, California, "West Coast, 1945–1969" (traveled to City Art Museum of St. Louis; Art Gallery of Ontario, Toronto; Fort Worth Art Center). Exhibition catalogue, text by John Coplans

1971 The National Museum of Modern Art, Kyoto, Japan, "Contemporary Ceramic Art: Canada, USA, Mexico and Japan" (traveled to National Museum of Modern Art, Tokyo). Exhibition catalogue, text by Kenji Suzuki

1972 San Francisco Museum of Art, "A Decade of Ceramic Art, 1962–1972: From the Collection of Professor and Mrs. R. Joseph Monsen." Exhibition catalogue, text by Suzanne Foley

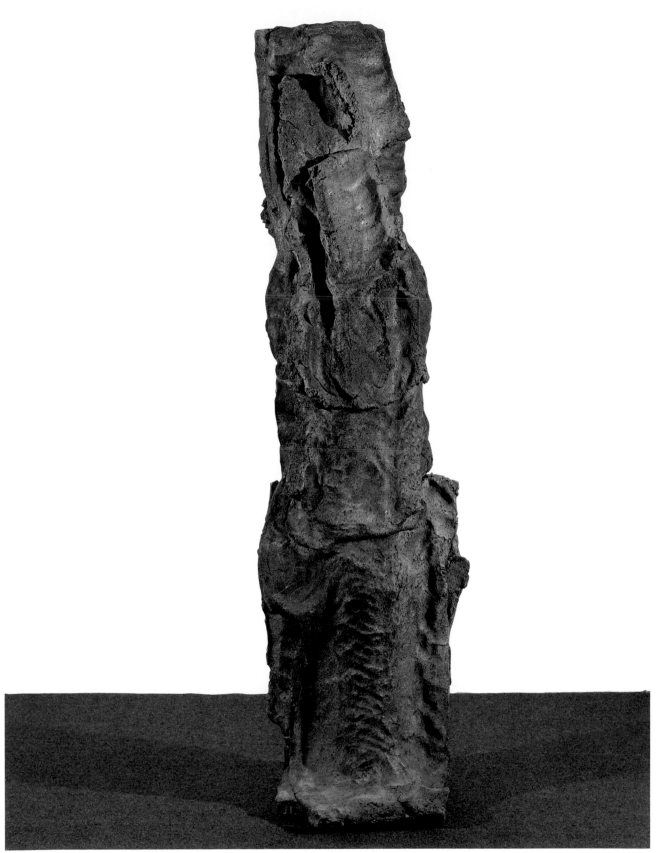

Vertical Edge Sculpture, 1961
Glazed stoneware, 64 x 16 x 9″ (162.6 x 40.6 x 22.9 cm)
Collection of the artist, courtesy Hansen Fuller Goldeen
Gallery, San Francisco

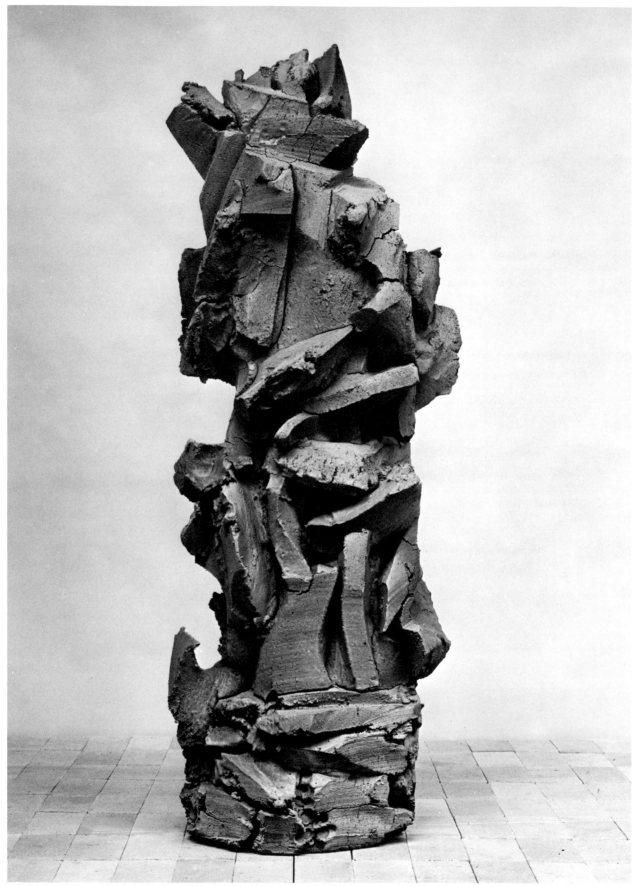

Vertical Sculpture, 1962
Glazed stoneware, 64 x 16 x 12″ (162.5 x 40.6 x 30.5 cm)
Private collection

1973 Grand Rapids Art Museum, Michigan, "Sculpture Off the Pedestal." Exhibition catalogue, text by Barbara Rose

 Whitney Museum of American Art, New York, "1973 Biennial Exhibition: Contemporary American Art." Exhibition catalogue

1974 Lang Art Gallery, Scripps College, Claremont, California, "The Fred and Mary Marer Collection: 30th Annual Ceramics Exhibition." Exhibition catalogue, texts by Jim Melchert and Paul Soldner

 The Oakland Museum, California, "Public Sculpture/ Urban Environment." Exhibition catalogue, text by George Neubert

1976 Newport Harbor Art Museum, Newport Beach, California, "The Last Time I Saw Ferus." Exhibition catalogue, text by Betty Turnbull

 San Francisco Museum of Modern Art, "Painting and Sculpture in California: The Modern Era" (traveled to National Collection of Fine Arts, Smithsonian Institution, Washington, D.C.). Exhibition catalogue, text by Henry T. Hopkins

 Whitney Museum of American Art, New York, "200 Years of American Sculpture." Exhibition catalogue, texts by Tom Armstrong et al.

1977 Los Angeles Institute of Contemporary Art, "Foundations in Clay." Exhibition catalogue, texts by Robert Smith and John Coplans

1979 Everson Museum of Art, Syracuse, New York, "A Century of Ceramics in the United States, 1878–1978" (traveled to Renwick Gallery of the National Collection of Fine Arts, Smithsonian Institution, Washington, D.C.). Exhibition catalogue, text by Garth Clark and Margie Hughto

1980 Norman Mackenzie Art Gallery, University of Saskatchewan, Regina, "The Continental Clay Connection." Exhibition catalogue

1981 University of Iowa Museum of Art, Iowa City, "Centering on Contemporary Clay: American Ceramics from the Joan Mannheimer Collection." Exhibition catalogue, text by Jim Melchert

Selected Articles and Reviews

J. Bennet Olson, "Exhibitions: Soldner, Mason, Rothman," *Craft Horizons*, 17 (September/October 1957), p. 41.

Donald Goodall, "Exhibitions: John Mason," *Craft Horizons*, 19 (September/October 1959), p. 41.

Gerald Nordland, "John Mason," *Craft Horizons*, 20 (May/ June 1960), pp. 28–33.

Paul LaPorte, "Letter from Los Angeles," *Craft Horizons*, 20 (July/August 1960), pp. 43–44.

Jules Langsner, "Los Angeles Letter," *Art International*, 5 (April 1961), p. 44.

Jules Langsner, "Art News from Los Angeles," *Art News*, 60 (Summer 1961), p. 66.

Paul LaPorte, "Letter from Los Angeles," *Craft Horizons*, 21 (July/August 1961), p. 43.

Jules Langsner, "Los Angeles Letter," *Art International*, 5 (October 1961), pp. 86–87.

"New Talent USA: Crafts," *Art in America*, 49, no. 1 (1961), pp. 58–61.

Paul LaPorte, "John Mason, Ceramic Sculptor," *Artforum*, 1 (February 1963), pp. 34–35.

Anita Ventura, "The Prospect Over the Bay," *Arts Magazine*, 37 (May/June 1963), pp. 19–20.

Constance Perkins, "John Mason: Ferus Gallery," *Artforum*, 1 (June 1963), pp. 14–15.

Jules Langsner, "Los Angeles," *Art News*, 65 (January 1967), p. 26.

Helen Giambruni, "Exhibitions: John Mason," *Craft Horizons*, 27 (January/February 1967), pp. 38–40.

Judith Wechsler, "Los Angeles: John Mason," *Artforum*, 5 (February 1967), p. 65.

Elena Karina Canavier, "John Mason Retrospective," *Artweek*, June 1, 1974, pp. 1, 20.

Bernard Kester, "Exhibitions: Los Angeles," *Craft Horizons*, 34 (August 1974), p. 32.

Kenneth Garber, "Pasadena," *Art in America*, 62 (November/December 1974), pp. 125–26.

Joanne A. Dickson, "John Mason at the Hudson River Museum and the San Francisco Museum of Modern Art," *Art in America*, 67 (January/February 1979), pp. 145–46.

Rosalind Krauss, "John Mason and Post-Modernist Sculpture: New Experiences, New Words," *Art in America*, 67 (May/June 1979), pp. 120–27.

Jeff Kelley, "John Mason," *Arts Magazine*, 55 (September 1980), p. 14.

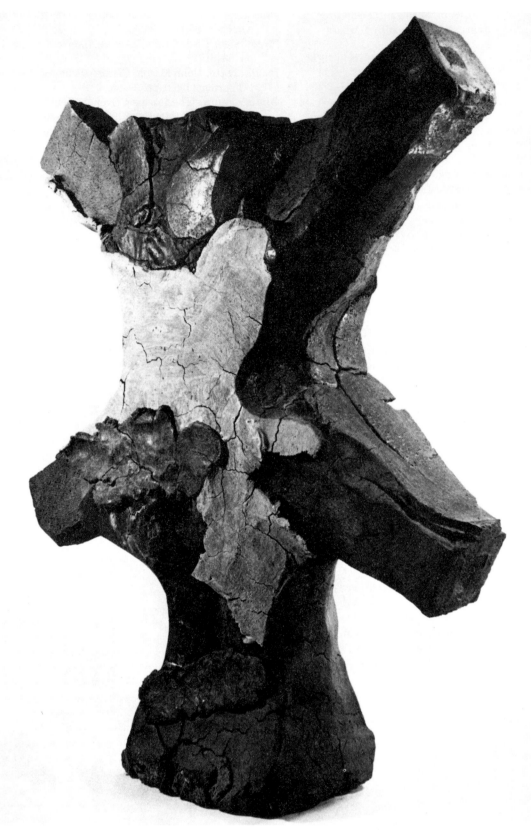

Desert Cross, 1963
Glazed stoneware, 54 x 43½ x 15″ (137.2 x 110.5 x 38.1 cm)
Sheppard Fine Arts Gallery, University of Nevada, Reno

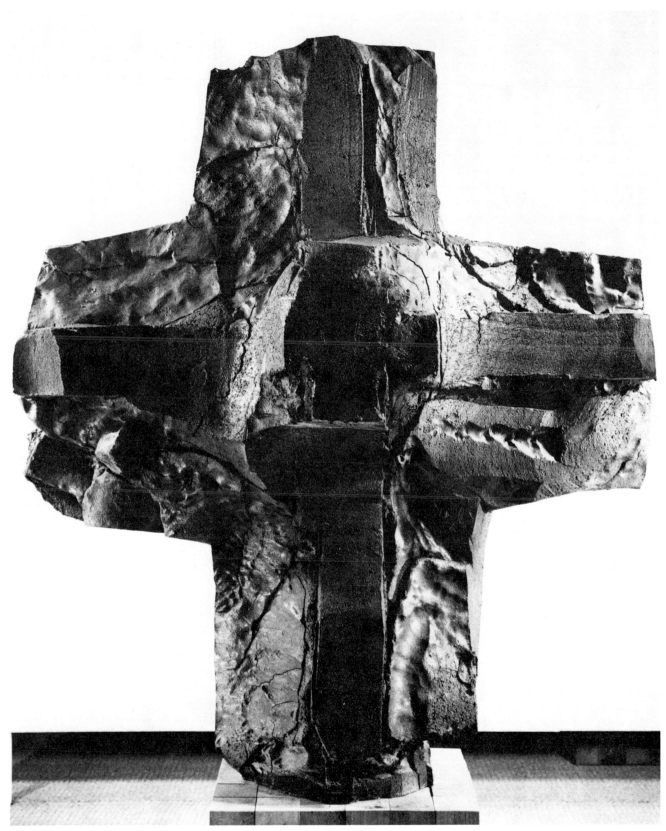

Cross Form, 1963
Glazed stoneware, 64 x 52 x 38″ (162.6 x 132.1 x 96.6 cm)
The Art Institute of Chicago; Gift of the Ford Foundation

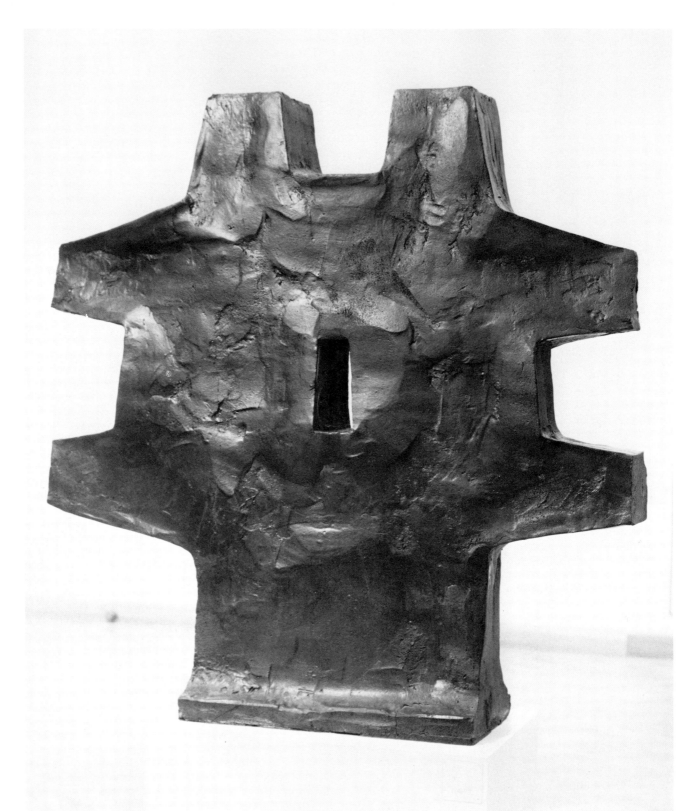

Untitled, 1964
Glazed stoneware, 66 x 63½ x 17″ (167.6 x 161.3 x 43.2 cm)
San Francisco Museum of Modern Art; Gift of the
Women's Board

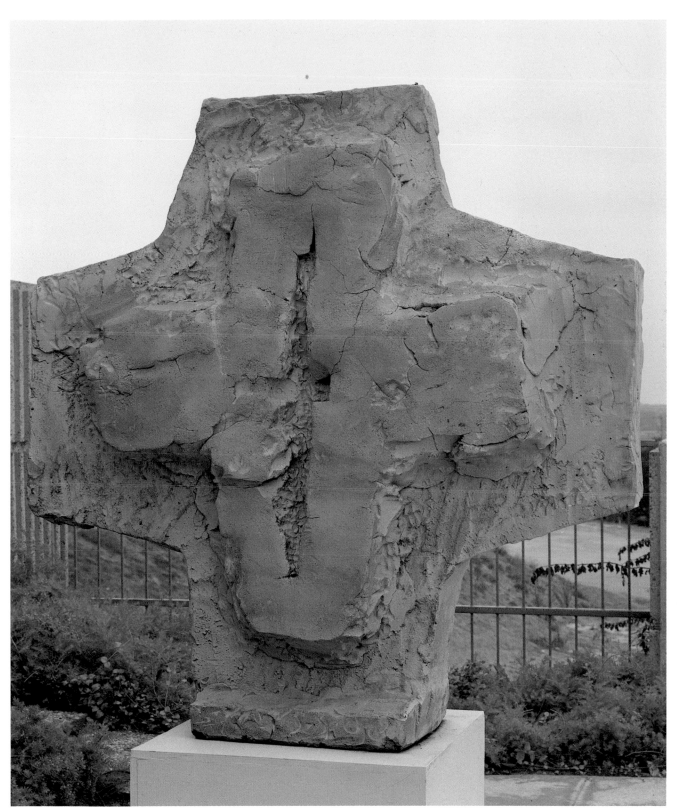

Cross Form—White, 1964
Glazed stoneware, 67 x 66 x 21″ (170.1 x 167.6 x 53.3 cm)
Collection of the artist, courtesy Hansen Fuller Goldeen
Gallery, San Francisco

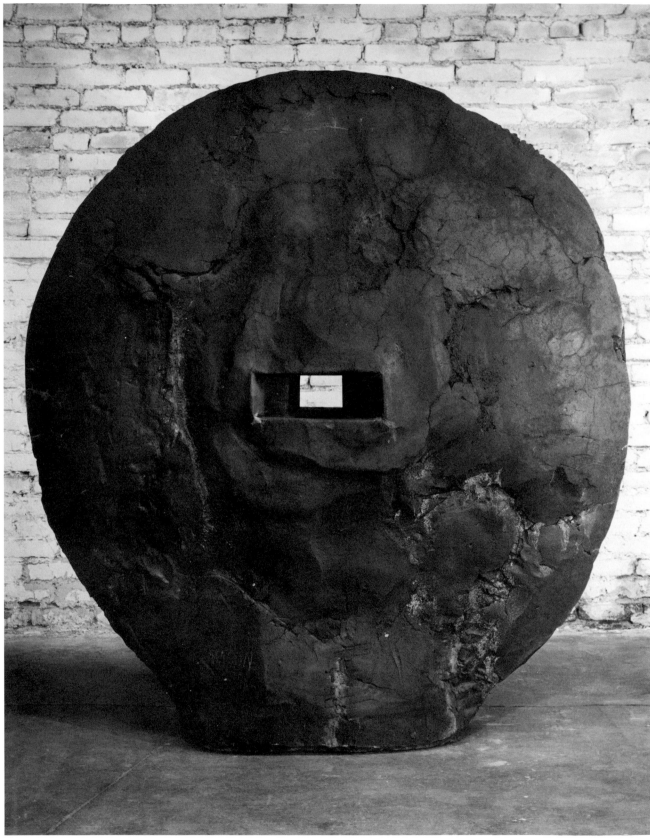

Dark Monolith with Opening, 1965
Glazed stoneware, 65 x 62 x 24″ (165.1 x 157.5 x 61 cm)
Collection of the artist, courtesy Max Hutchinson Gallery,
New York

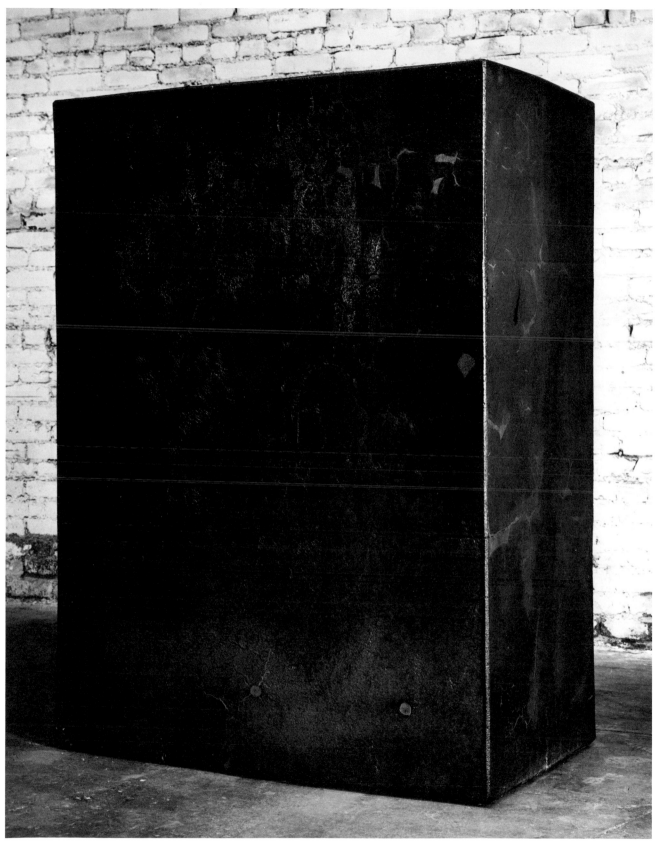

Geometric Form—Dark, 1966
Glazed stoneware, 59 x 43 x 25″ (149.9 x 109.2 x 63.5 cm)
Collection of Mr. and Mrs. C. David Robinson

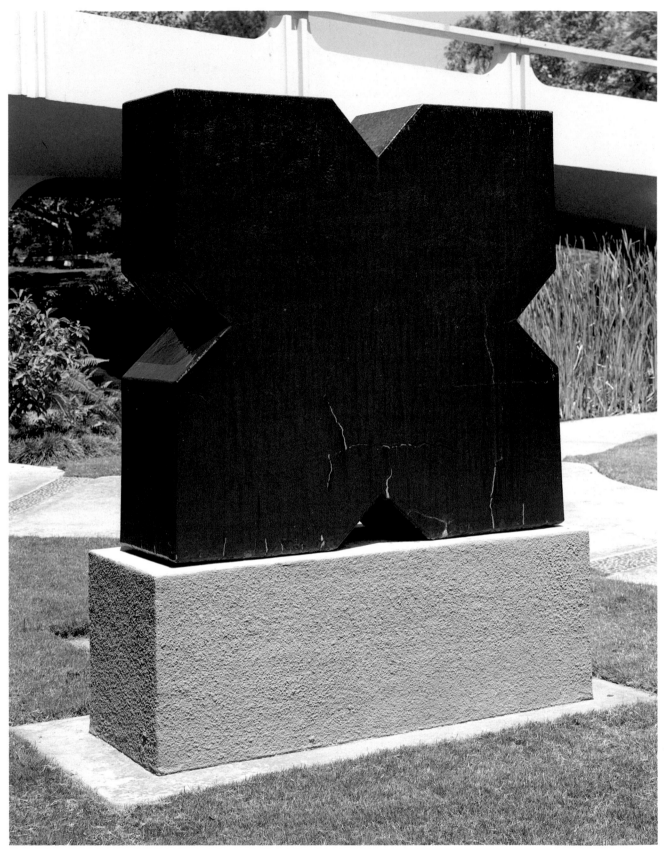

Geometric Form—Red X, 1966
Glazed stoneware, 58½ x 59½ x 17″ (148.5 x 151.1 x 43.2 cm)
Los Angeles County Museum of Art

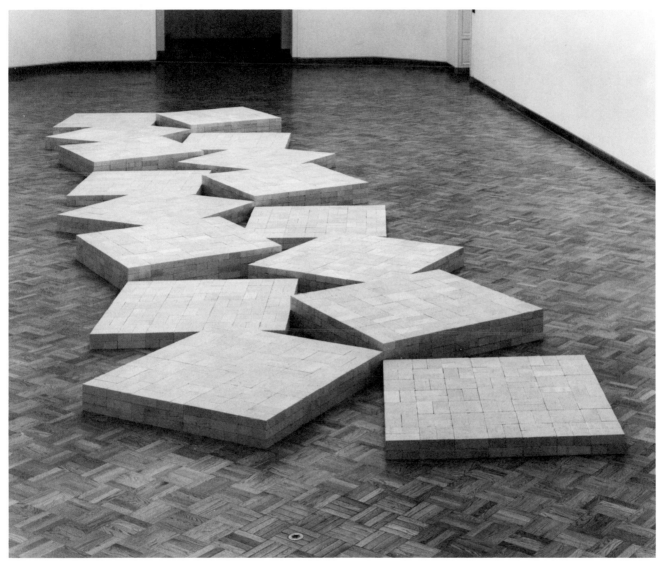

Hudson River Series VIII, 1978
Firebrick installation at the San Francisco Museum of
Modern Art
Collection of the artist

Kenneth Price

Kenneth Price's works of the late 1950s exhibit a freeness and expressiveness of form that reflect the impact of his work with Peter Voulkos at Otis Art Institute, and a freshness and brilliance in color application and decoration, combined with expert technical execution, that result from his studies in the science of clays and glazes at the New York State College of Ceramics, in Alfred. *Untitled* (1959) marks Price's de-emphasis of the functional aspects of a form to focus on its sculptural potential. A container with a wide, flat bottom tapers to a small opening capped by a removable lid. The focus of the piece, however, is the volumetric presence of the form and the attention given to the surface, glazed with bright, sharp green and yellow areas crusted with blisters and craters—one of which seems to have burst open to reveal a dark, mysterious interior. *Silver* (1961) further obfuscates the reference to a vessel. Although the work sits on a flat, wide base, the top opening and lid are eliminated, and the top rounded to a smooth dome shape, so that the focus of the piece shifts to the enlarged orifice on the side, from which protrude menacing finger-like tendrils. Price has also painted the ceramic with acrylic paint and automobile lacquer, thus not only avoiding the limitations and unpredictability of glazes, but also reinforcing the overall consistency of form, surface, and color, and masking the physical characteristics of the ceramic material.

A series of egg shapes followed that rejected the reference to the foot of a pot by completely rounding the form to an ovoid that balances on one point of the surface. These pieces strongly reflect Price's interest in and reference to zoology, and concurrently recall the surreal images and biomorphic forms of Arp, Miró, and Brancusi. *S. L. Green* (1963), like all of the egg pieces, is brightly painted in intense, vivid, and contrasting colors of matte and glossy finishes, often with outlined amoeboid shapes. In keeping with the biomorphic references of the form, the coloration also recalls the strong colors found in exotic birds, sea life, insects, and plant forms. These are tight, compacted, self-contained and

enigmatic objects that reveal Price's facility at juxtaposing contrasting features—organic form against severely geometrized, constructed wooden bases; smooth, reflective surfaces against grainy, matte finishes; hard outer shell against soft, undulating interior tendrils.

Price next completed a group of "specimens," such as *Green and Cream* (1967), in which he continued to explore small, organic forms painted with layers of glossy industrial paints and accented with indented, wormy markings and protruding knobs. These pieces—reminiscent of laboratory specimens and rudimentary life forms—are often displayed on specially designed and carefully crafted supports and cases, such as that in *Specimen B1520.06* (1964).

In the late 1960s, Price returned to the cup form. Like the "eggs" and "specimens," these cups exhibit images derived from biology and zoology, often animals with hard outer shells that protect soft, organic insides. The cups are thin-walled, brightly glazed cylinders resting on a wide, splayed foot that supports incongruously placed animals *(Blind Sea Turtle Cup*, 1968, and *Snail Cup*, 1968), or the foot itself takes on surreal characteristics *(Wart Cup*, 1969, and *Oyster Bay Rock Cup*, 1967). Although the cups are comfortable in the hand and potentially usable, Price is primarily dealing with form rather than function.

Following his move from Los Angeles to New Mexico in 1971, Price's cups began to suggest mineralogical sources. In *Crystal Cup* (1972) and *Slate Cup* (1972), configurations of natural rock formations that reflect various types of aggregation and extrusion offered Price angles, edges, and planes to consider for their sculptural and coloristic potential. The handle, foot, lip, and cup became increasingly abstracted and geometrized, so that these objects make a more direct reference to decorative and architectural styles than to utilitarian containers. Each plane and facet of *Untitled Cup* (1974)—some of which have separated from the main configuration and become satellite elements—is glazed in colors of differing intensity, transparency, and

Untitled, 1959
Glazed earthenware, 21½ x 20 x 20″ (54.6 x 50.8 x 50.8 cm)
Collection of Billy Al Bengston

reflectiveness. By thus creating spatial, perspectival, and optical tensions, Price establishes the cup as a sculptural container of form and color.

Price continued his investigations of the sculptural possibilities of glazed geometric volumes in the larger works done since the late 1970s. *Israeli Sculpture* (1979) and *Tail Piece* (1980) exhibit an increased complexity in configuration and coloration, and make no reference to functional pottery. The cutout openings are an integral part of the overall design considerations and have no functional purpose other than serving as a vent for the enclosed space of the object during the firing process. *De Chirico's Bathhouse* (1980) enhances the surreal overtones in Price's work, while exhibiting the interrelationship and interaction established between colors and between the two separate elements that comprise the piece. As in all of Price's geometric pieces, the edges of the form are not glazed, in order to keep the planes of color sharp, clear, and defined. These unglazed, white lines create a three-dimensional drawing in space that relates to the preparatory sketches Price uses to resolve volumetric configurations and color combinations.

After establishing a new studio in Taos, and concurrently working on the series of geometric, architectural cups, Price undertook the monumental *Happy's Curios*, an environmental installation that resembles a curio shop of decorated ceramic wares. It is a work of art about the art of pottery—it comments on the artistic, social, and economic aspects of pottery, and on its decoration, production, and distribution. The work is composed of multiple "units" and "shrines," each containing numerous ceramic objects inspired by Mexican and American Indian crafts and ceramic works. Price's intention was to elevate this "lowly" folk pottery—which he had always admired for its originality and high quality—to a "fine art" sculptural tableau. Each of the individual units explores a style or type of pottery. *Town Unit 1* (1972–77) presents cups, bowls, and plates glazed in a bright "Mexican palette," with clichéd scenes

of a sombreroed man in a dramatically colored Mexican landscape. Four plates hang on the wall above the painted wood cabinet and extend the sculptural space beyond the physical mass of the unit. In a related manner, the fence surrounding the cabinet in *Unit 1* (1972–77) defines and encompasses an enlarged environmental space. The fence, in addition to acting as a protective barrier, reinforces the tableau effect of the unit to ensure that the individual objects are perceived as designed, decorated, and arranged sculptural objects in an ensemble. *Unit 1* presents a group of radically stylized vases, with bright red geometric slab handles symmetrically attached to multicolored, mottled, and bright yellow vessels that contrast "low art" pottery with a "high style" Art Deco design.

Death Shrine 1 (1972–77) presents another facet of Price's exploration of ceramic styles, uses, and implications. The selection of death images— skulls and skeletons—is not used for morbid associations, but because of the highly charged and active visual imagery. This *Death Shrine* incorporates a large-scale architectural construction complete with candles, plastic flowers, colorful ribbons, and framed drawing, all reminiscent of roadside and cemetary altars and memorial shrines in Mexico and the Southwest. The *Happy's Curios* pieces, while seemingly a deviation from Price's concentration on independent sculptures, is conceptually and formally in complete accord with his artistic convictions and goals. The curio units, and the glazed, geometric objects—meticulously executed and carefully presented—continue to advance Price's interest in harmonizing color and form, in negating biases against the ceramic medium, and in establishing a unique sculptural expression.

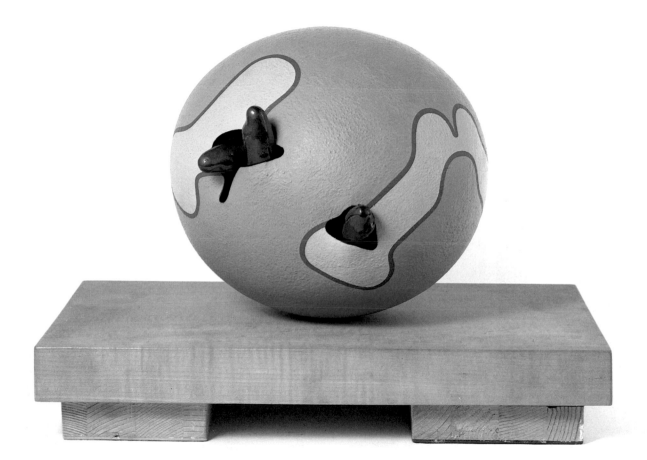

S. L. Green, 1963
Lacquer and acrylic on stoneware, 9½ x 10½ x 10½″
(24.1 x 26.7 x 26.7 cm)
Whitney Museum of American Art, New York; Gift of the
Howard and Jean Lipman Foundation, Inc. 66.35

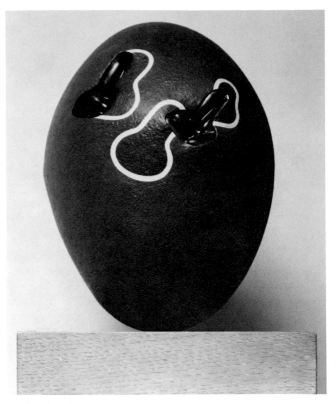

B. T. Blue, 1962
Lacquer and acrylic on stoneware, 10 x 6½ x 6½″
(25.4 x 16.5 x 16.5 cm)
Collection of Becky and Peter Smith

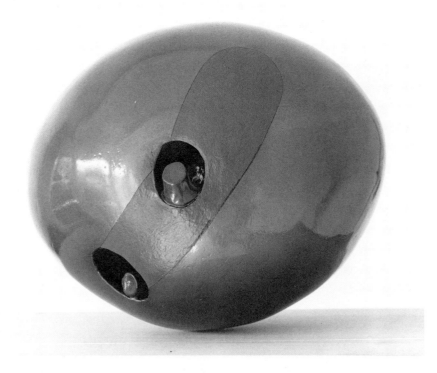

M. Green, 1961
Lacquer and acrylic on stoneware, 10 x 13 x 11½″
(25.4 x 33 x 29.2 cm)
Collection of Betty Asher

Kenneth Price

Born in Los Angeles, 1935
Studied at Chouinard Art Institute, Los Angeles (1953–54);
University of Southern California, Los Angeles (B.F.A.,
1956); Otis Art Institute, Los Angeles (1957–58); New York
State College of Ceramics, Alfred (M.F.A., 1959)
Lives in Taos, New Mexico

Selected Solo Exhibitions

1960 Ferus Gallery, Los Angeles

1961 Ferus Gallery, Los Angeles

1964 Ferus Gallery, Los Angeles

1968 Kasmin Gallery, London

1969 Mizuno Gallery, Los Angeles
Whitney Museum of American Art, New York

1970 Gemini G. E. L., Los Angeles
Kasmin Gallery, London

1971 Galerie Neuendorf, Cologne, West Germany
Mizuno Gallery, Los Angeles
David Whitney Gallery, New York

1972 Gemini G. E. L., Los Angeles

1973 Nicholas Wilder Gallery, Los Angeles

1974 Felicity Samuel Gallery, London
Willard Gallery, New York

1977 James Corcoran Gallery, Los Angeles

1978 Los Angeles County Museum of Art, "Ken Price:
Happy's Curios." Exhibition catalogue, text by Maurice
Tuchman

1979 Hansen Fuller Goldeen Gallery, San Francisco
Texas Gallery, Houston
Willard Gallery, New York

1980 Contemporary Arts Museum, Houston, "Ken Price:
Selections from *Happy's Curios*." Exhibition catalogue,
text by Linda L. Cathcart
James Corcoran Gallery, Los Angeles
Gallery of the School of Visual Arts, New York
Texas Gallery, Houston

1981 Betsy Rosenfield Gallery, Chicago

Selected Group Exhibitions

1961 Ferus Gallery, Los Angeles, "Group Show"

1962 Whitney Museum of American Art, New York,
"Fifty California Artists" (traveled to Walker Art Center,
Minneapolis; Albright-Knox Art Gallery, Buffalo, New
York; Des Moines Art Center, Iowa). Exhibition catalogue,
texts by Lloyd Goodrich and George D. Culler

1963 The Oakland Museum, California (at Kaiser Center),
"California Sculpture"

1964 Pasadena Art Museum, California, "New American
Sculpture." Exhibition catalogue, text by Walter Hopps

1966 Art Gallery, University of California, Irvine,
"Abstract Expressionist Ceramics" (traveled to San
Francisco Museum of Art). Exhibition catalogue, text by
John Coplans
Art Gallery, University of California, Irvine, "Five
Los Angeles Sculptors." Exhibition catalogue, text by John
Coplans
Los Angeles County Museum of Art, "Robert Irwin/
Kenneth Price." Exhibition catalogue, text by Lucy R.
Lippard
Seattle Art Museum, "Ten from Los Angeles."
Exhibition catalogue, text by John Coplans
Whitney Museum of American Art, New York, "1966
Annual Exhibition: Sculpture and Prints." Exhibition
catalogue
Whitney Museum of American Art, New York,
"Contemporary American Sculpture: Selection I."
Exhibition catalogue, text by John I. H. Baur

1967 Los Angeles County Museum of Art, "American
Sculpture of the Sixties" (traveled to Philadelphia Museum
of Art). Exhibition catalogue, text by Maurice Tuchman
University Art Museum, University of California,
Berkeley, "Funk." Exhibition catalogue, text by Peter Selz

1968 Los Angeles County Museum of Art, "Late Fifties at
the Ferus." Exhibition catalogue, text by James Monte

1969 The Museum of Modern Art, New York, "Tamarind:
Homage to Lithography." Exhibition catalogue, text by
Virginia Allen
National Collection of Fine Arts, Smithsonian
Institution, Washington, D.C., "Objects: USA—The
Johnson Collection of Contemporary Crafts" (traveled
nationally). Exhibition catalogue, text by Lee Nordness
Pasadena Art Museum, California, "West Coast,
1945–1969" (traveled to City Art Museum of St. Louis; Art
Gallery of Ontario, Toronto; Fort Worth Art Center, Texas).
Exhibition catalogue, text by John Coplans
Van Abbemuseum, Eindhoven, Holland, "Kompas 4:
West Coast USA." Exhibition catalogue, text by Jan
Leering

1970 The Pace Gallery, New York, "A Decade of
California Color, 1960–1970." Exhibition brochure
Whitney Museum of American Art, New York, "1970
Annual Exhibition: Contemporary American Sculpture."
Exhibition catalogue

1971 Hayward Gallery, London, "11 Los Angeles Artists."
Exhibition catalogue, texts by Maurice Tuchman and Jane
Livingston
The Museum of Modern Art, New York, "Technics
and Creativity: Gemini G. E. L." Exhibition catalogue,
text by Riva Castleman
The National Museum of Modern Art, Kyoto, Japan,
"Contemporary Ceramic Art: Canada, USA, Mexico and
Japan" (traveled to National Museum of Modern Art,
Tokyo). Exhibition catalogue, text by Kenji Suzuki

1972　Fort Worth Art Center, Texas, "Contemporary American Art: Los Angeles"

　　　Kunstverein Hamburg, West Germany, "USA West Coast" (traveled in West Germany to Kunstverein Hannover; Kölnischer Kunstverein; Wurttembergisches Kunstverein, Stuttgart). Exhibition catalogue, texts by Helmut Heissenbüttel and Helen Winer

　　　Museum Boymans-van Beuningen, Rotterdam, Holland, "Joe Goode, Kenneth Price, Edward Ruscha." Exhibition catalogue, text by Liesbeth Brandt Corstins

1974　Lang Art Gallery, Scripps College, Claremont, California, "The Fred and Mary Marer Collection: 30th Annual Ceramics Exhibition." Exhibition catalogue, texts by Jim Melchert and Paul Soldner

　　　Whitney Museum of American Art, New York, Downtown Branch, "Clay." Exhibition catalogue, text by Richard Marshall

1975　National Collection of Fine Arts, Smithsonian Institution, Washington, D.C., "Eight from California." Exhibition catalogue, text by Janet A. Flint

　　　National Collection of Fine Arts, Smithsonian Institution, Washington, D.C., "Sculpture: American Directions, 1945–1975." Exhibition catalogue

1976　Newport Harbor Art Museum, Newport Beach, California, "The Last Time I Saw Ferus." Exhibition catalogue, text by Betty Turnbull

　　　San Francisco Museum of Modern Art, "Painting and Sculpture in California: The Modern Era" (traveled to National Collection of Fine Arts, Smithsonian Institution, Washington, D.C.). Exhibition catalogue, text by Henry T. Hopkins

　　　Whitney Museum of American Art, New York, "200 Years of American Sculpture." Exhibition catalogue, texts by Tom Armstrong et al.

1977　The Brooklyn Museum, New York, "30 Years of American Printmaking." Exhibition catalogue, text by Gene Baro

　　　Los Angeles Institute of Contemporary Art, "Foundations in Clay." Exhibition catalogue, texts by Robert Smith and John Coplans

1978　Everson Museum of Art, Syracuse, New York, "Nine West Coast Clay Sculptors, 1978" (traveled to The Arts and Crafts Center of Pittsburgh). Exhibition catalogue, texts by Margie Hughto and Judy S. Schwartz

1979　Everson Museum of Art, Syracuse, New York, "A Century of Ceramics in the United States, 1878–1978" (traveled to Renwick Gallery of the National Collection of Fine Arts, Smithsonian Institution, Washington, D.C.). Exhibition catalogue, texts by Garth Clark and Margie Hughto

　　　Hirshhorn Museum and Sculpture Garden, Smithsonian Institution, Washington, D.C., "Directions." Exhibition catalogue, text by Howard N. Fox.

　　　Stedelijk Museum, Amsterdam, "West Coast Ceramics." Exhibition catalogue, text by Rose Slivka

　　　Whitney Museum of American Art, New York, "1979 Biennial Exhibition." Exhibition catalogue

1980　Delahunty Gallery, Dallas, "The Vessel." Exhibition catalogue, text by Rick Dillingham

　　　Norman Mackenzie Art Gallery, University of Saskatchewan, Regina, "The Continental Clay Connection." Exhibition catalogue

1981　Los Angeles County Museum of Art, "Art in Los Angeles: Seventeen Artists in the Sixties." Exhibition catalogue, text by Maurice Tuchman

　　　University of Iowa Museum of Art, Iowa City, "Centering on Contemporary Clay, American Ceramics from the Joan Mannheimer Collection." Exhibition catalogue, text by Jim Melchert

　　　Whitney Museum of American Art, New York, "1981 Biennial Exhibition." Exhibition catalogue

Selected Articles and Reviews

Paul LaPorte, "Letter from Los Angeles," *Craft Horizons*, 20 (July/August 1960), pp. 43–44.

Jules Langsner, "Los Angeles Letter," *Art International*, 5 (December 1961), pp. 46–48.

Henry T. Hopkins, "Kenneth Price," in "A Portfolio of California Sculptors," *Artforum*, 2 (August 1963), p. 41.

John Coplans, "The Sculpture of Kenneth Price," *Art International*, 8 (March 1964), pp. 33–34.

Clair Wolf, "Los Angeles," *Artforum*, 2 (April 1964), pp. 43–44.

"New Talent," *Art in America*, 52 (August 1964), pp. 98–99.

Donald Judd, "Specific Objects," *Arts Yearbook*, 8 (1965), pp. 74–82.

John Coplans, "5 Los Angeles Sculptors at Irvine," *Artforum*, 4 (February 1966), pp. 33–37.

Simon Watson Taylor, "London: Stop Press—Nature Survives," *Art and Artists*, 2 (March 1968), pp. 47–48.

Norbert Lynton, "London Letter," *Art International*, 12 (May 1968), pp. 62–63.

Jane Livingston, "Two Generations in L.A.," *Art in America*, 57 (January 1969), pp. 92–97.

Peter Layton, "London Commentary: Kenneth Price Cups at Kasmin," *Studio International*, 179 (February 1970), pp. 75–76.

David Zack, "Is Kenneth Price a Nut Artist?," *Art and Artists*, 4 (February 1970), pp. 46–47.

Peter Plagens, "Los Angeles," *Artforum*, 9 (March 1971), p. 71.

Carter Ratcliff, "New York Letter," *Art International*, 15 (March 20, 1971), pp. 47–50.

Phyllis Derfner, "Kenneth Price at Willard," *Art in America*, 63 (May/June 1975), pp. 87–89.

Carter Ratcliff, "Notes on Small Sculpture," *Artforum*, 14 (April 1976), pp. 35–42.

Bernard Kester, "Kenneth Price," *Craft Horizons*, 38 (June 1978), p. 57.

Peter Schjeldahl, "Ken Price: Los Angeles County Museum," *Artforum*, 17 (November 1978), pp. 78–79.

Joan Simon, "An Interview with Ken Price," *Art in America*, 68 (January 1980), pp. 98–104.

William Wilson, "The Galleries: La Cienega," *Los Angeles Times*, April 18, 1980, section 4, p. 10

John Perreault, "This Price is Right," *Soho News*, October 8, 1980, p. 43.

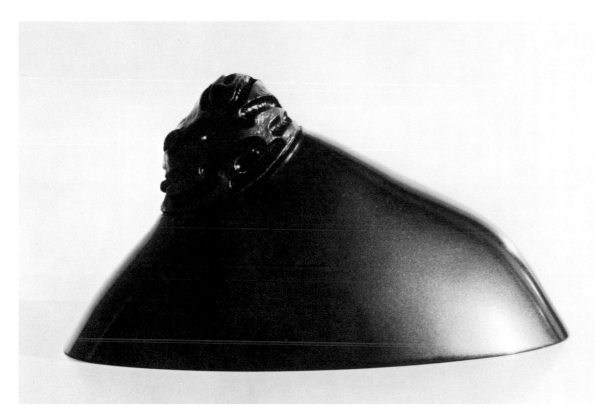

S. D. Green, 1966
Lacquer and acrylic on stoneware, 5 x 4 x 9½"
(12.7 x 10.2 x 24.1 cm)
Collection of James J. Meeker

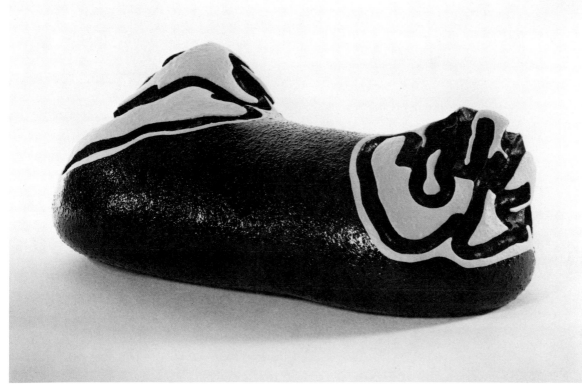

Green and Cream, 1967
Lacquer and acrylic on stoneware, 3½ x 4 x 9"
(8.9 x 10.2 x 22.9 cm)
Collection of the artist

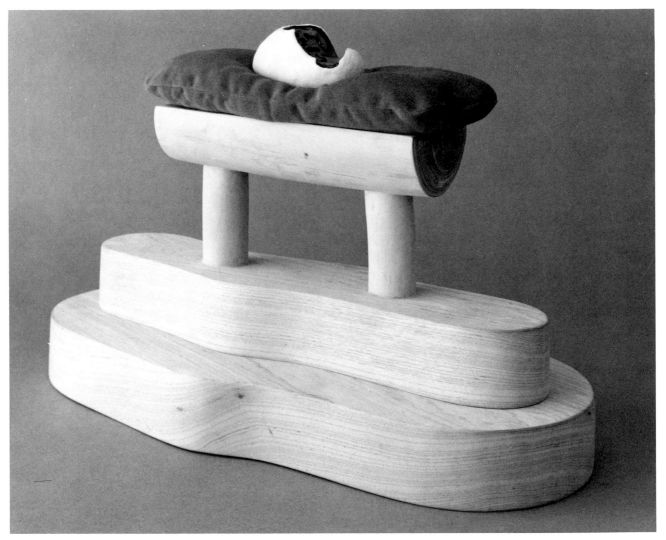

Specimen B1520.06, 1964
Lacquer and acrylic on stoneware with fabric and wood
construction, 12 x 15½ x 7″ (30.5 x 39.4 x 17.8 cm)
Collection of the artist

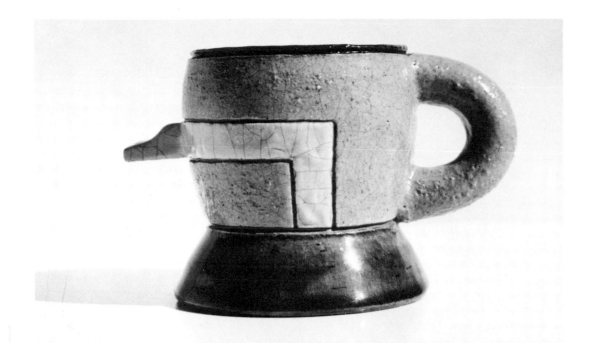

Nose Cup, 1968
Glazed earthenware, 3 x 3 x 5″ (7.6 x 7.6 x 12.7 cm)
Collection of Frank Stella

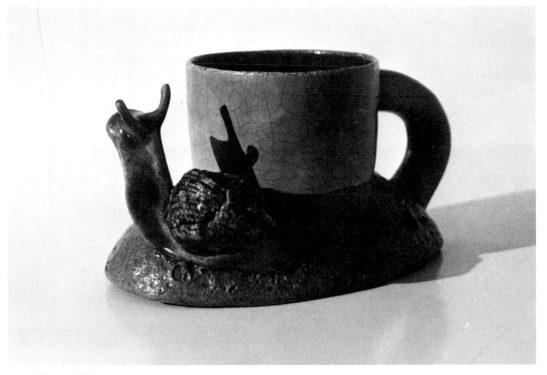

Snail Cup, 1968
Glazed earthenware, 2⅝ x 3 x 4½″ (6.7 x 7.6 x 11.4 cm)
Collection of the artist

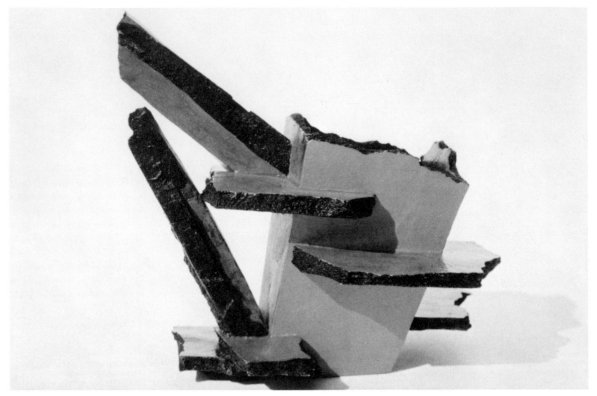

Slate Cup, 1972
Acrylic on earthenware, 5½ x 6 x 5″ (14 x 15.2 x 12.7 cm)
Collection of Edwin Janss

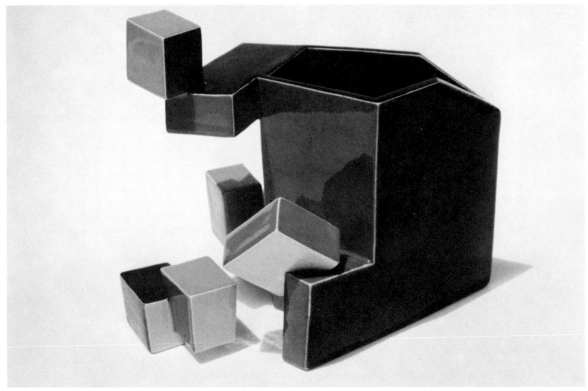

Untitled Cup, 1974
Glazed earthenware, two parts; 4¾ x 5¼ x 4″ (12.1 x 13.3
x 10.2 cm) and 1¼ x 1⅛ x 2″ (3.2 x 2.9 x 5.1 cm)
Collection of the artist

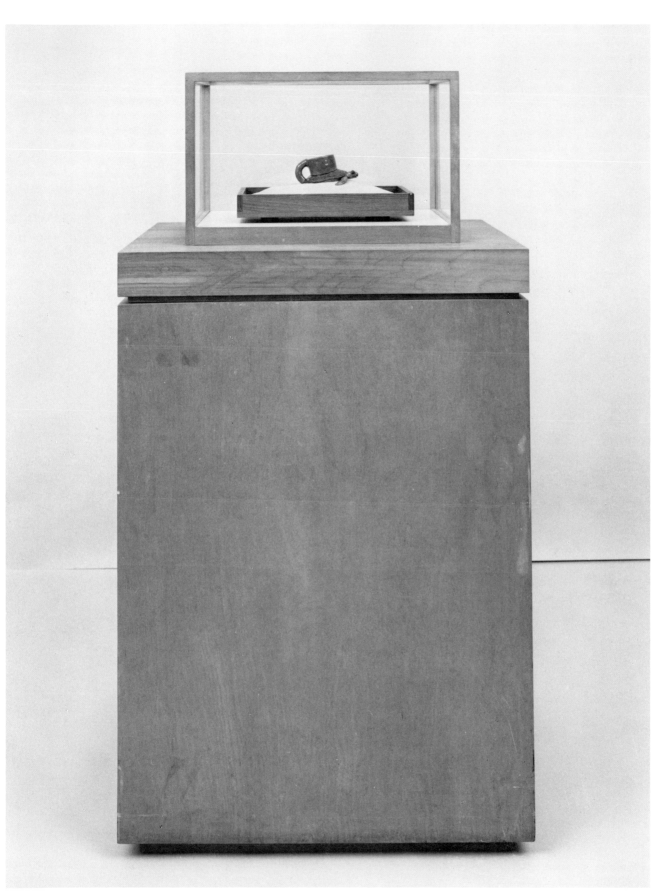

Blind Sea Turtle Cup, 1968
Glazed earthenware with sand, glass and wood
construction, 63½ x 29½ x 32″
(161.3 x 74.9 x 81.3 cm) overall
The Museum of Modern Art, New York; Fractional gift of
Charles Cowles

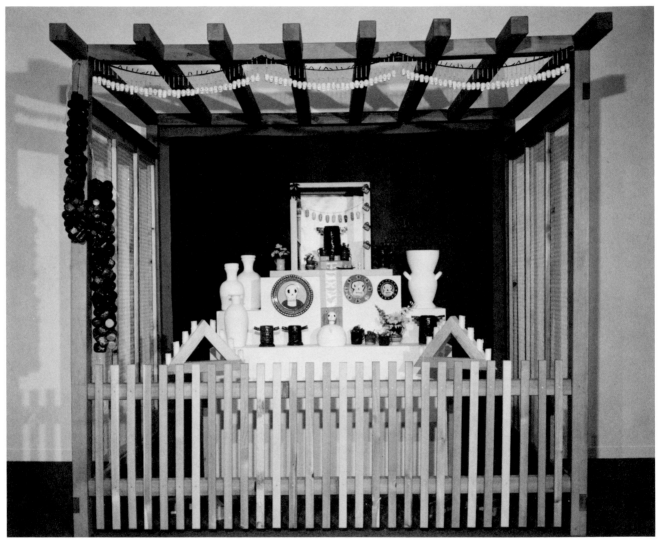

Death Shrine 3, 1972–78
Glazed earthenware, wood construction, and mixed media
accessories, 101 x 108 x 72″ (256.5 x 274.3 x 182.9 cm) overall
The Art Institute of Chicago; Restricted gift of
Andrew and Betsy Rosenfield

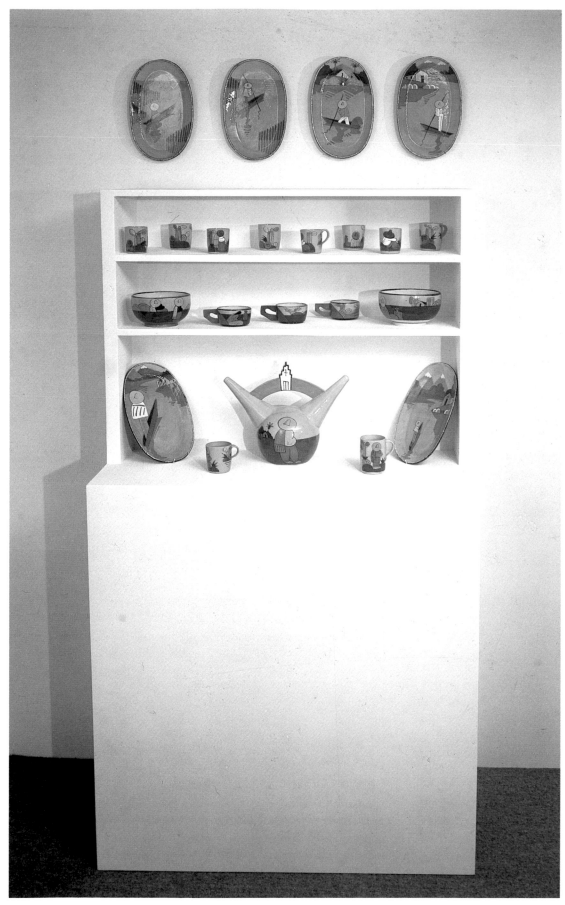

Town Unit 1, 1972–77
Glazed earthenware and wood cabinet, 70 x 39 x 20″
(177.8 x 99.1 x 50.8 cm)
Private collection

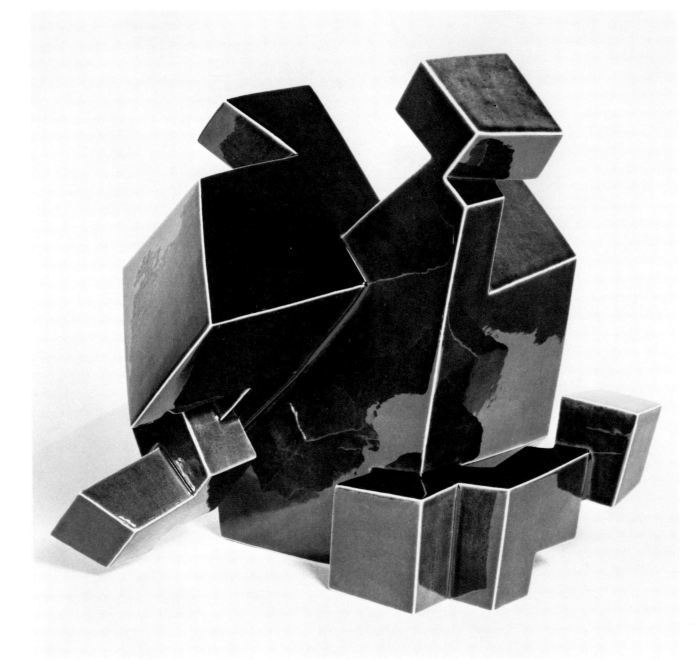

Israeli Sculpture, 1979
Glazed earthenware, 7 x 6¼ x 5½″ (17.8 x 15.9 x 14)
Private collection

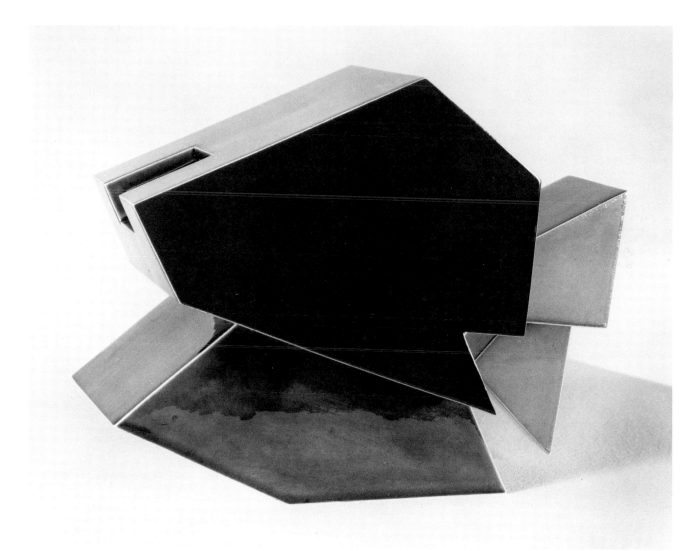

Tail Piece, 1980
Glazed earthenware, 6¼ x 8 x 5½″ (15.9 x 20.3 x 14 cm)
Willard Gallery, New York

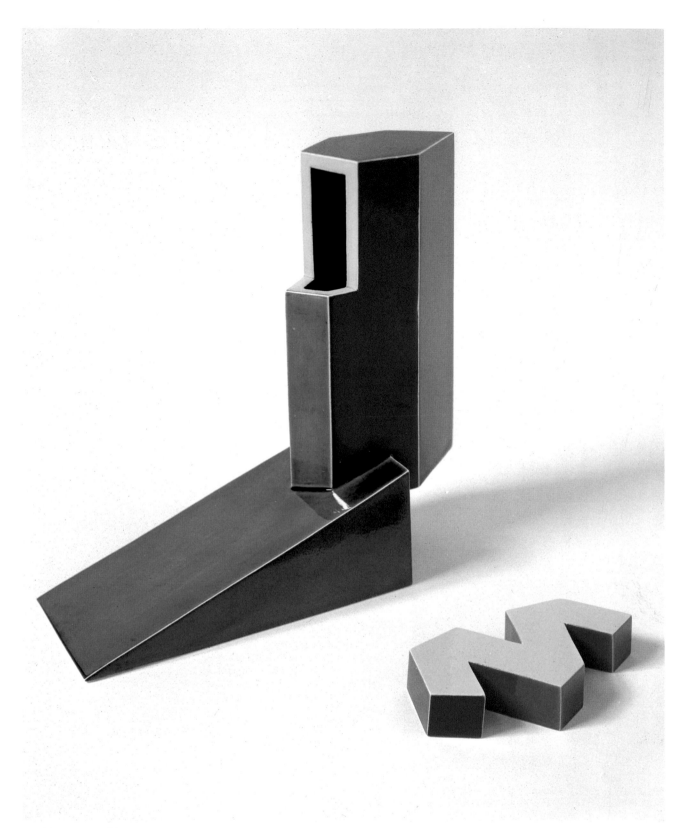

De Chirico's Bathhouse, 1980
Glazed earthenware, two parts; 8¼ x 8¹⁵⁄₁₆ x 3¹⁄₁₆″
(21 x 21.1 x 7.8 cm) and ¾ x 4⅜ x 2½″ (1.9 x 11.1 x 6.4 cm)
Dallas Museum of Fine Arts; Foundation for the Arts
Collection, Anonymous gift

Robert Arneson

Smorgi-Bob, The Cook (1971), one of Robert Arneson's earliest large-scale works, is the culmination of a group of pieces done in the late 1960s that depicted plates, dishes, foods, and household items. It features Arneson in a chef's hat at the head of an illusionistically receding table laden with banquet foods—a celebration of ceramics and of the artist as the cook who makes it all. In addition to the strongly autobiographical references, the work introduces a number of characteristics of his later work—large-scale pieces composed of multiple units assembled like a puzzle, illusionistic space and false perspective, and references to art making and art history.

In 1972 Arneson began a series of self-portraits executed in unglazed terra-cotta. This type of ceramic material reinforced the intentional allusion to ancient Roman bust portraits and herms. In *Classical Exposure* (1972), Arneson chews a cigar—atop a classical column from which exposed genitals protrude and feet appear under draped rings at the base. *Fragment of Western Civilization* (1972), originally planned as a full-scale portrait in hand-built bricks, developed into an installation of toppled fragments of Arneson's head and body that is reminiscent of an archaeological dig. The punning title suggests additional speculation on what Arneson called "the fall of man" and "the breakdown of culture." The broken bricks strewn around the floor all bear autobiographical stampings (where a brick manufacturer's name would otherwise appear) including: "Arneson," "Bob," "Clay," "Benicia" (Arneson's birthplace), "9-4-1930" (Arneson's birthdate), "Virgo," and miscellaneous profanities.

Current Event (1973), *The Palace at 9 A.M.* (1974), and *Casualty in the Art Realm* (1979) are all large-scale pieces made of multiple, brightly glazed units individually hand-built and fired. The multi-unit construction allows for a scale that size limitations of a kiln would prohibit were they single-unit works. *Current Event* depicts Arneson swimming in an arrow-shaped current of high-gloss wet-looking glazes of blue and green

that contrast sharply with the dryness of the unglazed terra-cotta head and arm—like a rock in a stream. The configuration of the piece on the floor amplifies the movement and thrust of the activity depicted in the same way that the puddling effect of the clear glazes mimics the characteristics of water. A similar sense of movement is apparent in *The Palace at 9 A.M.*— a ten-foot-wide rendering of Arneson's former Alice Street home in Davis, California, seen in pictorial perspective as the house and street slope down a graded platform. The title makes a direct reference to Alberto Giacometti's *The Palace at 4 A.M.* (1932–33), but as Arneson remarks, "it's a little later." A more updated art-historical reference appears in *Casualty in the Art Realm*. Arneson's works often display his handprints or footprints stamped into wet clay. Here, however, it is an impression of his entire body that appears in this gigantic, floor-based artist's palette surrounded by numerous quotes, misquotes, and clichés of art stamped into the clay. The casualty, in this case, has dual references—in particular to Arneson, who was physically pushed into the wet clay, and in general to the artist, who is subjected to the vagaries of art criticism.

Self-portraits have been a constant, ongoing exploration for Arneson, and the busts begun in 1976 are increasingly ambitious in scale and expression. They almost doubled the scale of his earlier busts, allowing him greater range of characterization, coloration, and experimen-tation. Arneson uses—he says "abuses"—his likeness to develop a total characterization of emotion and reaction that captures a frozen moment in time. He describes these portraits as a type of "robust assassination." These works exist on multiple levels of meaning and have titles that are clues or anti-clues to narrative references. *Cheek* (1976) refers both to his bandaged cheek and to Arneson's self-characterization as having the "cheek" to even attempt such a portrait. *Whistling in the Dark* (1976) acknowledges the facial action in a darkened, unglazed clay body, and also comments

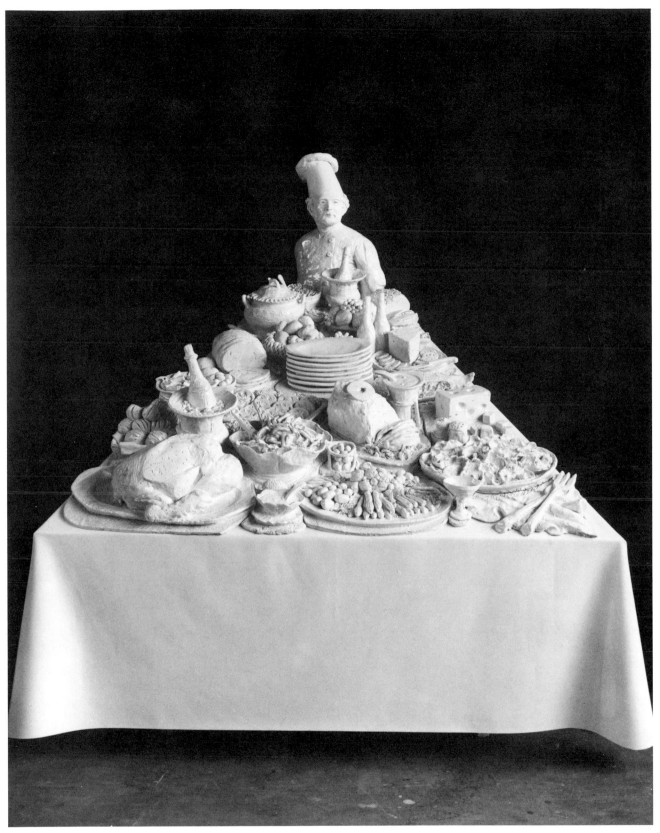

Smorgi-Bob, The Cook, 1971
Glazed earthenware on vinyl-covered wood base,
72 x 60 x 60″ (182.3 x 152.4 x 152.4 cm)
San Francisco Museum of Modern Art; Purchase

on the uncertainty that often accompanies an artist's exploration of ideas and forms. *Nasal Flat* (1981) is Arneson's largest self-portrait—over three feet high—and emphasizes his facility and dexterity as a painter and draftsman. The work reverses traditional sculptural concerns by physically and conceptually pushing a three-dimensional piece toward two dimensions. Arneson has enhanced the flatness of the form and overall color application by applying a network of interwoven and layered washes, lines, and spatters of color that do not always correspond to the modeling or dimensionality of the facial features.

Arneson also portrayed friends, colleagues, and admired artists—the list includes Peter Voulkos, David Gilhooly, Vincent van Gogh, Marcel Duchamp, and Francis Bacon. *Roy of Port Costa* (1976), depicting the artist Roy De Forest, is the first non-self-portrait done in the enlarged scale. William T. Wiley is humorously presented as *Mr. Unatural* (1978), a frequent character in Wiley's own paintings and drawings. Picasso also makes an appearance as *Pablo Ruiz with Itch* (1980). The artist, shown scratching his own back, is a collage of art-historical references. The head is based on Picasso's *Self-Portrait* (1907), the posture and angle of the arm taken from *Les Demoiselles d'Avignon* (1907), and the pedestal, integral to the piece, is designed and decorated with characteristic Cubist features—the double curls at the top of the pedestal mimic Picasso's portraits of women with paired eyes on the same side of the nose.

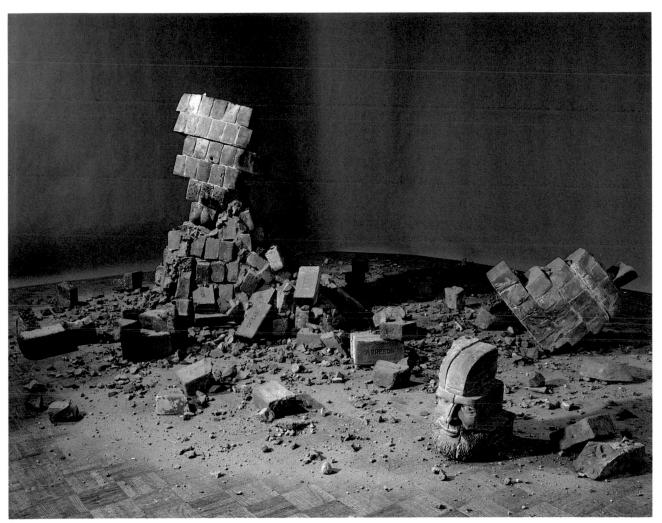

Fragment of Western Civilization, 1972
Terra-cotta, 41 x 120 x 120″ (104.1 x 304.8 x 304.8 cm)
overall
Australian National Gallery, Canberra

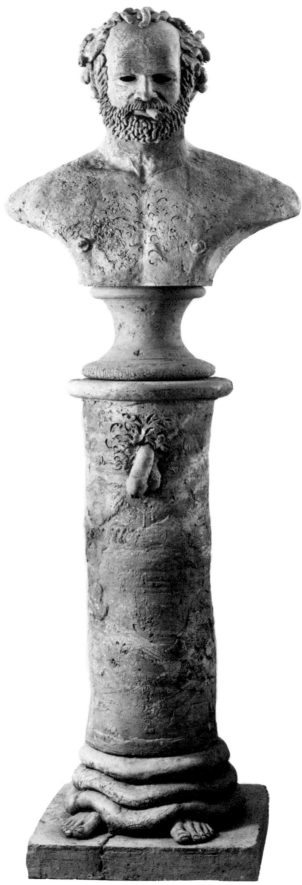

Classical Exposure, 1972
Terra-cotta, 96 x 36 x 24″ (243.8 x 91.4 x 61 cm)
Collection of Mr. and Mrs. Daniel Fendrick

Robert Arneson

Born in Benicia, California, 1930
Studied at College of Marin, Kentfield, California (1949–51);
California College of Arts and Crafts, Oakland (B.A., 1954);
Mills College, Oakland (M.F.A., 1958)
Taught at Mills College, Oakland (1960–62); University of
California, Davis (1962–present)
Lives in Benicia, California

Selected Solo Exhibitions

1960 Oakland Art Museum, California

1963 Richmond Art Center, California

1964 Cellini Gallery, San Francisco
 Allan Stone Gallery, New York

1968 Galeria Del Sol, Santa Barbara, California,
"Arneson: Ceramics and Drawings." Exhibition brochure
 Hansen Fuller Gallery, San Francisco

1969 Hansen Fuller Gallery, San Francisco
 Allan Stone Gallery, New York

1970 Hansen Fuller Gallery, San Francisco

1971 Hansen Fuller Gallery, San Francisco

1972 Hansen Fuller Gallery, San Francisco

1973 Hansen Fuller Gallery, San Francisco

1974 Hansen Fuller Gallery, San Francisco
 Museum of Contemporary Art, Chicago, "Robert
Arneson" (traveled to San Francisco Museum of Modern
Art). Exhibition catalogue, texts by Stephen Prokopoff and
Suzanne Foley

1975 Allan Frumkin Gallery, New York
 Hansen Fuller Gallery, San Francisco
 Ruth S. Schaffner Gallery, Los Angeles

1976 Fendrick Gallery, Washington, D.C.
 Hansen Fuller Gallery, San Francisco
 Memorial Union Art Gallery, University of
California, Davis

1977 Allan Frumkin Gallery, New York, "Seven
Monumental Heads." Exhibition brochure
 Hansen Fuller Gallery, San Francisco

1978 Allan Frumkin Gallery, Chicago

1979 Allan Frumkin Gallery, New York, "Robert
Arneson: Heroes and Clowns." Exhibition catalogue, text
by Michael McTwigan
 Moore College of Art Gallery, Philadelphia, "Robert
Arneson: Self-Portraits." Exhibition catalogue, text by Beth
Coffelt

1980 Fendrick Gallery, Washington, D.C.
 Frumkin and Struve Gallery, Chicago
 Hansen Fuller Goldeen Gallery, San Francisco

1981 Allan Frumkin Gallery, New York, "Robert
Arneson: New Ceramic Sculpture." Exhibition catalogue,
text by Michael McTwigan

Selected Group Exhibitions

1962 Seattle World's Fair, "Adventures in Art." Exhibition
catalogue, text by Gervais Reed

1963 Museum of Contemporary Crafts of the American
Crafts Council, New York, "Creative Casting." Exhibition
catalogue, text by Paul J. Smith
 The Oakland Museum, California (at Kaiser Center),
"California Sculpture"

1964 Cellini Gallery, San Francisco, "Group Show"

1966 Museum West, American Craftsmen's Council, San
Francisco, "Ceramics from Davis"
 Reed College, Portland, Oregon, "California Ceramic
Sculpture." Exhibition catalogue, text by Erik Gronborg

1967 San Francisco Museum of Art, "Arts of San
Francisco"
 University Art Museum, University of California,
Berkeley, "Funk." Exhibition catalogue, text by Peter Selz

1968 The Museum of Modern Art, New York, "Dada,
Surrealism, and Their Heritage" (traveled to Los Angeles
County Museum of Art; The Art Institute of Chicago).
Exhibition catalogue, text by William S. Rubin

1969 Institute of Contemporary Art of The University of
Pennsylvania, Philadelphia, "The Spirit of the Comics."
Exhibition catalogue, text by Joan C. Siegfried
 National Collection of Fine Arts, Smithsonian
Institution, Washington, D.C., "Objects: USA—The
Johnson Collection of Contemporary Crafts" (traveled
nationally). Exhibition catalogue, text by Lee Nordness
 Whitney Museum of American Art, New York,
"Human Concern/Personal Torment: The Grotesque in
American Art." Exhibition catalogue, text by Robert M.
Doty

1970 Whitney Museum of American Art, New York, "1970
Annual Exhibition: Contemporary American Sculpture."
Exhibition catalogue

1971 Museum of Contemporary Crafts of the American
Crafts Council, New York, "Clayworks: 20 Americans."
Exhibition catalogue, text by Paul J. Smith
 The National Museum of Modern Art, Kyoto, Japan,
"Contemporary Ceramic Art: Canada, USA, Mexico and
Japan" (traveled to National Museum of Modern Art,
Tokyo). Exhibition catalogue, text by Kenji Suzuki

1972 Lowe Art Museum, University of Miami, Coral
Gables, Florida, "Phases of New Realism." Exhibition
catalogue, texts by John J. Baratte and Paul E. Thompson
 San Francisco Museum of Art, "A Decade of
Ceramic Art, 1962–1972: From the Collection of Professor
and Mrs. R. Joseph Monsen." Exhibition catalogue, text by
Suzanne Foley

1974 Lang Art Gallery, Scripps College, Claremont, California, "The Fred and Mary Marer Collection: 30th Annual Ceramics Exhibition." Exhibition catalogue, texts by Jim Melchert and Paul Soldner

University of Illinois at Urbana-Champaign, "Contemporary American Painting and Sculpture, 1974." Exhibition catalogue, texts by James R. Shipley and Allen S. Weller

Whitney Museum of American Art, New York, Downtown Branch, "Clay." Exhibition catalogue, text by Richard Marshall

1975 Fendrick Gallery, Washington, D.C., "Clay USA." Exhibition catalogue, text by Daniel Fendrick

National Collection of Fine Arts, Smithsonian Institution, Washington, D.C., "Sculpture: American Directions, 1945–1975." Exhibition catalogue

1976 San Francisco Museum of Modern Art, "Painting and Sculpture in California: The Modern Era" (traveled to National Collection of Fine Arts, Smithsonian Institution, Washington, D.C.). Exhibition catalogue, text by Henry T. Hopkins

1977 William Hayes Ackland Art Center, University of North Carolina, Chapel Hill, "Contemporary Ceramic Sculpture." Exhibition catalogue, text by Louise Hobbs

Laguna Beach Museum of Art, California, "Illusionistic Realism." Exhibition catalogue

Renwick Gallery of the National Collection of Fine Arts, Smithsonian Institution, Washington, D.C., "The Object as Poet." Exhibition catalogue, text by Rose Slivka

1978 Everson Museum of Art, Syracuse, New York, "Nine West Coast Clay Sculptors, 1978" (traveled to The Arts and Crafts Center of Pittsburgh). Exhibition catalogue, texts by Margie Hughto and Judy S. Schwartz

1979 Everson Museum of Art, Syracuse, New York, "A Century of Ceramics in the United States, 1878–1978" (traveled to Renwick Gallery of the National Collection of Fine Arts, Smithsonian Institution, Washington, D.C.) Exhibition catalogue, texts by Garth Clark and Margie Hughto

Stedelijk Museum, Amsterdam, "West Coast Ceramics." Exhibition catalogue, text by Rose Slivka

Whitney Museum of American Art, New York, "1979 Biennial Exhibition." Exhibition catalogue

1980 Norman Mackenzie Art Gallery, University of Saskatchewan, Regina, "The Continental Clay Connection." Exhibition catalogue

San Diego Museum of Art, California, "Sculpture in California, 1975–80." Exhibition catalogue, text by Richard Armstrong

San Francisco Museum of Modern Art, "Twenty American Artists." Exhibition catalogue, text by Henry T. Hopkins

1981 American Craft Museum, New York, "The Clay Figure"

Museum of Art, Rhode Island School of Design, Providence, "Clay." Exhibition catalogue

University of Iowa Museum of Art, Iowa City, "Centering on Contemporary Clay: American Ceramics from the Joan Mannheimer Collection." Exhibition catalogue, text by Jim Melchert

Selected Articles and Reviews

Elizabeth M. Polley, "Robert Arneson: Richmond Art Center," *Artforum*, 2 (January 1964), p. 9.

Donald Judd, "Review: Robert Arneson," *Arts Magazine*, 39 (January 1965), p. 69.

David Zack, "The Ceramics of Robert Arneson," *Craft Horizons*, 30 (January/February 1970), pp. 36–41, 60–61.

Robert Arneson, *My Head in Ceramics* (Davis, Calif.: Robert Arneson, 1972).

Alan R. Meisel, "Letter from San Francisco: Robert Arneson," *Craft Horizons*, 32 (February 1972), pp. 44–45.

Fred Ball, "Arneson," *Craft Horizons*, 34 (February 1974), pp. 29–30, 63–65.

Dennis Adrian, "Robert Arneson's Feats of Clay," *Art in America*, 62 (September/October 1974), pp. 80–83.

Alfred Frankenstein, "Of Bricks, Pop Bottles, and a Better Mousetrap," *San Francisco Sunday Examiner & Chronicle, This World Magazine*, October 6, 1974, p. 37.

Cecile N. McCann, "About Arneson, Art and Ceramics," *Artweek*, October 26, 1974, pp. 1, 6–7.

Phyllis Derfner, "New York Letter," *Art International*, 19 (April 1975), p. 58.

Allen Ellenzweig, "Review: Robert Arneson," *Arts Magazine*, 49 (April 1975), p. 14.

C. E. Licka, "A Prima Facie Sampler: A Case for Popular Ceramics, I." *Currant*, 1 (August/September 1975), pp. 30–34, 60.

C. E. Licka, "A Prima Facie Sampler: A Case for Popular Ceramics, II," *Currant*, 1 (October/November 1975), pp. 8–13, 50–53.

Alfred Frankenstein, "The Ceramic Sculpture of Robert Arneson: Transforming Craft into Art," *Art News*, 75 (January 1976), pp. 48–50.

Gwen Stone, "Robert Arneson in Conversation with Gwen Stone," *Visual Dialog*, 2 (September/October/November 1976), pp. 5–8.

Hilton Kramer, "Sculpture: From Boring to Brilliant," *New York Times*, May 15, 1977, p. D27.

Sarah McFadden, "Robert Arneson at Frumkin," *Art in America*, 65 (July/August 1977), p. 100.

Jeff Perrone, "New York Reviews," *Artforum*, 16 (September 1977), p. 75.

Beth Coffelt, "Delta Bob and Captain Ace," *San Francisco Sunday Examiner & Chronicle, California Living Magazine*, April 8, 1979, pp. 40–47.

Knute Stiles, "San Francisco: Robert Arneson at Hansen Fuller Goldeen," *Art in America*, 68 (September 1980), p. 132.

Vivien Raynor, "Art: Ceramic Caricatures by Robert Arneson," *New York Times*, May 8, 1981. p. C18.

Grace Glueck, "Art People: A Partner to His Kiln," *New York Times*, May 15, 1981, p. C21.

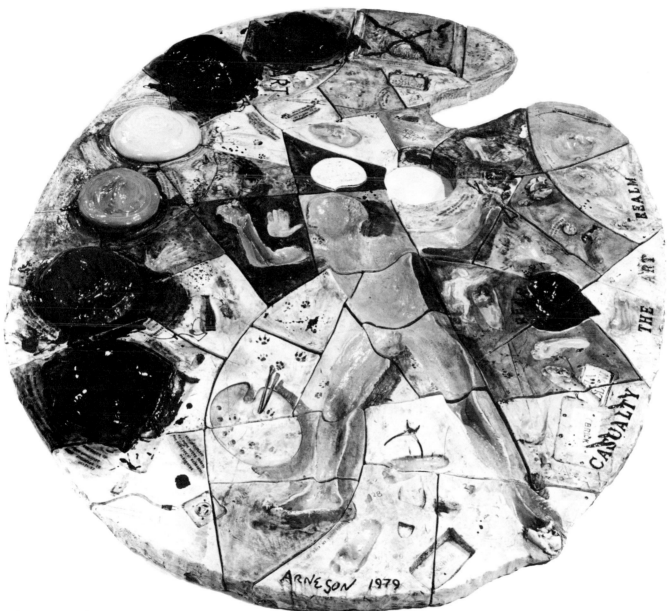

Casualty in the Art Realm, 1979
Glazed earthenware, 8 x 97 x 132″ (20.3 x 246.4 x 335.3 cm)
Hansen Fuller Goldeen Gallery, San Francisco

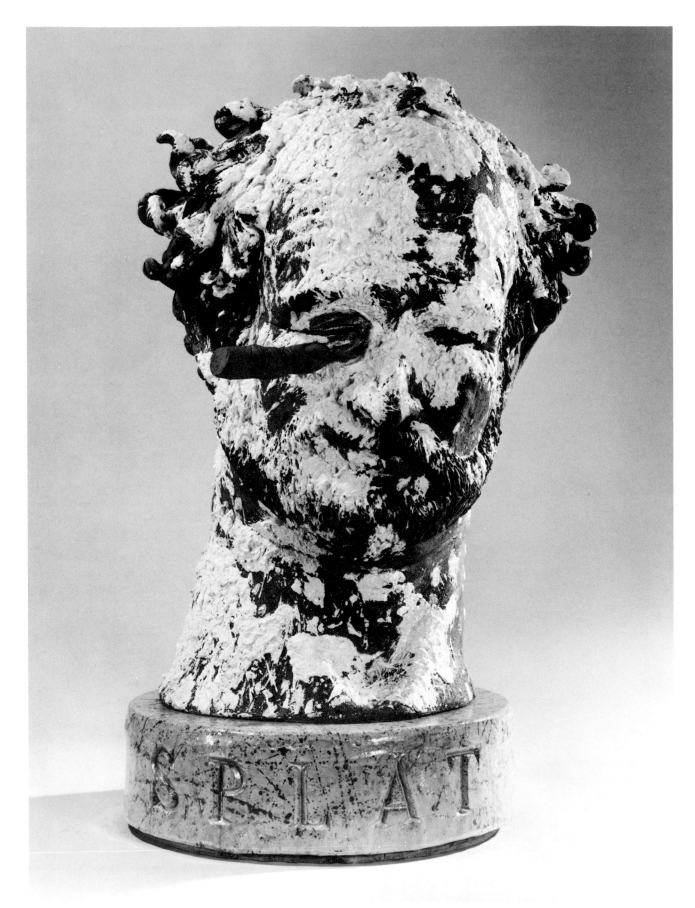

Splat, 1978
Terra-cotta and glazed earthenware, 33 x 22 x 22″
(83.8 x 55.9 x 55.9 cm)
Collection of the artist, courtesy Hansen Fuller Goldeen
Gallery, San Francisco

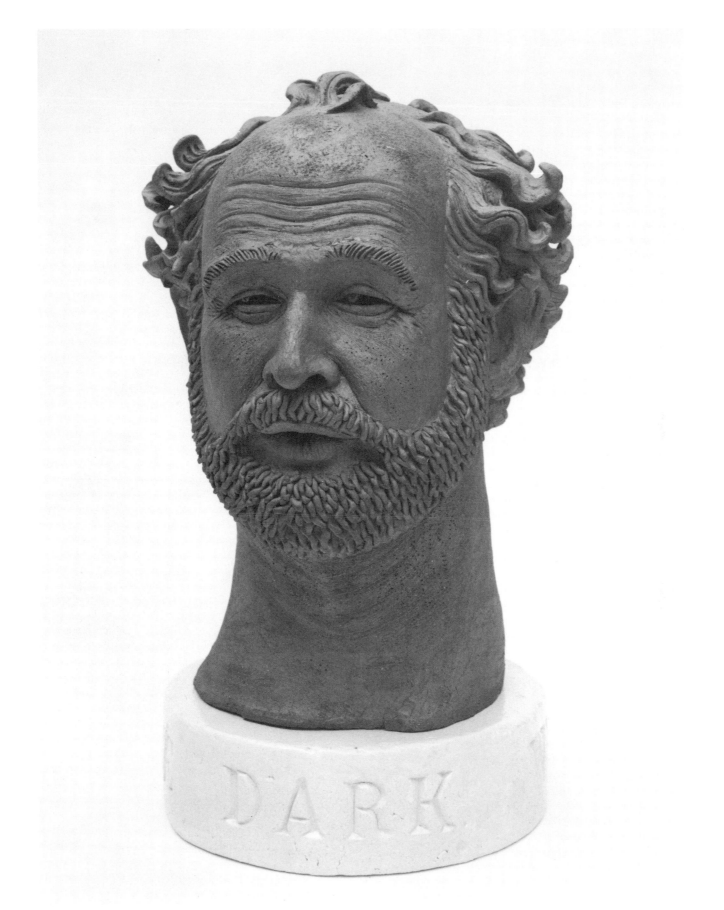

Whistling in the Dark, 1976
Terra-cotta and glazed earthenware, 35½ x 20 x 20″
(90.2 x 50.8 x 50.8 cm)
Whitney Museum of American Art, New York; Gift of
Sydney and Frances Lewis 77.37

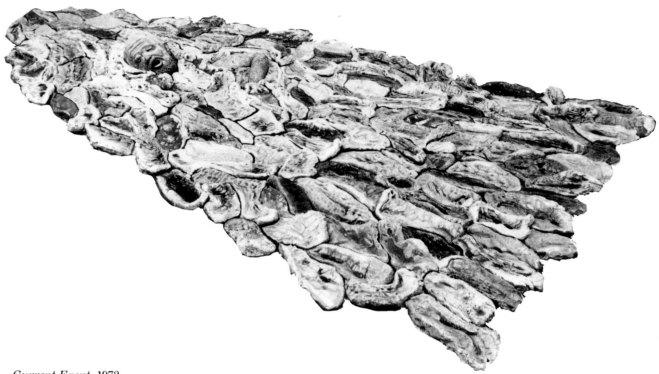

Current Event, 1973
Terra-cotta and glazed earthenware, 9½ x 173 x 84″
(24.1 x 439.4 x 213.4 cm)
Stedelijk Museum, Amsterdam

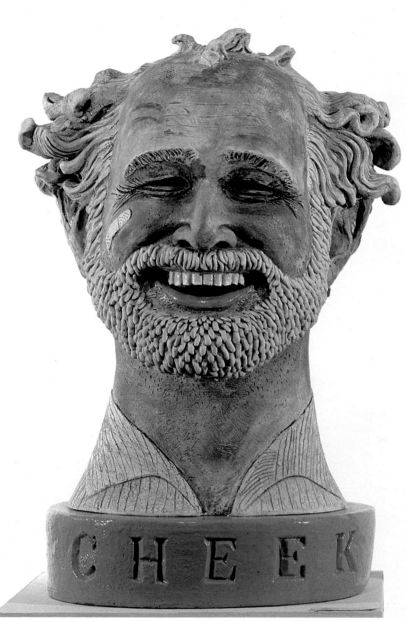

Cheek, 1976
Glazed earthenware, 34 x 21 x 21″ (86.4 x 53.3 x 53.3 cm)
Collection of Sydney and Frances Lewis

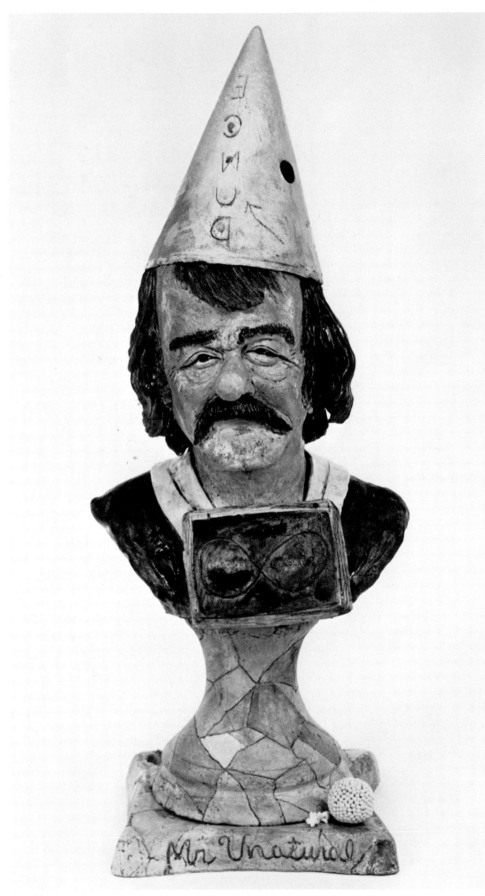

Mr. Unatural, 1978
Glazed earthenware, 53½ x 22 x 22″ (135.9 x 55.9 x 55.9 cm)
Private collection

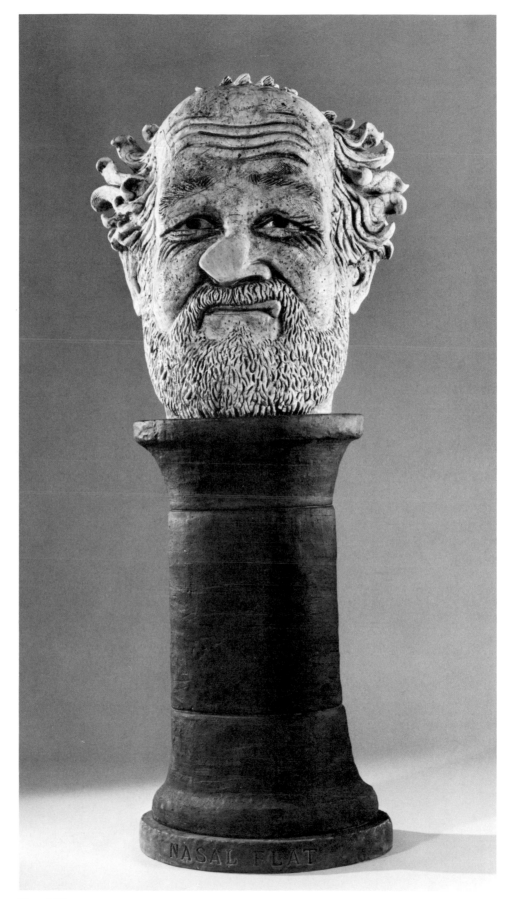

Nasal Flat, 1981
Glazed earthenware, two parts; bust 37¼ x 36½ x 18″
(95.9 x 92.7 x 45.7 cm), pedestal 46⅜ x 28 x 20½″
(117.8 x 71.1 x 52.1 cm)
Allan Frumkin Gallery, New York

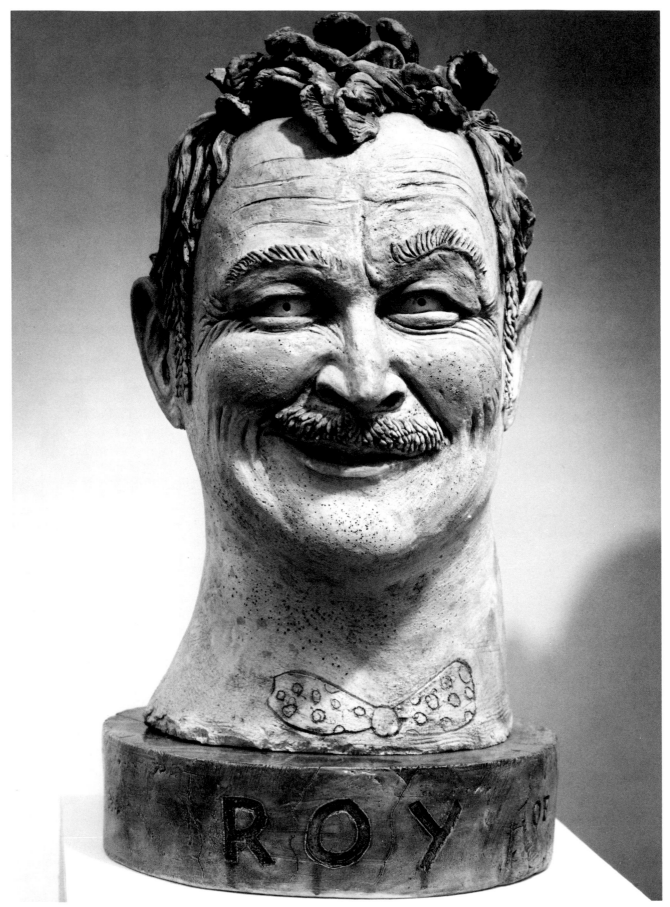

Roy of Port Costa, 1976
Glazed earthenware, 34 x 18¾ x 18¾″ (86.4 x 47.6 x 47.6 cm)
Collection of Sydney and Frances Lewis

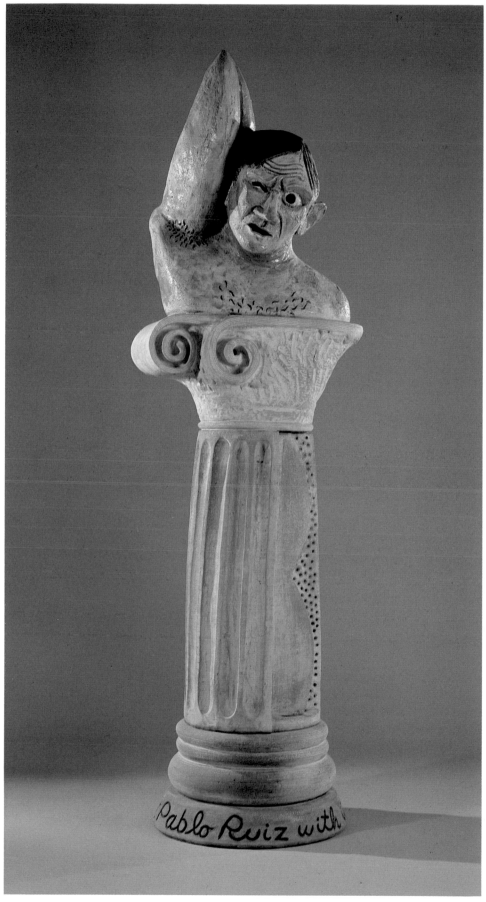

Pablo Ruiz with Itch, 1980
Glazed earthenware, two parts; bust 29½ x 22 x 22″
(74.9 x 55.9 x 55.9 cm), pedestal 58 x 27½ x 15″
(147.3 x 69.8 x 38.1 cm)
Allan Frumkin Gallery, New York

David Gilhooly

Frogs entered David Gilhooly's work in the late 1960s and have since multiplied into a large and complex population which often mimics, parallels, and comments on human civilization. Gilhooly employs frog images in outlandish circumstances and costumes—which often have counterparts in the artist's own world—to advance and elaborate his imaginary sculptural narrative of frog history, customs, and characters.

An early group of works concerns itself with some of the major personalities of the frog world. *Artemis, First Fertility Goddess* (1971) is one of the earliest frog deities to be created. She is seen with a number of fat animals on her head, necklaces of brightly colored vegetables, and a double row of breasts. Artemis introduces the unique aspect of Gilhooly's frog culture—the recurring and abundant use of food. His frogs do not eat food (because they gain nourishment directly through their skin, from the sun and from microorganisms in the air), but use food for decoration, amusement, and artistic expression. Frogs also have the capability of transforming themselves into various guises and food types to suit many implausible situations and sculptural requirements. *The Miracle of Production* (1972) is an announcement for a frog movie production about the processing of raw foods into packaged goods. It depicts Osiris, the male fertility god and frog movie star, wrapped mummy-like in woven pastry strips with an arc spanning the body. On one side of the arc raw foods appear, commercial products on the other. Osiris' fertility is displayed in the rows of colorful vegetables that sprout from his body. The Honey Sisters, cohorts of Osiris in the frog pantheon, make a personal appearance to bolster farm growth in *The Honey Sisters Do a Garden Blessing* (1973). Another piece, *Drowning in the Consumer Market* (1973–74) is also the title of a moralistic frog movie—like *The Miracle of Production*—about overconsumption and hoarding. It shows Frog Fred, a contemporary manifestation of Osiris, engulfed by colorful packages and kitchen appliances.

Gilhooly takes advantage of the special characteristics and properties of the clay material, which are often analogous in texture, consistency, and color to what is being depicted. He maintains a close relationship between the material and the subject matter: wet clay mimics the malleability of dough; shiny and colorful glazes substitute for frostings and vegetable skins; hardened clay can be carved like stone and wood; clay, vegetables, and frogs share associations with earth and water. In an ironic and perverse way, Gilhooly is also making reference to the kitschy, cheap and gaudily colored dime-store or homemade animals and figurines that ceramic sculpture often strives to separate itself from.

A group of works completed in 1975 displays Gilhooly's use of clay for its stone-like qualities—they are carved when the clay is in a leather-hard state. Depicting historical events in frog civilization, they appear as commemorative and memorial-like objects. *The Ten Commandments* (1975) are two tablets embedded in rock that present in bas-relief pictographs some vague and mysterious canons of Frog Moses' law. Commandment VI, for instance, presents a chorus line of different animals that symbolizes "All Races Dance Together." *Frog Fred's Prayer Stela: The Presentation of His New Work* (1975), again in bas-relief, records the progress of his work: the Honey Sisters give Frog Fred inspiration, in the form of a bunch of bananas (panel 1); tradesmen bring Frog Fred needed goods—pastry, tobacco, automobiles (panels 2 and 3); the presentation of the finished work, *The Ten Commandments*, to applauding frogs (panel 4); and the rewards of work in the form of a humanoid collector and a frog art critic (panel 5). The monumental *Many Lives of Frog Fred Memorial Obelisk* (1975) shows, in ascending order, all the various physical and spiritual manifestations of Frog Fred: as a consumer, in his animal and occupational guises, to his ultimate metamorphosis into angelic forms.

As in other cultures, the frog culture also has important historical and religious figures, such as *Frog Victoria, Mao Tse Toad*, and the erotic

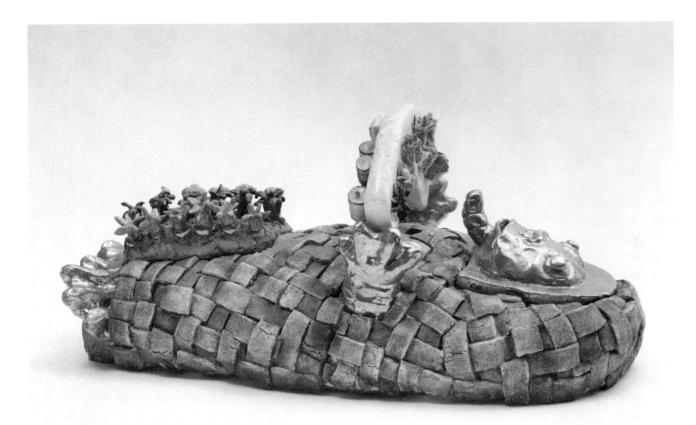

The Miracle of Production, 1972
Glazed earthenware, 13½ x 14 x 28″ (34.3 x 35.6 x 71.1 cm)
Collection of David Bourdon

Tantric Frog Buddha Camping Out (all 1976). Surfaced in highly reflective gold glaze, this full and rounded Tantric Frog Buddha acts as an electric power generating station for the frog world, deriving his energy from sexual stimulation provided by the dancing temple girls seen on the base cavorting with Boy Scouts and forest rangers while "camping out."

In the frog world, the body is mutable and can change for any situation or occasion. This allows for great flexibility both in the narrative of the frog civilization and in sculptural expression. As a result, a *Frog de Kooning with Cubist Pigeons* (1976), displaying colorful expressionistic brushstrokes, can bring Fine Art to the frog world, and the frog Pastry God can metamorphose himself into the *Count of Crumbs Dressed for His Bar Mitzvah* (1974), exchanging his amphibious skin for one of cupcakes, donuts, bagels, pizza, and cookies. Another popular inhabitant of the frog world is the merfrog, a frog with a fish tail. These amicable creatures live in the water and befriend other aquatic animals, as in *Merfrog and Her Pet Fish* (1976). The many strange and absurd figures that populate Gilhooly's work uphold the frog world principle that the spirit rather than the body is the essential thing.

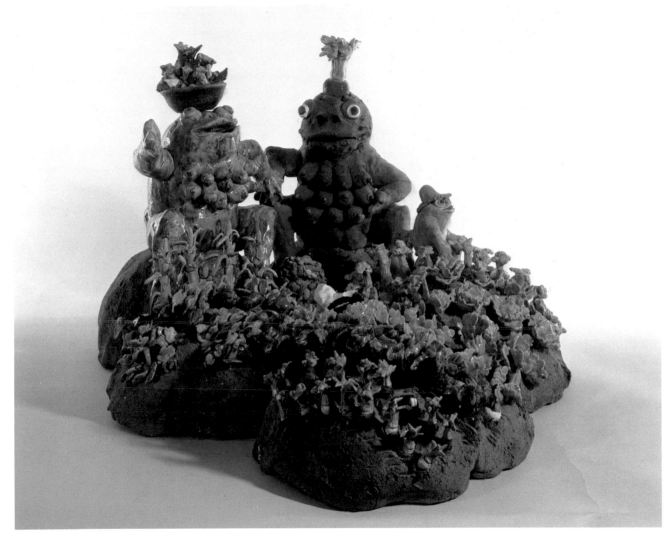

The Honey Sisters Do a Garden Blessing, 1973
Glazed earthenware, 19 x 33 x 26″ (48.3 x 83.8 x 66 cm)
San Francisco Museum of Modern Art; William L. Gerstle
Collection, William L. Gerstle Fund Purchase

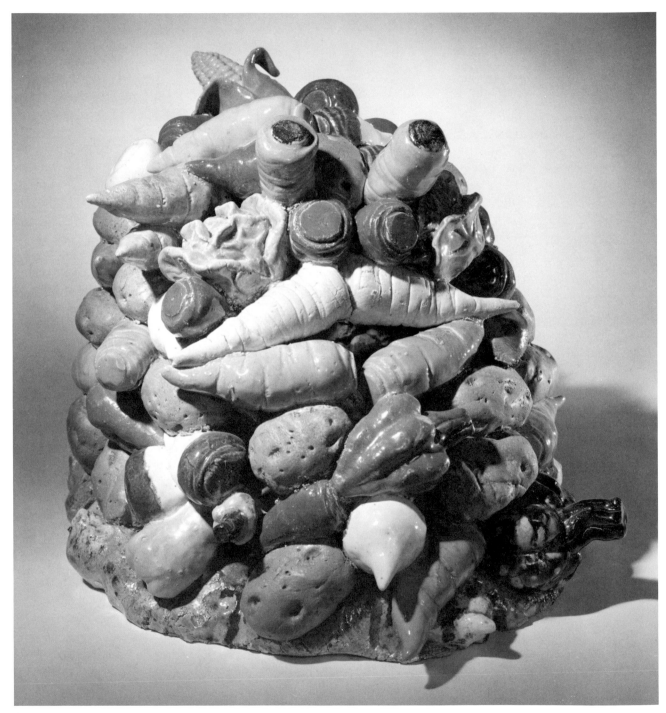

Osiris Vegefrogged, 1973
Glazed earthenware, 45 x 17 x 17″ (114.3 x 43.2 x 43.2 cm)
Philadelphia Museum of Art; Bloomfield-Moore Fund

David Gilhooly

Born in Auburn, California, 1943
Studied at University of California, Davis (B.A., 1965; M.A., 1967)
Taught at San Jose State College, California (1967–69); University of Saskatchewan, Regina (1969–71); York University, Toronto (1971–75, 1976–77); University of California, Davis (1975–76, 1980); Sacramento State College, California (1978–79)
Lives in Davis, California

Selected Solo Exhibitions

1965 Richmond Art Center, California

1966 University of California, Davis

1969 Art Department Gallery, Sonoma State College, Rohnert Park, California
 M. H. de Young Memorial Museum, San Francisco

1970 Hansen Fuller Gallery, San Francisco

1971 Candy Store Gallery, Folsom, California
 Hansen Fuller Gallery, San Francisco
 Martha Jackson Gallery, New York

1972 Art Gallery, York University, Toronto, "Gifts from the Frog World" (traveled to The Robert McLaughlin Gallery, Oshawa, Ontario). Exhibition catalogue, text by Gary Michael Dault

1973 Hansen Fuller Gallery, San Francisco

1974 and/or Gallery, Seattle
 Hansen Fuller Gallery, San Francisco

1975 Candy Store Gallery, Folsom, California
 Galerie Martal, Montreal
 Hansen Fuller Gallery, San Francisco

1976 Hansen Fuller Gallery, San Francisco
 Museum of Contemporary Art, Chicago, "David Gilhooly." Exhibition catalogue, texts by Judith R. Kirshner and Stephen Prokopoff
 The Vancouver Art Gallery, "My Beaver and I...." Exhibition catalogue, text by Gary Michael Dault

1977 ARCO Center for Visual Art, Los Angeles, "David Gilhooly." Exhibition brochure
 Candy Store Gallery, Folsom, California
 Helen Drutt Gallery, Philadelphia
 Ruth S. Schaffner Gallery, Los Angeles
 Galerie Darthea Speyer, Paris

1978 Nina Freudenheim Gallery, Buffalo
 Museum of Contemporary Crafts of the American Crafts Council, New York, "David Gilhooly: Ceramics." Exhibition brochure, text by David Gilhooly
 University Art Galleries, University of North Dakota, Grand Forks

1979 Hansen Fuller Goldeen Gallery, San Francisco
 Owens Art Gallery, Mount Allison University, Sackville, New Brunswick, "David Gilhooly: Recent Works" (traveled to Confederation Centre Art Gallery and Museum, Charlottetown, Prince Edward Island; Art Gallery of Nova Scotia, Halifax; Memorial University Art Gallery, St. John's, Newfoundland). Exhibition catalogue, text by T. Keilor Bentley

1980 Rebecca Cooper, Inc., New York
 Crocker Art Museum, Sacramento, California, "David Gilhooly: Big Stuff." Exhibition brochure

Selected Group Exhibitions

1966 Museum West, American Craftsmen's Council, San Francisco, "Ceramics from Davis"
 Reed College, Portland, Oregon, "California Ceramic Sculpture." Exhibition catalogue, text by Erik Gronborg

1967 Hansen Fuller Gallery, San Francisco, "Ceramic Sculpture"
 San Francisco Museum of Art, "Arts of San Francisco"
 University Art Museum, University of California, Berkeley, "Funk." Exhibition catalogue, text by Peter Selz

1968 Hansen Fuller Gallery, San Francisco, "Zoological Garden"

1969 Institute of Contemporary Art of The University of Pennsylvania, Philadelphia, "The Spirit of the Comics." Exhibition catalogue, text by Joan C. Siegfried
 National Collection of Fine Arts, Smithsonian Institution, Washington, D.C., "Objects: USA—The Johnson Collection of Contemporary Crafts" (traveled nationally). Exhibition catalogue, text by Lee Nordness

1970 The Montreal Museum of Fine Arts, "Réalismes 70" (traveled to Art Gallery of Toronto). Exhibition catalogue, text by Mario Amaya
 Whitney Museum of American Art, New York, "1970 Annual Exhibition: Contemporary American Sculpture." Exhibition catalogue

1971 Museum of Contemporary Crafts of the American Crafts Council, New York, "Clayworks: 20 Americans." Exhibition catalogue, text by Paul J. Smith
 The National Museum of Modern Art, Kyoto, Japan, "Contemporary Ceramic Art: Canada, USA, Mexico and Japan" (traveled to National Museum of Modern Art, Tokyo). Exhibition catalogue, text by Kenji Suzuki

1972 Lowe Art Museum, University of Miami, Coral Gables, Florida, "Phases of New Realism." Exhibition catalogue, texts by John J. Baratte and Paul E. Thompson
 San Francisco Museum of Art, "A Decade of Ceramic Art, 1962–1972: From the Collection of Professor and Mrs. R. Joseph Monsen." Exhibition catalogue, text by Suzanne Foley

1973 Allan Frumkin Gallery, New York, "Four Ceramic Sculptors from California"

1974 The Oakland Museum, California, "Public Sculpture/
Urban Environment." Exhibition catalogue, text by George
Neubert

 Whitney Museum of American Art, New York,
Downtown Branch, "Clay." Exhibition catalogue, text by
Richard Marshall

1975 Fendrick Gallery, Washington, D.C. "Clay USA."
Exhibition catalogue, text by Daniel Fendrick

1976 Hopkins Center, Dartmouth College, Hanover, New
Hampshire, "Contemporary Clay: Ten Approaches"
(traveled to Davison Art Center, Wesleyan University,
Middleton, Connecticut). Exhibition catalogue, text by
Malcom Cochran

 San Francisco Museum of Modern Art, "Painting
and Sculpture in California: The Modern Era" (traveled to
National Collection of Fine Arts, Smithsonian Institution,
Washington, D.C.). Exhibition catalogue, text by Henry T.
Hopkins

1977 William Hayes Ackland Art Center, University of
North Carolina, Chapel Hill, "Contemporary Ceramic
Sculpture." Exhibition catalogue, text by Louise Hobbs

1978 Everson Museum of Art, Syracuse, New York,
"Nine West Coast Clay Sculptors, 1978" (traveled to The
Arts and Crafts Center of Pittsburgh). Exhibition
catalogue, texts by Margie Hughto and Judy S. Schwartz

 Grossmont College Gallery, El Cajón, California,
"Viewpoints: Ceramics 1978." Exhibition catalogue, text by
Rudy Turk

1979 Everson Museum of Art, Syracuse, New York, "A
Century of Ceramics in the United States, 1878–1978"
(traveled to Renwick Gallery of the National Collection of
Fine Arts, Smithsonian Institution, Washington, D.C.).
Exhibition catalogue, text by Garth Clark and Margie
Hughto

 Stedelijk Museum, Amsterdam, "West Coast
Ceramics." Exhibition catalogue, text by Rose Slivka

1980 Norman Mackenzie Art Gallery, University of
Saskatchewan, Regina, "The Continental Clay Connection."
Exhibition catalogue

1981 University of Iowa Museum of Art, Iowa City,
"Centering on Contemporary Clay: American Ceramics
from the Joan Mannheimer Collection." Exhibition
catalogue, text by Jim Melchert

Selected Articles and Reviews

David Zack, "David Gilhooly," *Craft Horizons*, 30 (March/
 April 1970), p. 46.
Jeannette Arneson, "David Gilhooly: Ceramist for the
 Cacops, Eryops, Buettneria, Diplocaulus, Cephlapods,
 and Trilobites," *Craft Horizons*, 31 (August 1971), pp.
 20–21, 70–71.
Alan R. Meisel, "Letter from San Francisco," *Craft
 Horizons*, 31 (October 1971), pp. 52–53.
Cecile N. McCann, "David Gilhooly and Friends," *Artweek*,
 October 30, 1971, p. 7.
Gary Michael Dault, "With David Gilhooly in the Frog
World," *Artscanda*, 29 (Spring 1972), pp. 12–13.
David Gilhooly, *Frog Fred's Erotic Frog Colouring Book*
 (Toronto: David Gilhooly, 1973).
Cecile N. McCann, "Frog Fred and Associated Deities,"
 Artweek, June 23, 1973, p. 7.
Ron Shuebrook, "Regina Funk," *Art and Artists*, 8
 (August 1973), pp. 38–41.
Thomas Albright, "David Gilhooly at Hansen Fuller," *Art in
 America*, 61 (September/October 1973), pp. 120–21.
Dale McConathy, "David Gilhooly's Mythanthropy, or From
 the Slime to the Ridiculous," *Artscanada*, 32 (June
 1975), pp. 1-11.
Roberta Loach, "David Gilhooly in Conversation with
 Roberta Loach," *Visual Dialog*, 2 (September/
 October/November 1976), pp. 13–17.
Elaine Levin, "David Gilhooly's Bountiful Beastiary,"
 Artweek, October 22, 1977, pp. 1, 16.
"Seattle's Own Ark," *Seattle Arts*, 2 (December 1978), p. 1.
Jane Goldman, "From the Beslimed to the Ridiculous: The
 Frog World of Artist David Gilhooly," *Sacramento*, 5
 (November 1979), pp. 44–50, 58, 70.

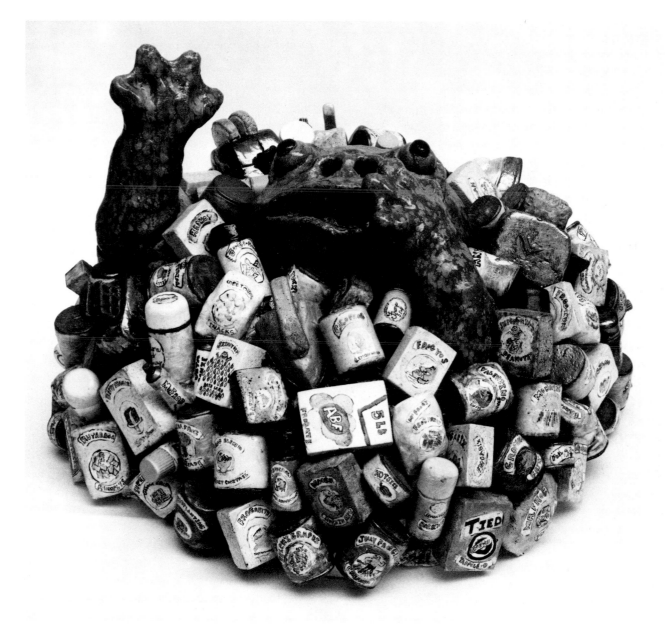

Drowning in the Consumer Market, 1973–74
Glazed earthenware, 19 x 33 x 26″ (48.3 x 83.8 x 66 cm)
Stedelijk Museum, Amsterdam

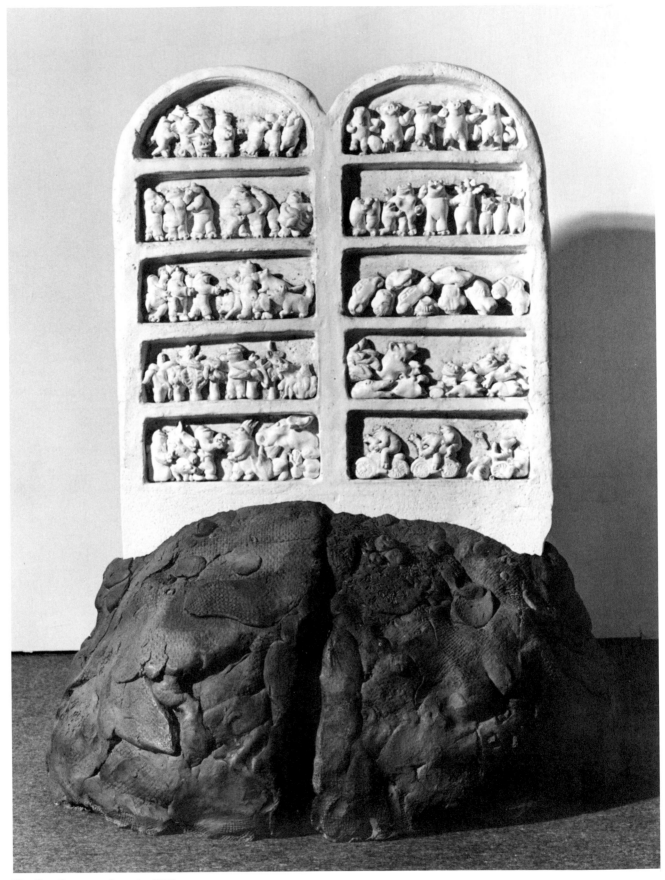

The Ten Commandments, 1975
Glazed earthenware, 31½ x 25¾ x 17½" (79.2 x 65.4 x 44.5 cm)
Australian National Gallery, Canberra

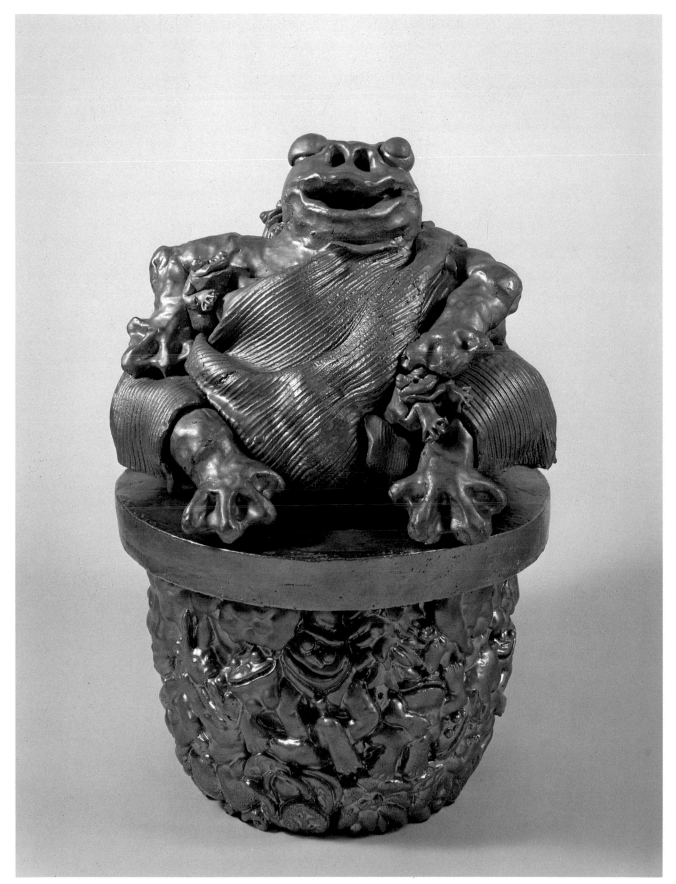

Tantric Frog Buddha Camping Out, 1976
Glazed earthenware, 26½ x 16 x 15″ (67.3 x 40.6 x 38.1 cm)
Collection of Mr. and Mrs. Robert H. Shoenberg

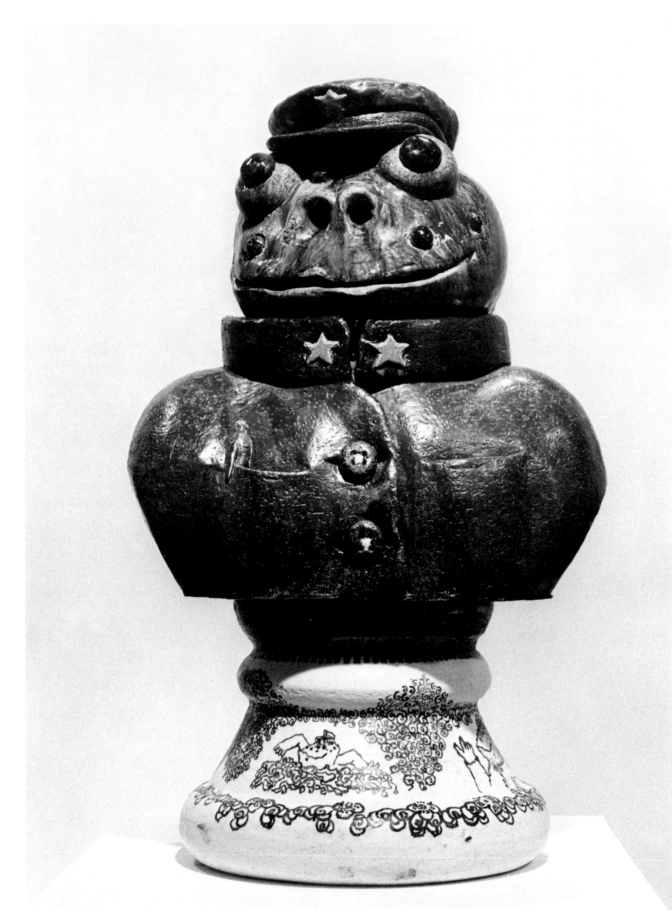

Mao Tse Toad, 1976
Glazed earthenware, 31 x 21 x 14½″ (78.7 x 53.3 x 36.8 cm)
The Canada Council Art Bank, Ottawa, Ontario

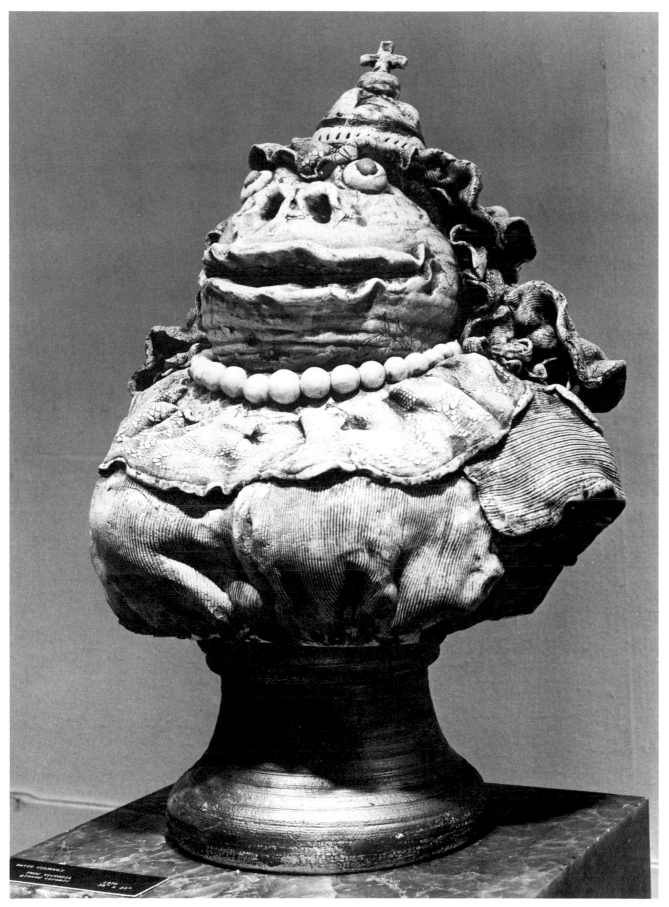

Frog Victoria (Her 100th Year as Queen), 1976
Glazed earthenware, 33½ x 24 x 19½″ (85.1 x 61 x 49.5 cm)
Vancouver Art Gallery, British Columbia

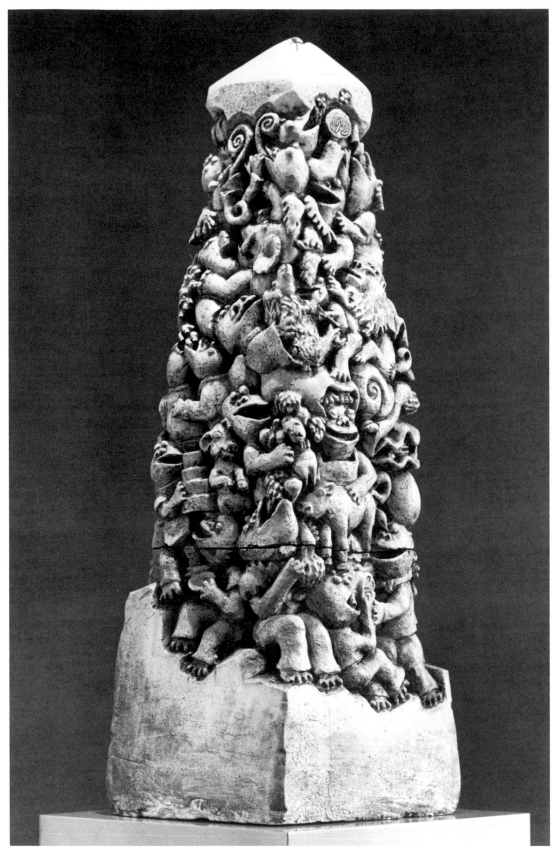

The Many Lives of Frog Fred Memorial Obelisk, 1975
Glazed earthenware, 38¼ x 12 x 13″ (96.8 x 30.5 x 33 cm)
Collection of the Capital Group, Inc., Los Angeles

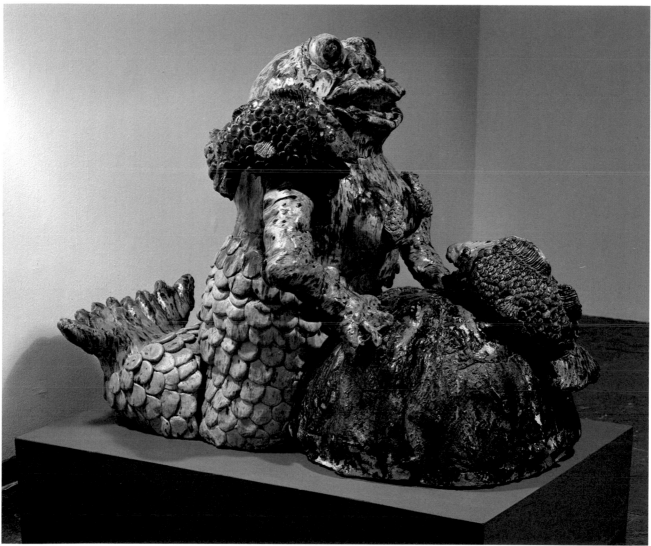

Merfrog and Her Pet Fish, 1976
Glazed earthenware, 42 x 29 x 48″ (106.7 x 73.7 x 121.9 cm)
Whitney Museum of American Art, New York; Gift of
Mr. and Mrs. William A. Marsteller, the John I. H. Baur
Purchase Fund (and purchase) 79.26

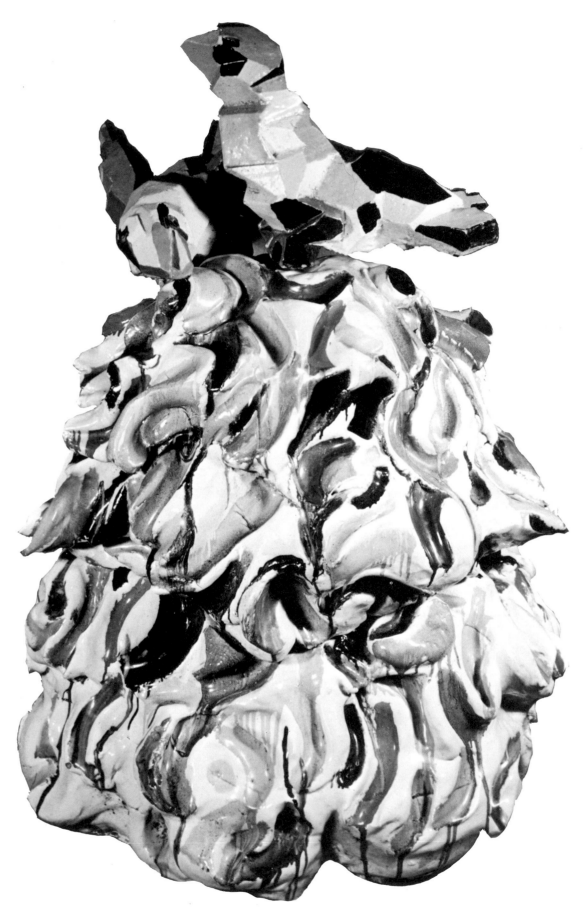

Frog de Kooning with Cubist Pigeons, 1976
Glazed earthenware, 29 x 22 x 22″ (73.7 x 55.9 x 55.9 cm)
Private collection

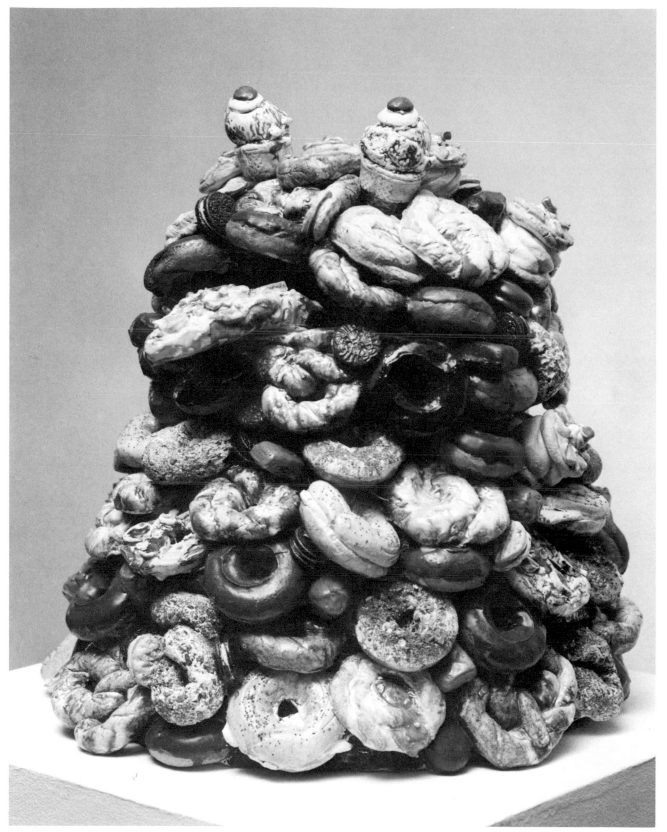

Count of Crumbs Dressed for His Bar Mitzvah, 1974
Glazed earthenware, 21 x 21 x 21″ (53.3 x 53.3 x 53.3 cm)
Collection of Barney A. Ebsworth

Richard Shaw

Richard Shaw's sculptures are imaginative assemblages of meticulously executed objects that display a refined sense of composition, contradiction, and humor. His works of the late 1960s were hand-built objects in earthenware—animals, furniture, and vessels—with painted illusionistic decoration and surreal scenes. In 1971, however, Shaw changed materials and technique, beginning a series of works in cast and glazed porcelain. *S on a Pillow* (1971) is one of the first pieces made of assembled porcelain items cast from found objects. Shaw expertly casts hundreds of objects—geometric shapes and odd, interesting things found in the studio, taken from friends, and bought in junk shops—using a system of plaster molds into which a porcelain slip is poured. The mold is turned so that the entire inside of it is equally coated, and the excess slip is poured out. The cast object is then removed from the mold, fired, and later assembled, glazed, and fired a second time. *S on a Pillow*—a brightly colored S-hook balanced on a pillow atop a rock—emphasizes the tension between different surfaces, textures, and colors, and between hard and soft. It simultaneously announces the incongruity and irony of depicting metal, fabric, feathers, and stone in the same thin-walled porcelain material that is glazed to achieve realistic coloration.

Cup on a Rock (1972) and *Teapot* (1973) make reference to the traditional use of porcelain, and other ceramic materials, for the formation of functional vessels and containers. Shaw's concerns, however, are with formal rather than functional associations. Although these pieces could be used to hold liquids, the awkwardness of form and dysfunctionality of design make their utility conceptual rather than actual. The works explore issues of balance, form, and color by combining real objects in surreal juxtapositions. *Wood Slab with Cup and Case Knife* (1974) exhibits a shift away from the surreal to a greater involvement with the construction of realistic, sculptural still lifes. Shaw's objects are charged with references and associations that reflect a type of folksy, rustic Americana, a "down home" life-style often associated with rural areas of Northern California. *Moonlight Goose* (1978) and *Target with Coffee Can* (1978) are both tightly composed arrangements of common, undistinguished items—coffee cans, twigs, plywood, and cylinders—recalling fence-post shooting targets and duck whirligigs. Their realism extends beyond the exact reproduction of shape and surface decoration to encompass a structural composition that reveals actual supports and bracing. A direct and conscious reference to the nineteenth-century American trompe-l'oeil paintings of John Peto and William Harnett is apparent in *Styrofoam Cup with Pencils* (1976). This work is from a series of wall-mounted plaques resembling wall boards with paper, playing cards, letters, and objects attached. Like all of Shaw's work, these three-dimensional collages of derelict objects presented in a hallucinatory style explore visual, sculptural, and psychological issues.

Stack of Books #1 (1978) and *House of Cards with Two Volumes* (1980) extend Shaw's involvement with precise still-life constructions and exhibit his expert adaptation of the structural possibilities of porcelain and the decorative capabilities of glazes. *Stack of Books #1* is the first of a series of book pieces—each with different things topping the stack—that explores the qualities of texture and color, and the tensions and transitions existing between cast, hand-built, and wheel-thrown elements. The books are entirely hand-built, with marbelized porcelain slabs for the covers rather than glazes, and identified with imaginary, although often autobiographical and punning, titles and authors. These book stacks also make ironic reference to the functional origins of ceramic work: the pile of letters topped by a pipe in a bowl lifts to reveal a camouflaged jar.

House of Cards with Two Volumes displays in a direct and obvious manner the precariousness and the tensile characteristics of Shaw's assemblages, and acknowledges the versatility and fragility of the porcelain medium. The decoration of the playing cards

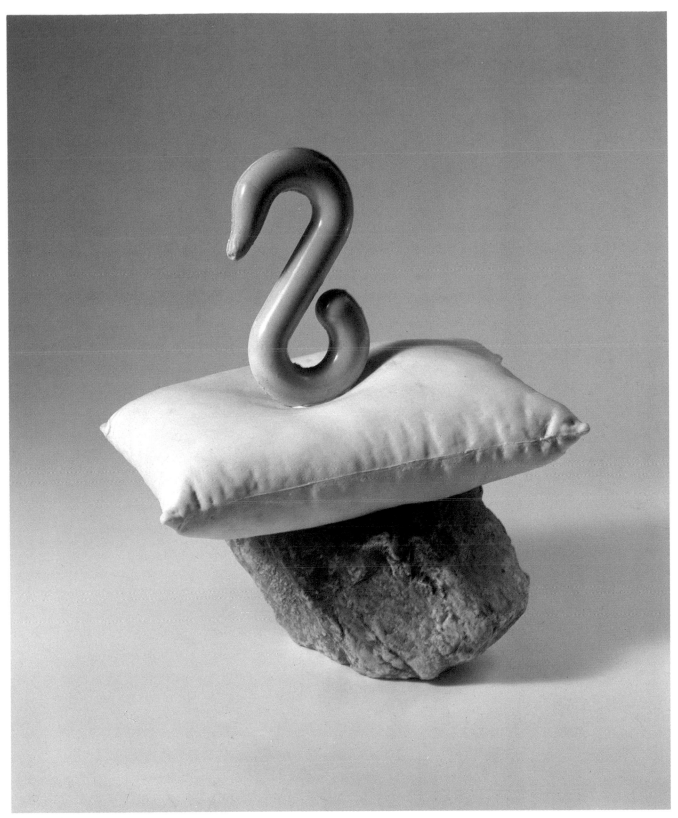

S on a Pillow, 1971
Porcelain with underglaze and glaze, 8½ x 7 x 5″
(21.6 x 17.8 x 12.7 cm)
Collection of Nancy and Roger Boas

also exhibits Shaw's mastery of the ceramic-transfer procedure that he began using in 1974 to replicate labels, newspapers, lettering, and patterning. The selected image is converted to a photographic silkscreen and is screened on decal paper, using low-fire, color-stable glazes as the inks. A clear coat of enamel is screened over the entire image to hold it in place when it is transferred from the decal paper—after immersion in water—to the porcelain object. The piece is then given a third and final firing, which burns away the protective enamel coating and fluxes the screened glaze into place. The use of this process of duplicating images is not only analogous to the mold procedure of slip-casting objects, but maintains the integrity of the ceramic makeup of the entire sculpture.

By 1978 Shaw's desire to make figurative works but to also continue his exploration of the variations and possibilities in the still-life genre resulted in walking figures. These works, much larger, looser, and more open than earlier pieces, can be perceived as highly animated, anthropo-morphic still lifes. Their final configuration is derived from Shaw's own preparatory sketches, but their inspiration and associations are related to scarecrow figures, children's stick figures, carved figures from primitive cultures, and American folk painting and sculpture. *Junkman Walking* (1978) is a blocky, marching figure, characteristically composed of discarded junk, which at the same time uses and makes reference to paints, painting, drawing, ceramics, farm tools, school books, natural and milled woods, and commercial products. These walking figures are always in motion, making awkward, halting gestures that reflect the nature of their body parts. *Mike Goes Back to T.* (1980), titled after a friend of Shaw's who returned to Texas, depicts a striding figure with paint-can head and body, a wine bottle for a lower leg, and a paintbrush hand that appears to be quick on the draw. These figures have advanced Shaw's work in scale and complexity, synthesizing technique, craft, ceramics, painting, and sculpture.

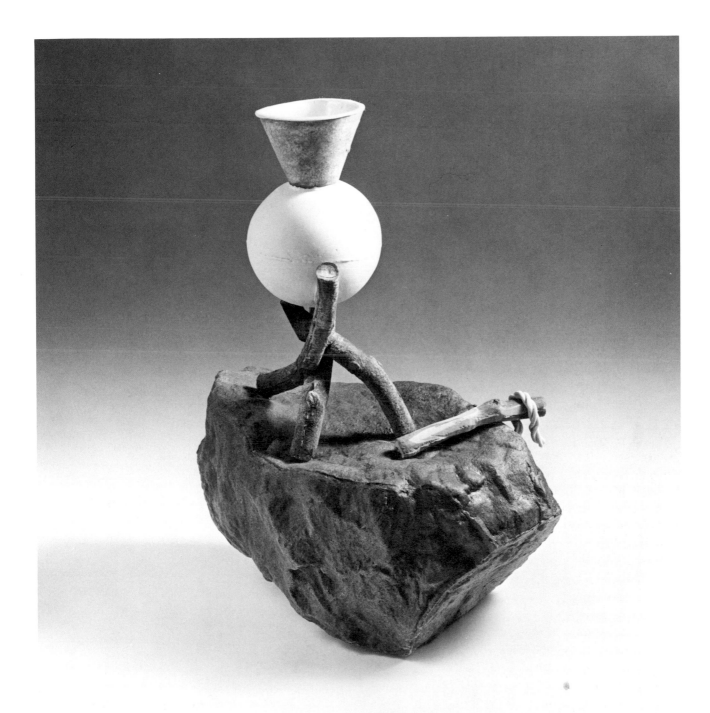

Cup on a Rock, 1972
Porcelain with underglaze and glaze, 12 x 9 x 6¼″
(28 x 22.9 x 15.9 cm)
Collection of the artist, courtesy Braunstein Gallery,
San Francisco

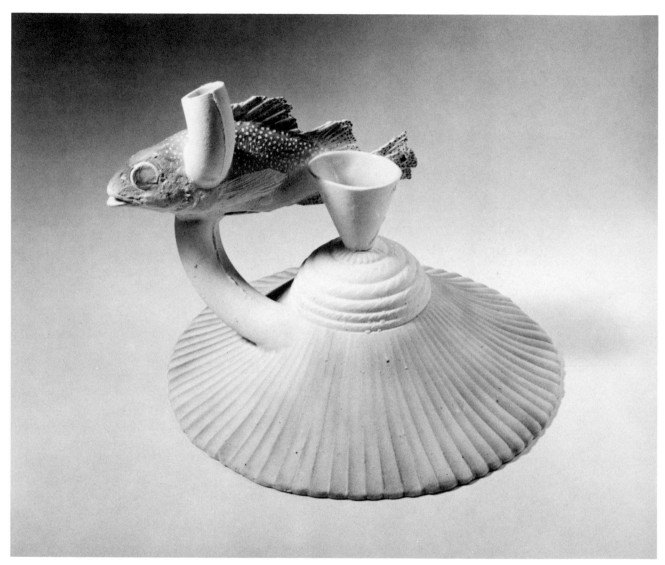

Teapot, 1973
Porcelain with underglaze and glaze, 8½ x 10¼ x 10⅜″
(21.6 x 26 x 26.4 cm)
San Francisco Museum of Modern Art; In Memory of
Alma Walker, given by her friends

Richard Shaw

Born in Hollywood, 1941
Studied at Orange Coast College, Costa Mesa, California,
(1961–63); San Francisco Art Institute (B.F.A. 1965); New
York State College of Ceramics, Alfred (1965); University of
California, Davis (M.A., 1968)
Taught at San Francisco Art Institute (1966–present);
University of California, Berkeley (1970); University of
Wisconsin, Madison (1971)
Lives in Fairfax, California

Selected Solo Exhibitions

1967 San Francisco Art Institute

1968 Dilexi Gallery, San Francisco

1970 Quay Gallery, San Francisco

1971 Quay Gallery, San Francisco

1973 Quay Gallery, San Francisco

1976 Braunstein/Quay Gallery, New York
 Braunstein/Quay Gallery, San Francisco

1977 Jacqueline Anhalt Gallery, Los Angeles

1979 The Arts and Crafts Center and Michael Berger
Gallery, Pittsburgh
 Braunstein/Quay Gallery, San Francisco, "Richard
Shaw: Ceramic Sculpture." Exhibition catalogue

1980 Allan Frumkin Gallery, New York

1981 Braunstein Gallery, San Francisco

Selected Group Exhibitions

1965 Museum of Contemporary Crafts of the American
Crafts Council, New York, "New Ceramic Forms"

1966 Museum West, American Craftsmen's Council, San
Francisco, "Ceramics from Davis"

1969 National Collection of Fine Arts, Smithsonian
Institution, Washington, D.C., "Objects: USA—The
Johnson Collection of Contemporary Crafts" (traveled
nationally). Exhibition catalogue, text by Lee Nordness

1970 The Brooklyn Museum, New York, "Attitudes"
 Whitney Museum of American Art, New York, "1970
Annual Exhibition: Contemporary American Sculpture."
Exhibition catalogue

1971 Museum of Contemporary Crafts of the American
Crafts Council, New York, "Clayworks: 20 Americans."
Exhibition catalogue, text by Paul J. Smith
 The National Museum of Modern Art, Kyoto, Japan,
"Contemporary Ceramic Art: Canada, USA, Mexico and
Japan" (traveled to National Museum of Modern Art,
Tokyo). Exhibition catalogue, text by Kenji Suzuki

1972 Lowe Art Museum, University of Miami, Coral
Gables, Florida, "Phases of New Realism." Exhibition
catalogue, texts by John J. Baratte and Paul E. Thompson
 San Francisco Museum of Art, "A Decade of
Ceramic Art, 1962–1972: From the Collection of Professor
and Mrs. R. Joseph Monsen." Exhibition catalogue, text by
Suzanne Foley
 Victoria and Albert Museum, London, "International
Ceramics 1972." Exhibition catalogue

1973 San Francisco Museum of Art, "Robert Hudson/
Richard Shaw: Works in Porcelain." Exhibition catalogue,
text by Suzanne Foley

1974 San Francisco Art Institute, "Ceramic Sculpture."
Exhibition brochure, text by Phil Linhares
 Whitney Museum of American Art, New York,
Downtown Branch, "Clay." Exhibition catalogue, text by
Richard Marshall

1975 Fendrick Gallery, Washington, D.C., "Clay USA."
Exhibition catalogue, text by Daniel Fendrick

1976 The Art Gallery, California State University,
Fullerton, "Richard Shaw, Ed Blackburn, Tony Costanzo,
Redd Ekks, John Roloff." Exhibition catalogue, text by
Suzanne Foley
 Hopkins Center, Dartmouth College, Hanover, New
Hampshire, "Contemporary Clay: Ten Approaches"
(traveled to Davison Art Center, Wesleyan University,
Middleton, Connecticut). Exhibition catalogue, text by
Malcolm Cochran
 Renwick Gallery of the National Collection of Fine
Arts, Smithsonian Institution, Washington D.C., "The
Object as Poet." Exhibition catalogue, text by Rose Slivka
 San Francisco Museum of Modern Art, "Painting
and Sculpture in California: The Modern Era" (traveled to
National Collection of Fine Arts, Smithsonian Institution,
Washington, D.C.). Exhibition catalogue, text by Henry T.
Hopkins.

1977 William Hayes Ackland Art Center, University of
North Carolina, Chapel Hill, "Contemporary Ceramic
Sculpture." Exhibition catalogue, text by Louise Hobbs
 Grossmont College, El Cajón, California,
"Viewpoints: Ceramics 1977." Exhibition catalogue, text by
Erik Gronborg
 Laguna Beach Museum of Art, California,
"Illusionistic Realism." Exhibition catalogue

1978 Everson Museum of Art, Syracuse, New York,
"Nine West Coast Clay Sculptors, 1978" (traveled to The
Arts and Crafts Center of Pittsburgh). Exhibition
catalogue, texts by Margie Hughto and Judy S. Schwartz

1979 The Denver Art Museum, "Reality of Illusion"
(traveled to University Galleries, University of Southern
California, Los Angeles; Honolulu Academy of Arts; The
Oakland Museum, California; University Art Museum,
University of Texas, Austin; Herbert F. Johnson Museum of
Art, Cornell University, Ithaca, New York). Exhibition
catalogue, text by Donald J. Brewer

Everson Museum of Art, Syracuse, New York, "A Century of Ceramics in the United States, 1878–1978" (traveled to Renwick Gallery of the National Collection of Fine Arts, Smithsonian Institution, Washington, D.C.). Exhibition catalogue, texts by Garth Clark and Margie Hughto

Richard L. Nelson Gallery, University of California, Davis, "Large-Scale Ceramic Sculpture." Exhibition catalogue, text by L. Price Amerson, Jr.

Security Pacific Bank, Los Angeles, "West Coast Clay Spectrum Artists." Exhibition catalogue, text by Elaine Levin

Stedelijk Museum, Amsterdam, "West Coast Ceramics." Exhibition catalogue, text by Rose Slivka

1980 Norman Mackenzie Art Gallery, University of Saskatchewan, Regina, "The Continental Clay Connection." Exhibition catalogue

Renwick Gallery of the National Collection of Fine Arts, Smithsonian Institution, Washington, D.C., "American Porcelain: New Expressions in an Ancient Age." Exhibition catalogue, text by Lloyd E. Herman

1981 American Craft Museum, New York, "The Clay Figure"

San Diego Museum of Art, California, "Sculpture in California, 1975–80." Exhibition catalogue, text by Richard Armstrong

University of Iowa Museum of Art, Iowa City, "Centering on Contemporary Clay: American Ceramics from the Joan Mannheimer Collection." Exhibition catalogue, text by Jim Melchert

Whitney Museum of American Art, New York, "1981 Biennial Exhibition." Exhibition catalogue

Selected Articles and Reviews

Alan R. Meisel, "Letter from San Francisco," *Craft Horizons*, 30 (October 1970), p. 60.

Alan R. Meisel, "Letter from San Francisco," *Craft Horizons*, 31 (October 1971), pp. 53–54.

Alan R. Meisel, "Letters: San Francisco," *Craft Horizons*, 33 (August 1973), p. 26.

Mary Fuller McChesney, "Porcelain by Richard Shaw and Robert Hudson," *Craft Horizons*, 33 (October 1973), pp. 34–37.

Alan R. Meisel, "Letters: San Francisco," *Craft Horizons*, 34 (February 1974), pp. 48–49.

Mikhail Zakin, "New York: Clay," *Craft Horizons*, 36 (February 1976), p. 21.

Peter Frank, "Reviews: Richard Shaw," *Art News*, 75 (March 1976), p. 139.

Mary Fuller, "The Ceramics of Richard Shaw," *Craft Horizons*, 36 (December 1976), pp. 34–37.

Judith L. Dunham, "Richard Shaw: Acuity of Percept and Concept," *Artweek*, January 27, 1979, pp. 1, 24.

Thomas Albright, "San Francisco: Star Streaks," *Art News*, 78 (April 1979), p. 101.

Hal Fischer, "San Francisco: Richard Shaw," *Artforum*, 17 (April 1979), p. 77.

Rose Slivka, "Review of Exhibitions: Richard Shaw at Frumkin," *Art in America*, 69 (February 1981), p. 153.

Grace Glueck, "Art: 'The Clay Figure' at the Craft Museum," *New York Times*, February 20, 1981, p. C17.

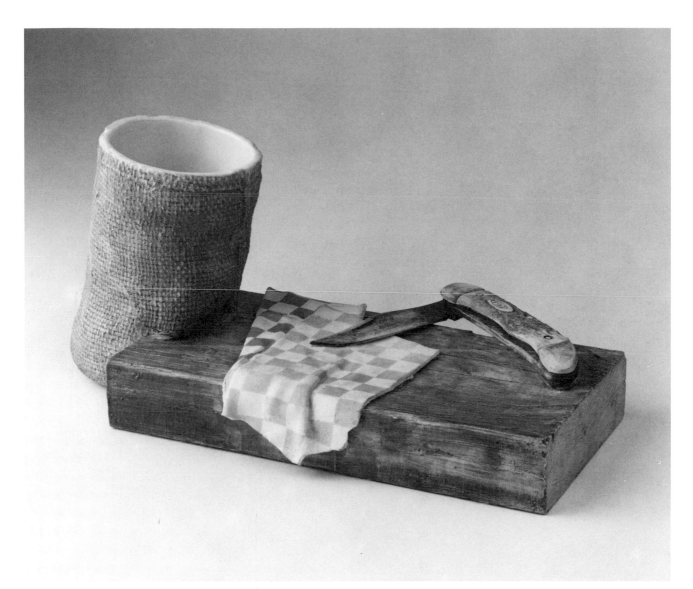

Wood Slab with Cup and Case Knife, 1974
Porcelain with underglaze and glaze, 6 x 8 x 12″
(15.2 x 20.3 x 30.5 cm)
Collection of Mr. and Mrs. John Lowell Jones

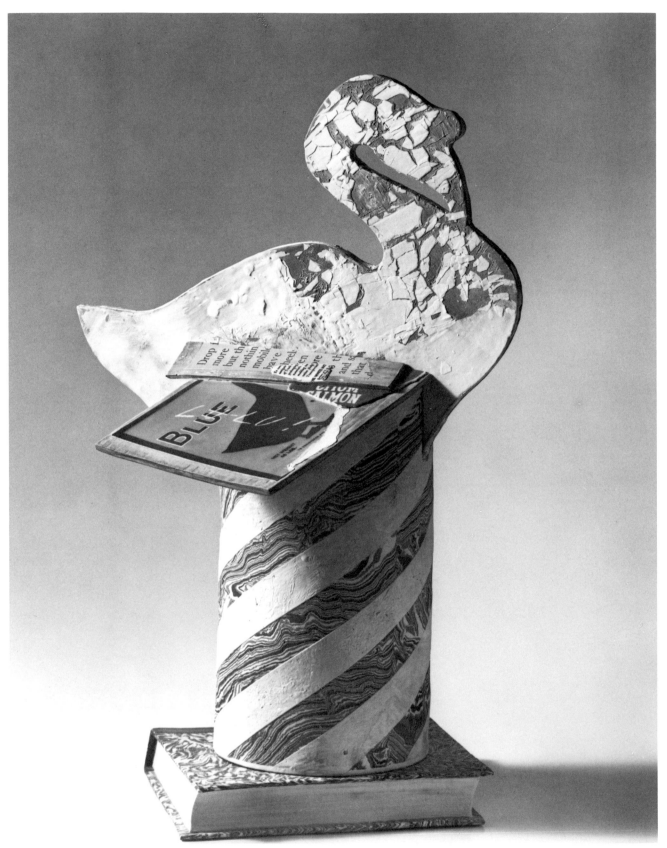

Moonlight Goose, 1978
Porcelain with underglaze, glaze, and overglaze transfers,
24 x 16 x 16″ (61 x 40.6 x 40.6 cm)
Stedelijk Museum, Amsterdam

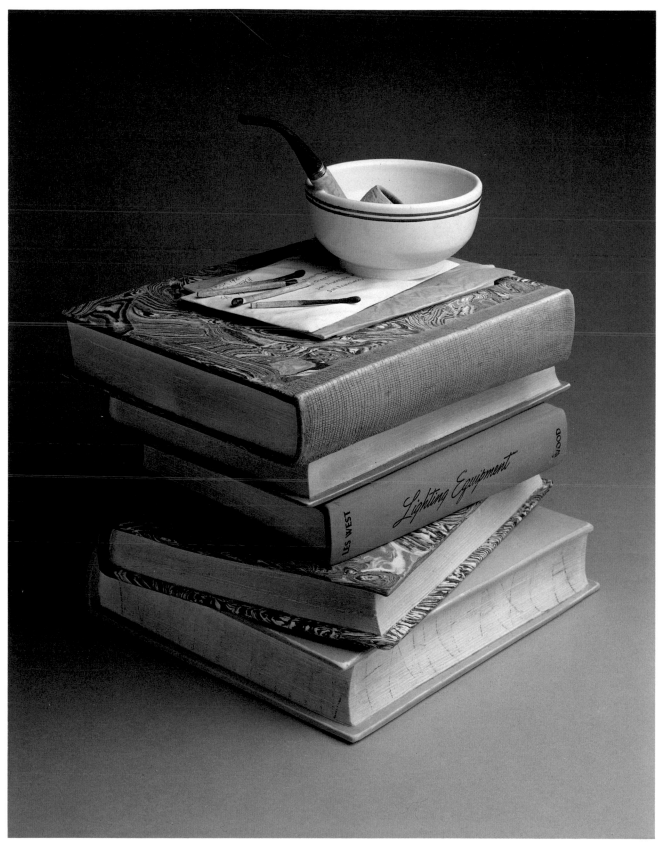

Stack of Books #1, 1978
Porcelain with underglaze, glaze, and overglaze transfers,
9½ x 7½ x 13″ (24.1 x 19.1 x 33 cm)
Collection of Harold and Gayle Kurtz

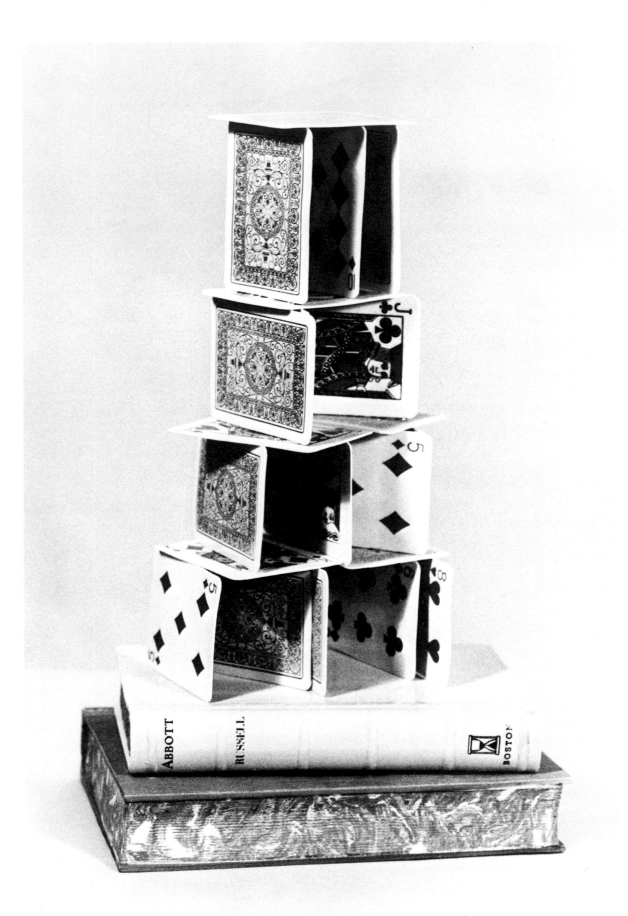

House of Cards with Two Volumes, 1980
Porcelain with underglaze, glaze, and overglaze transfers,
15 x 19½ x 7¼ (38.1 x 49.5 x 18.4 cm)
Private collection

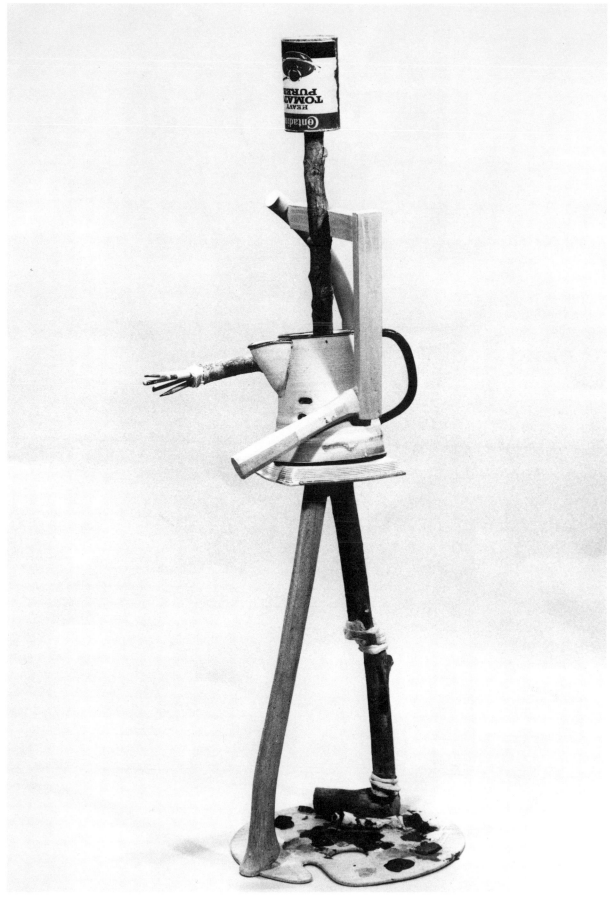

Figure on a Palette, 1980
Porcelain with underglaze, glaze, and overglaze transfers,
39 x 13 x 18″ (99.1 x 33 x 45.7 cm)
Private collection

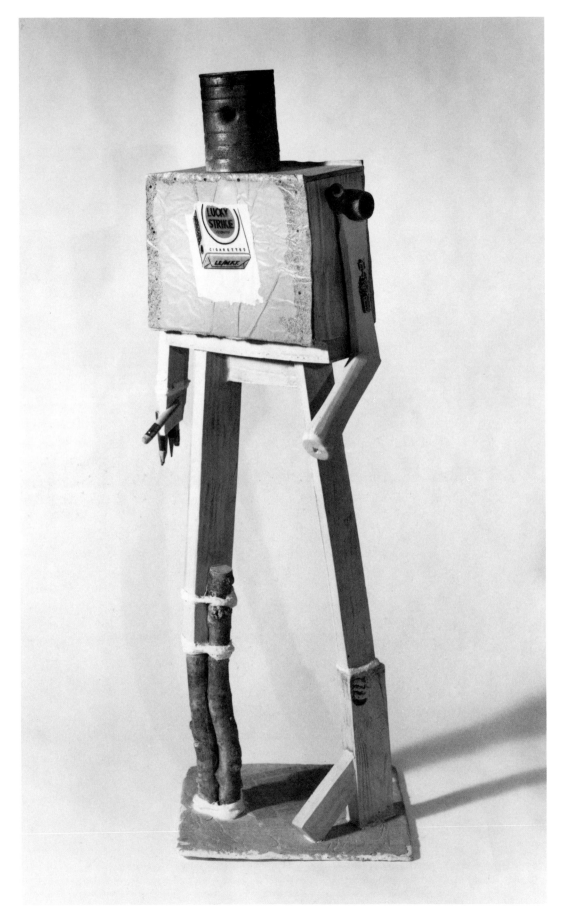

Junkman Walking, 1978
Porcelain with underglaze, glaze, and overglaze transfers,
31 x 9 x 8″ (78.7 x 22.9 x 20.3 cm)
Collection of Austin Conkey

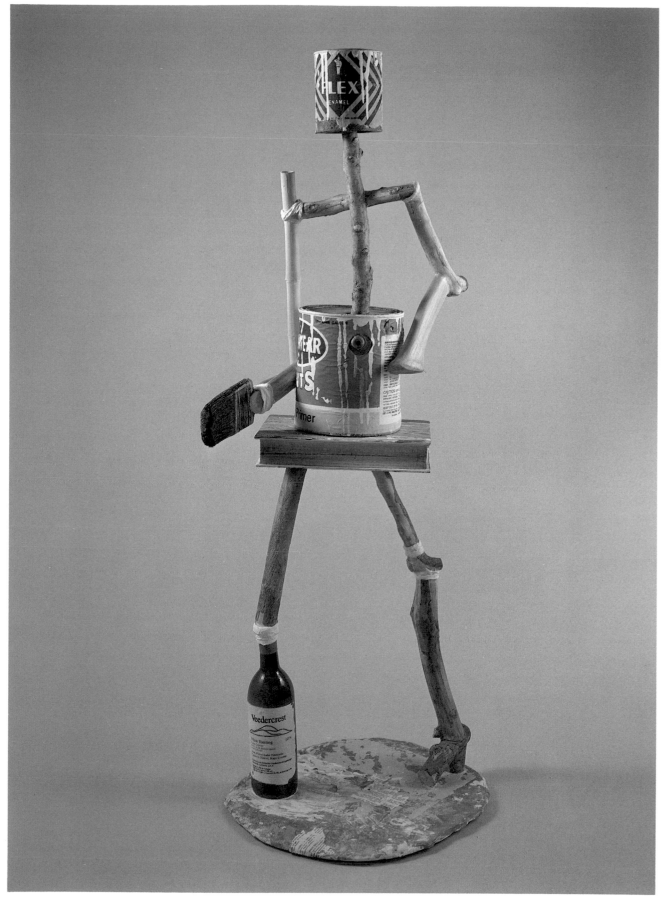

Mike Goes Back to T., 1980
Porcelain with underglaze, glaze, and overglaze transfers,
41¾ x 14 x 19″ (106 x 35.6 x 48.3 cm)
Whitney Museum of American Art, New York; Burroughs
Wellcome Purchase Fund 81.4

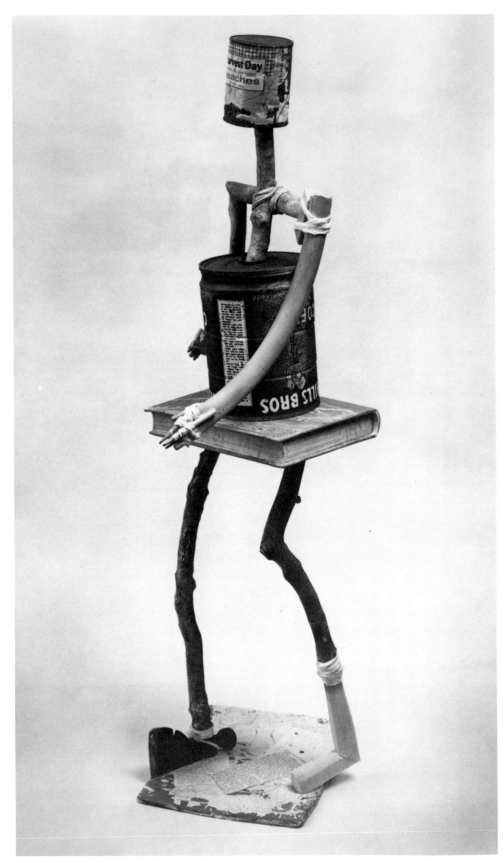

Melodious Double Stops, 1980
Porcelain with underglaze, glaze, and overglaze transfers,
39 x 11½ x 9″ (99.1 x 29.2 x 22.9 cm)
San Francisco Museum of Modern Art; Purchased with
matching funds from the National Endowment for the
Arts, and Frank O. Hamilton, Byron Meyer, and Mrs.
Peter Schlesinger

Catalogue

Dimensions are given first in inches, then in centimeters; height precedes width, precedes depth.

Peter Voulkos

Flying Black, 1958
Glazed stoneware, 39¼ x 45 x 24 (99.7 x 114.3 x 61)
The Weisman Family Collection

Camelback Mountain, 1959
Glazed stoneware, 45¼ x 19½ x 20¼ (114.9 x 49.5 x 51.4)
Museum of Fine Arts, Boston; Gift of Mr. and Mrs. Stephen
D. Paine

Cross, 1959
Glazed stoneware, 31 x 21¾ x 9½ (78.7 x 55.2 x 24.1)
American Craft Museum, New York; Gift of S. C. Johnson
& Sons, Inc., from "Objects: USA"

Hack's Rock, 1959
Glazed stoneware, 60 x 24½ x 16¼ (152.4 x 62.2 x 41.3)
Collection of Mr. and Mrs. Phillip S. Hack

Little Big Horn, 1959
Glazed stoneware, 62 x 40 x 40 (157.5 x 101.6 x 101.6)
The Oakland Museum, California; Gift of The Art Guild of
the Oakland Museum Association

Sevillanas, 1959
Glazed stoneware, 56¾ x 28 x 16⅞ (144.1 x 71.1 x 42.9)
San Francisco Museum of Modern Art; Albert M. Bender
Collection, Albert M. Bender Bequest Fund Purchase

Sitting Bull, 1959
Glazed stoneware, 69 x 37 x 37 (175.3 x 94 x 94)
The Santa Barbara Museum of Art, California; Bequest of
Hans G. M. De Schulthess

Red River, 1960
Glazed stoneware 37 x 12½ x 14½ (94 x 31.8 x 36.8)
Whitney Museum of American Art, New York; Gift of the
Howard and Jean Lipman Foundation, Inc. 66.42

USA 41, 1960
Glazed stoneware with epoxy paint, 34 x 11¾ x 10½
(86.5 x 29.8 x 26.7)
The Corcoran Gallery of Art, Washington, D.C.;
Gift of Wayne Parrish

Anada, 1968
Glazed stoneware, 34⅜ x 11¾ x 11½ (87.3 x 29.8 x 29.3)
San Francisco Museum of Modern Art;
Gift of Mrs. Edgar Sinton

Untitled, 1980
Stoneware, 48 x 18½ x 19 (121.9 x 47 x 48.3)
Collection of Mr. and Mrs. John Pappajohn

Untitled, 1981
Stoneware, 34½ x 16 x 16 (90.2 x 40.6 x 40.6)
Thomas Segal Gallery, Boston

John Mason

Vertical Sculpture—Spear Form, 1957
Glazed stoneware, 67 x 28 x 12 (170.9 x 71.1 x 30.5)
Collection of the artist, courtesy Hansen Fuller Goldeen
Gallery, San Francisco

Vertical Edge Sculpture, 1961
Glazed stoneware, 64 x 16 x 9 (162.6 x 40.6 x 22.9)
Collection of the artist, courtesy Hansen Fuller Goldeen
Gallery, San Francisco

Vertical Sculpture, 1961
Glazed stoneware, 64 x 18 x 10 (162.6 x 45.7 x 25.4)
Collection of the artist, courtesy Max Hutchinson Gallery,
New York

Vertical Sculpture, 1962
Glazed stoneware, 64 x 16 x 12 (162.5 x 40.6 x 30.5)
Private collection

Desert Cross, 1963
Glazed stoneware, 54 x 43½ x 15 (137.2 x 110.5 x 38.1)
Sheppard Fine Arts Gallery, University of Nevada, Reno

Cross Form—White, 1964
Glazed stoneware, 67 x 66 x 21 (170.1 x 167.7 x 53.3)
Collection of the artist, courtesy Hansen Fuller Goldeen
Gallery, San Francisco

Untitled, 1964
Glazed stoneware, 66 x 63½ x 17 (167.6 x 161.3 x 43.2)
San Francisco Museum of Modern Art; Gift of the
Women's Board

Dark Monolith with Opening, 1965
Glazed stoneware, 65 x 62 x 24 (165.1 x 157.5 x 61)
Collection of the artist, courtesy Max Hutchinson Gallery,
New York

Geometric Form—Dark, 1966
Glazed stoneware, 59 x 43 x 25 (149.9 x 109.2 x 63.5)
Collection of Mr. and Mrs. C. David Robinson

Geometric Form—I, 1966–81
Glazed stoneware, 58½ x 59½ x 17 (148.6 x 151.1 x 43.2)
Collection of the artist, courtesy Max Hutchinson Gallery,
New York

Modular Series—Firebrick, 1981
Firebrick, variable dimensions
Collection of the artist, courtesy Max Hutchinson Gallery,
New York

Kenneth Price

Untitled, 1959
Glazed earthenware, 21½ x 20 x 20 (54.6 x 50.8 x 50.8)
Collection of Billy Al Bengston

M. Green, 1961
Lacquer and acrylic on stoneware, 10 x 13 x 11½
(25.4 x 33 x 29.2)
Collection of Betty Asher

Silver, 1961
Lacquer and acrylic on stoneware, 11½ x 17½ x 13¼
(29.2 x 44.5 x 33.7)
Collection of Edward S. Bevan

B. T. Blue, 1962
Lacquer and acrylic on stoneware, 10 x 6½ x 6½
(25.4 x 16.5 x 16.5)
Collection of Becky and Peter Smith

S. L. Green, 1963
Lacquer and acrylic on stoneware, 9½ x 10½ x 10½
(24.1 x 26.7 x 26.7)
Whitney Museum of American Art, New York; Gift of the
Howard and Jean Lipman Foundation, Inc. 66.35

Untitled, 1963
Lacquer and acrylic on stoneware, 9 x 6 x 6
(22.9 x 15.2 x 15.2)
Collection of Mr. and Mrs. Robert Lauter

Specimen B1520.06, 1964
Lacquer and acrylic on stoneware with fabric and wood
construction, 12 x 15½ x 7 (30.5 x 39.4 x 17.8) overall
Collection of the artist

D. Violet, 1965
Lacquer and acrylic on stoneware, 6 x 4 x 5
(15.2 x 10.2 x 12.7)
Collection of the artist

S. D. Green, 1966
Lacquer and acrylic on stoneware, 5 x 4 x 9½
(12.7 x 10.2 x 24.1)
Collection of James J. Meeker

Green and Cream, 1967
Lacquer and acrylic on stoneware, 3½ x 4 x 9
(8.9 x 10.2 x 22.9)
Collection of the artist

Oyster Bay Rock Cup, 1967
Glazed earthenware, 4½ x 3¼ x 2¾ (11.4 x 9.5 x 6.9)
Collection of the artist

Blind Sea Turtle Cup, 1968
Glazed earthenware with sand, glass and wood
construction, 63½ x 29½ x 32 (161.3 x 74.9 x 81.3) overall
The Museum of Modern Art, New York;
Fractional gift of Charles Cowles

Nose Cup, 1968
Glazed earthenware, 3 x 3 x 5 (7.6 x 7.6 x 12.7)
Collection of Frank Stella

Snail Cup, 1968
Glazed earthenware, 2⅝ x 3 x 4½ (6.7 x 7.6 x 11.4)
Collection of the artist

Wart Cup, 1969
Glazed earthenware, 3 x 3 x 4 (7.6 x 7.6 x 10.2)
Collection of Joan and Jack Quinn

Slate Cup, 1972
Acrylic on earthenware, 5½ x 6 x 5 (14 x 15 x 12.7)
Collection of Edwin Janss

Untitled Cup, 1973
Glazed earthenware, 4¾ x 3½ x 3¾ (12.1 x 8.9 x 9.5)
Collection of Fredericka Hunter

Untitled Cup, 1973
Glazed earthenware, 4½ x 3¾ x 4 (11.4 x 9.5 x 10.2)
Collection of the artist

Untitled Cup, 1974
Glazed earthenware, two parts; 4¾ x 5¼ x 4 (12.1 x 13.3 x
10.2) and 1¼ x 1⅛ x 2 (3.2 x 2.9 x 5.1)
Collection of the artist

Death Shrine 1, 1972–77
Glazed earthenware, wood construction, and mixed media
accessories, 102 x 102 x 87 (259.1 x 259.1 x 221) overall
Private collection

Town Unit 1, 1972–77
Glazed earthenware and wood cabinet, 70 x 39 x 20
(177.8 x 99.1 x 50.8)
Private collection

Unit 1, 1972–77
Glazed earthenware and wood cabinet, 70 x 71 x 41
(177.8 x 180.3 x 104.1) overall
Collection of Katherine and Benjamin Kitchen

Israeli Sculpture, 1979
Glazed earthenware, 7 x 6¼ x 5½ (17.8 x 15.9 x 14)
Private collection

De Chirico's Bathhouse, 1980
Glazed earthenware, two parts; 8¼ x 8¹⁵⁄₁₆ x 3¹⁄₁₆ (21 x 21.1
x 7.8) and ¾ x 4⅜ x 2½ (1.9 x 11.1 x 6.4)
Dallas Museum of Fine Arts; Foundation for the Arts
Collection, Anonymous gift

Tail Piece, 1980
Glazed earthenware, 6¼ x 8 x 5½ (15.9 x 20.3 x 14)
Willard Gallery, New York

Black Widow, 1981
Acrylic and glaze on earthenware, 9½ x 5 x 2⅝
(24.1 x 12.7 x 6)
Collection of the artist

Robert Arneson

Smorgi-Bob, The Cook, 1971
Glazed earthenware on vinyl-covered wood base,
72 x 60 x 60 (182.3 x 152.4 x 152.4)
San Francisco Museum of Modern Art; Purchase

Classical Exposure, 1972
Terra-cotta, 96 x 36 x 24 (243.8 x 91.4 x 61)
Collection of Mr. and Mrs. Daniel Fendrick

Fragment of Western Civilization, 1972
Terra-cotta, 41 x 120 x 120 (104.1 x 304.8 x 304.8) overall
Australian National Gallery, Canberra

Current Event, 1973
Terra-cotta and glazed earthenware, 9½ x 173 x 84
(24.1 x 439.4 x 213.4)
Stedelijk Museum, Amsterdam

The Palace at 9 A.M., 1974
Terra-cotta and glazed earthenware, 24 x 118 x 84
(61 x 299.7 x 213.4)
Allan Frumkin Gallery, New York

Cheek, 1976
Glazed earthenware, 34 x 21 x 21 (86.4 x 53.3 x 53.3)
Collection of Sydney and Frances Lewis

Roy of Port Costa, 1976
Glazed earthenware, 34 x 18¾ x 18¾ (86.4 x 47.6 x 47.6)
Collection of Sydney and Frances Lewis

Whistling in the Dark, 1976
Terra-cotta and glazed earthenware, 35½ x 20 x 20
(90.2 x 50.8 x 50.8)
Whitney Museum of American Art, New York; Gift of
Sydney and Frances Lewis 77.37

Mr. Unatural, 1978
Glazed earthenware, 53½ x 22 x 22 (135.9 x 55.9 x 55.9)
Private collection

Splat, 1978
Terra-cotta and glazed earthenware, 33 x 22 x 22
(83.8 x 55.9 x 55.9)
Collection of the artist, courtesy Hansen Fuller Goldeen
Gallery, San Francisco

Casualty in the Art Realm, 1979
Glazed earthenware, 8 x 97 x 132 (20.3 x 246.4 x 335.3)
Hansen Fuller Goldeen Gallery, San Francisco

Pablo Ruiz with Itch, 1980
Glazed earthenware, two parts; bust 29½ x 22 x 22 (74.9 x
55.9 x 55.9), pedestal 58 x 27½ x 15 (147.3 x 69.8 x 38.1)
Allan Frumkin Gallery, New York

Nasal Flat, 1981
Glazed earthenware, two parts; bust 37¼ x 36½ x 18 (95.9
x 92.7 x 45.7), pedestal 46⅜ x 28 x 20½ (117.8 x 71.1 x 52.1)
Allan Frumkin Gallery, New York

David Gilhooly

Artemis, First Fertility Goddess, 1971
Glazed earthenware, 18 x 15 x 13 (45.7 x 38.1 x 33)
Private collection

The Miracle of Production, 1972
Glazed earthenware, 13½ x 14 x 28 (34.3 x 35.6 x 71.1)
Collection of David Bourdon

The Honey Sisters Do a Garden Blessing, 1973
Glazed earthenware, 19 x 33 x 26 (48.3 x 83.8 x 66)
San Francisco Museum of Modern Art; William L. Gerstle
Collection, William L. Gerstle Fund Purchase

Drowning in the Consumer Market, 1973–74
Glazed earthenware, 19 x 33 x 26 (48.3 x 83.8 x 66)
Stedelijk Museum, Amsterdam

Count of Crumbs Dressed for His Bar Mitzvah, 1974
Glazed earthenware, 21 x 21 x 21 (53.3 x 53.3 x 53.3)
Collection of Barney A. Ebsworth

*Frog Fred's Prayer Stela: The Presentation of His New
Work*, 1975
Glazed earthenware, 25½ x 18 x 8 (64.8 x 45.7 x 20.3)
Collection of Mr. and Mrs. Ross Turk

The Many Lives of Frog Fred Memorial Obelisk, 1975
Glazed earthenware, 38¼ x 12 x 13 (96.8 x 30.5 x 33)
Collection of the Capital Group, Inc., Los Angeles

The Ten Commandments, 1975
Glazed earthenware, 31½ x 25¾ x 17½ (79.2 x 65.4 x 44.5)
Australian National Gallery, Canberra

The Beavers Doing Their Self-Portraits, 1976
Stained earthenware, 38 x 8 x 8 (96.5 x 20.3 x 20.3)
Collection of Mr. and Mrs. A. J. Krisik

Frog de Kooning with Cubist Pigeons, 1976
Glazed earthenware, 29 x 22 x 22 (73.7 x 55.9 x 55.9)
Private collection

Frog Victoria (Her 100th Year As Queen), 1976
Glazed earthenware, 33½ x 24 x 19½ (85.1 x 61 x 49.5)
Vancouver Art Gallery, British Columbia

Mao Tse Toad, 1976
Glazed earthenware, 31 x 21 x 14½ (78.7 x 53.3 x 36.8)
The Canada Council Art Bank, Ottawa, Ontario

Merfrog and Her Pet Fish, 1976
Glazed earthenware, 42 x 29 x 48 (106.7 x 73.7 x 121.9)
Whitney Museum of American Art, New York; Gift of Mr.
and Mrs. William A. Marsteller, the John I. H. Baur
Purchase Fund (and purchase) 79.26

Tantric Frog Buddha Camping Out, 1976
Glazed earthenware, 26½ x 16 x 15 (67.3 x 40.6 x 38.1)
Collection of Mr. and Mrs. Robert H. Shoenberg

Richard Shaw

S on a Pillow, 1971
Porcelain with underglaze and glaze, 8½ x 7 x 5
(21.6 x 17.8 x 12.7)
Collection of Nancy and Roger Boas

Cup on a Rock, 1972
Porcelain with underglaze and glaze, 12 x 9 x 6¼
(28 x 22.9 x 15.9)
Collection of the artist, courtesy Braunstein Gallery,
San Francisco

Teapot, 1973
Porcelain with underglaze and glaze, 8½ x 10¼ x 10⅜
(21.6 x 26 x 26.4)
San Francisco Museum of Modern Art; In memory of
Alma Walker, given by her friends

Wood Slab with Cup and Case Knife, 1974
Porcelain with underglaze and glaze, 6 x 8 x 12
(15.2 x 20.3 x 30.5)
Collection of Mr. and Mrs. John Lowell Jones

Roof Cup, 1976
Porcelain with underglaze, glaze and overglaze transfers,
10 x 7 x 6½ (25.4 x 17.8 x 16.5)
Collection of Mr. and Mrs. Millard F. Rogers, Jr.

Styrofoam Cup with Pencils, 1976
Porcelain with underglaze, glaze, and overglaze transfers,
16 x 12 x 1 (40.6 x 30.5 x 2.5)
Collection of Byron Meyer

Open Book #1, 1977
Porcelain with underglaze, glaze, and overglaze transfers,
9½ x 10¾ x 9 (24.1 x 27.3 x 22.9)
Collection of Cecile N. McCann

Junkman Walking, 1978
Porcelain with underglaze, glaze, and overglaze transfers,
31 x 9 x 8 (78.7 x 22.9 x 20.3)
Collection of Austin Conkey

Moonlight Goose, 1978
Porcelain with underglaze, glaze, and overglaze transfers,
24 x 16 x 16 (61 x 40.6 x 40.6)
Stedelijk Museum, Amsterdam

Stack of Books #1, 1978
Porcelain with underglaze, glaze, and overglaze transfers,
9½ x 7½ x 13 (24.1 x 19.1 x 33)
Collection of Harold and Gayle Kurtz

Target with Coffee Can, 1978
Porcelain with underglaze, glaze, and overglaze transfers,
30 x 13½ x 9 (76.2 x 34.3 x 22.9)
University Art Museum, The University of New Mexico,
Albuquerque

Figure on a Palette, 1980
Porcelain with underglaze, glaze, and overglaze transfers,
39 x 13 x 18 (99.1 x 33x 45.7)
Private collection

House of Cards with Two Volumes, 1980
Porcelain with underglaze, glaze, and overglaze transfers,
15 x 19½ x 7¼ (38.1 x 49.5 x 18.4)
Private collection

Melodious Double Stops, 1980
Porcelain with underglaze, glaze, and overglaze transfers,
39 x 11½ x 9 (99.1 x 29.2 x 22.9)
San Francisco Museum of Modern Art; Purchased with
matching funds from the National Endowment for the
Arts, and Frank O. Hamilton, Byron Meyer, and Mrs.
Peter Schlesinger

Mike Goes Back to T., 1980
Porcelain with underglaze, glaze, and overglaze transfers,
41¾ x 14 x 19 (106 x 35.6 x 48.3)
Whitney Museum of American Art, New York; Burroughs
Wellcome Purchase Fund 81.4

Photograph Credits

Photographs of works of art reproduced have been supplied, in many cases, by the owners or custodians of the works, as cited in the captions. The following list applies to photographs for which an additional acknowledgment is due.

This publication was organized at the Whitney Museum of American Art by Doris Palca, Head, Publications and Sales; Sheila Schwartz, Editor; and James Leggio, Associate Editor. At the San Francisco Museum of Modern Art, Victoria Potts assisted in research for Suzanne Foley's essay and Anne Munroe compiled the biographies, bibliographies, and exhibition histories, based on the initial research of Beth C. McBride.

Designer: Nathan Garland
Typesetter: Elizabeth Typesetting Company
Printer: Princeton Polychrome Press